THE MODERN ART INVASION

THE MODERN ART INVASION

*Picasso, Duchamp, and the 1913
Armory Show That Scandalized America*

ELIZABETH LUNDAY

LYONS PRESS
Guilford, Connecticut
An imprint of Globe Pequot Press

Lyons Press is an imprint of Globe Pequot Press.

All photo insert images in the public domain unless otherwise noted.

Project editor: Meredith Dias
Layout: Lisa Reneson, TwoSistersDesign.com

Library of Congress Cataloging-in-Publication Data is available on file.

ISBN 978-0-7627-9017-3

Printed in the United States of America

10 9 8 7 6 5 4 3 2 1

For Chris and Nathan, my guys

CONTENTS

Introduction

I like this thing because it's a revolt, and I'm for revolt every time.
—ARTHUR YOUNG, AMERICAN ARTIST

March 1913
New York City

Traffic backed up for blocks around the 69th Regiment National Guard Armory on the east side of Manhattan. Limousines, taxis, and old-fashioned horse-drawn carriages fought for position on Lexington Avenue. Under the baleful glare of beat cops, uniformed attendants wearing spiffy caps shouted into megaphones in a vain attempt to keep traffic flowing. In the line that snaked around the corner and down the block, visitors craned their necks to see how close they were getting to the wide stairs leading to the entrance. They were willing to wait.

Officially, they were attending the International Exhibition of Modern Art—but everyone was already calling it the Armory Show. It was, by far, the most anticipated and talked about event of the season. *Everyone* wanted to see it.[1]

Inside, staff members checked coats and handed out catalogs; sales staff talked up potential buyers; and art students studied gallery maps to be sure they could handle their guide duties. The high ceiling echoed with conversation and laughter. A few officers of the 69th Regiment wandered around, marveling at the transformation of their drill hall, which was now filled with paintings and sculptures and decorated with potted pine trees and swags of greenery. One newspaper critic said the hall resembled an Italian garden.

Clutching their programs, visitors entered the galleries and moved between brilliantly colored paintings that were unlike anything seen in the United States before: A bullfight by Édouard Manet. Green olive

trees against a pale blue sky by Vincent van Gogh. An old woman counting rosary beads by Paul Cézanne. The farther from the entrance, the stranger the art became. A drawing of interlocking charcoal lines by Pablo Picasso was inexplicably titled *Standing Female Nude*. A jumble of gray and orange blocks claimed to depict a religious procession in Seville, and a chunk of plaster was identified, unaccountably, as *The Kiss*.

The visitors shared their frank opinions of the art. "If I caught my boy Tommy making pictures like that, I'd certainly give him a good spanking," announced one matron to her friends.[2] "It's a long way from Ingres* to Matisse, but only a short one from Matisse to anger," declared another observer, probably proud of the quip—a reporter obligingly jotted it down.[3] One gentleman in a frock coat removed his hat and bent over to survey a canvas upside-down between his legs in a vain attempt to better understand it.[4]

In one of the last galleries, a crowd piled up around one painting, an arrangement of tan slabs and wedges descending diagonally across a brown background. The catalog identified it as #241: "Nu descendant un escalier"—*Nude Descending a Staircase*—by Marcel Duchamp. One guest stood peering at the work as an art student wearing an "Information" pin on his lapel tried desperately to explain it.

The visitor shook his head at the end of the student's spiel. "It may be all as you say," he said, "but I fail to discover anything like a girl going down stairs."

"Don't let that worry you," broke in another guest. "She's going down so fast you can't see her. Don't you notice the smoke?"

Some mocked the strange new art, but other visitors were delighted by the work on display. A journalist encountered Arthur Young, an artist with drawings in the show, cheerfully wandering the galleries. "You know, I like this thing because it's a revolt, and I'm for revolt every time," he said. "These post-impressionists and cubists and futurists are throwing figurative bombs. Let 'em go!"[5]

Young wasn't the only one to describe the Armory Show in military terms, perhaps inspired by the martial location. The headline for the *New York Herald* declared "Flying Wedge of Futurists Armed with Paint and Brush Batters Line of Regulars in Terrific Art War." The article went on to say, "The battle has been raging in Europe for years, and now the fighting

* Jean-Auguste-Dominique Ingres was an esteemed French Neoclassical painter of the nineteenth century.

has spread to this country. Armed to the teeth with brushes and pencils, the rival factions are attacking each other's artistic ideas at every opportunity."[6]

The *American Art News* called the art exhibit "a bomb from the blue" and critic Hutchins Hapgood, writing for the *Globe*, described the city in ruins as if from an assault: "Immense conflagrations, terrifying and exciting fires burst out all over the city. . . . The skyscrapers of prejudice were shaken and the static buildings of outworn tradition were set on fire." Hapgood believed the show would infuse American art with new energy: "It is the most life enhancing exhibition of a large and inclusive character that we have ever had in New York."[7] Opponents to the show took a contrary view—they felt as if their homeland was under invasion by a foreign artistic force and took up arms to defend America from the besieging Cubists, Futurists, and Fauvists.

———

The first thing to know about the Armory Show is that it was *huge*. In the 69th Regiment drill hall were 1,200 to 1,300 paintings, sculptures, and drawings. Featured were the works of nearly 300 artists, both American and European, ranging from painters with household names (van Gogh, Picasso, Claude Monet) to artists so completely unknown to this day that art historians can tell us neither the dates of their births and deaths nor even, in a few cases, their full names. The exhibit visited three cities in America—New York, Chicago, and Boston—and nearly a quarter of a million people saw the show. Guests included artists, writers, architects, and poets; queens of society and titans of industry; political heavyweights and marginalized radicals; shopgirls, chauffeurs, bartenders, and students.

Newspapers, the sole mass media of 1913, covered the show from start to finish. Headlines appeared not only in the three tour cities but also across the United States in papers from Grand Rapids to El Paso, Tacoma to Cleveland. The blanket coverage sparked trends in more than just art. "Cubism," a narrowly defined art movement in Europe, became a catchall term for anything new, fresh, and modern. Designers unveiled Cubist fashions; hostesses threw Cubist parties where their guests played Cubist games and ate Cubist food. To use a twenty-first-century term, Cubism became a meme.

But the real impact of the show came not in fads and fashions but in fundamental transformations within American art. Modern

European art established a beachhead in America with the Armory Show, a secure position from which to launch future incursions. More modernism would follow as European artists realized the potential of the market; soon cross-Atlantic trade in radical art became commonplace. In time, museums such as the Whitney, the Guggenheim, and the Museum of Modern Art opened to showcase it. The stage was set for New York to rise—relatively quickly—from provincial backwater to capital of the art world.

The Armory Show also transformed the lives of numerous painters and sculptors. Duchamp went from unknown French painter, overshadowed by his better-known older brothers, to the most famous European artist in America. He remains well-known to this day—most people with basic cultural knowledge still recognize his name and can identify one or two of his works. For most artists the change was more subtle; the show offered an opportunity to glimpse a wider world of art, a chance to feel part of a community of modernists, a moment to study styles wilder and more thrilling than any they had seen before.

For some artists, the Armory Show was a disaster—it exposed their weaknesses and diminished their authority. For others, the Armory Show was their first step in becoming professional artists—Edward Hopper, later one of the most famous artists in America, made his first sale at the show.

American art institutions as a whole were shaken by the force of the Armory Show—the blast sent old establishments with rotting foundations tumbling to the ground. Before the show, the National Academy of Design—"the Academy"—dominated U.S. tastes and shaped (or denied) the careers of U.S. artists. The Armory Show demolished the power of the Academy and proved artists didn't need associations to succeed in the twentieth century. They could be modernists on their own terms.

———

Before the Armory Show, the art world seemed a stable place built upon certainties. After the show, those certainties were swept away, sometimes violently and with prejudice. The greatest transformation wrought by the Armory Show was that it changed the very *definition* of art. Critics attacked the show because the art on display violated

their long-established, preconceived notions. One critic wrote in the *New York Tribune:*

> *Can these paintings properly be designated works of art? Does art imply beauty in some manner? Is it not necessary that there be beauty either of form or of thought expressed in masterly fashion? We will grant to the "sensationalists" the credit for masterly expression.... But is it beautiful? ... It might be interesting, but would it be worthwhile?*[8]

Traditionalists had a clear idea of what art *should* be, and their standard provided a basis for art education, a guide to everyday art production, and a rule book by which art could be judged. First of all, art was—if nothing else—beautiful. Art was also rooted in a tradition that reached back to the Old Masters, painters whose names artists repeated as mantra: Michelangelo, Titian, Rembrandt, Rubens. Art was passed from generation to generation in a painstaking process that required the mastery of age-old techniques. Acquiring these techniques mattered more than demonstrating originality or creativity. Art conveyed a message, a moral, or an uplifting story intended to better the lives of those who viewed it.

Modern art questioned all of these assumptions—and contradicted most of them. Modern art didn't care about tradition—it was new and brash and disrespectful of the past. Modern art didn't care about technique; originality counted more than competent execution. Modern art claimed no consensus on what it was "about." Artists might capture an image of the world, or their feelings about the world, or an interpretation of the world—or they might create abstract arrangements of lines and colors. Modern art didn't have to be beautiful, and it certainly didn't need to teach a lesson.

No wonder so many artists furiously resisted modernism at first. "If the new things were right ... then, I thought, my beloved Old Masters were wrong," wrote Walter Pach, one of the artists who helped organize the Armory Show, describing his own process of understanding the new art. Furthermore, if traditional art had to be abandoned, "my whole preceding work had been misdirected. I had paid high for it in money and effort, one does not easily give in under such circumstances."[9] In this context, the mass of resistance and anger about the new work makes a great deal of sense.

Yet modern art had an undeniable newness that fascinated artists and audiences. In comparison, traditional art couldn't help but seem shabby and worn. The world was changing in 1913 America—automobiles rumbled

down city streets under soaring skyscrapers, airplanes took to the skies above crisscrossing telephone lines. Even music was new, the syncopated beat of ragtime drowning out Victorian waltzes. Why should an artist of 1913 paint like an artist of 1813? "Ideas were at work in the world that made the older formulas for painting and sculpture unserviceable for the new generation,"[10] said Pach. The modern age demanded modern art. Its moment had come.

———

In 1913, everyone who bothered to read a newspaper—and most people read more than one, since they were the only source of news—knew about the Armory Show. Avid fans could follow every step of its progress, from New York to Chicago to Boston, through all of the trials of angry art instructors and offended politicians.

But over time, the Armory Show has faded from popular memory. Today few people know about the exhibition, and even those with a passing awareness hold misconceptions about the show and its effect on the art world, on New York, and on the culture at large. Many people believe—and some art history textbooks teach—that the show was universally attacked by critics and newspapers.

It's true the show produced fantastic mocking headlines. ("No one who has been drinking is let in to see this show," is a favorite.) However, many critics celebrated the art at the show and were fascinated by the experiments of modernism. Another myth holds that the only *good* art at the show was European and that the American art was an embarrassing display of subpar work. Certainly the most radical art at the exhibition was international, but the American art was nothing to be ashamed of, and it received glowing reviews.

The greatest misconception about the Armory Show is that it had no effect on the course of American art in the twentieth century. Some historians in recent years have downplayed the show, claiming it was more a fad than a transformative moment in art history. It's true that the immediate impact of the show was limited—but that is mostly because when World War I broke out in 1914, cultural progress and exchange between the United States and Europe was violently interrupted.

However, the long-term implications of the show were vast, even if they took decades to realize. From the perspective of the present, it's clear the Armory Show marked a turning point when old became new,

academic became modern, and American art stepped out of the wings and onto the world stage.

———

Back in March 1913, as night fell and the clock neared 10:00 p.m., the student guides joined the police in herding the last visitors from the Armory Show galleries. Persistent types had to be firmly ordered to vacate the room containing *Nude Descending a Staircase*. The guests retrieved their coats and hats, and some bought postcards from the display stand by the exit. A special mailbox had been placed by the door, and guests scribbled a few words about the show to friends—people wanted to brag they had seen it!—before dropping their cards in the box and emerging into the brisk spring night.

Artists exhausted from a long day at the Armory headed across the street to a friendly bar that had become their home away from home during the show. They tossed back drinks and traded war stories about their encounters with hostile critics. The treasurer added up the day's take, and the publicity team scanned the evening papers for a mention of what was going on over at the 69th Regiment Armory.

In the now-dark, echoingly empty Armory, the art waited for another day. Faint city light filtered down through the skylights to fix on the paintings and sculptures—a sailboat leaving a narrow wake in green water, a young man's torso gleaming in white plaster, a young woman with a pert nose reading a book in bed. The show would open the next day, and again the crowds would line up around the block. But in the dark, it's as if the art held its breath, waiting to launch the city—and the country—into the future.

※ generally one must be very good @ old world art — this gives you a basis to subtract images — line — ideas out of past creations

Part I

Organizing the Assault

CHAPTER 1

Itching for a Fight

Originality is the bane of art. Art is a matter of evolution; a new note
is not struck more than once in a thousand years.
—WILLIAM ORDWAY PARTRIDGE, AMERICAN ARTIST

December 11, 1911
New York City

~~KING PIN~~
~~ARMORY~~

Walt Kuhn was in a slump.

He'd had an exhausting few weeks. The thirty-four-year-old artist
had worked tirelessly to promote his first solo show, but not only were
sales slim, the press had completely ignored him—and for good reason.
Unfortunately for Kuhn, the same day his show closed, the biggest and
most important art event in North America, the annual National Acad-
emy of Design exhibition, opened. Things were not going his way.

"Guess we'll get no kick coming as regards the show," he wrote his wife,
Vera.[1] "The *Times* [review] was spoiled by the opening of the Academy,
so of course they crowded out my photo. . . . I'm naturally demoralized."

Demoralization came rarely to Kuhn, a tall man with a square jaw,
piercing eyes, and imperious eyebrows—his wife said he looked like a
cross between Mephistopheles and Abraham Lincoln.[2] He'd worked his
tail off getting ready for the show, spending hours running around the city
wooing reviewers before slogging home to his lonely, chilly house in Fort
Lee, New Jersey. Despite being just across the Hudson from Washington
Heights, this was a heck of a trek before the construction of the George
Washington Bridge. The house was chilly because Kuhn couldn't afford
to heat it and lonely because Vera had decamped with their baby daugh-
ter, Brenda, to her parents' house in Washington, D.C. Vera wanted help

caring for the five-month-old, but she also needed a break from life with an ambitious but struggling artist. Kuhn made a living selling cartoons to magazines, but it wasn't a great living even at the best of times, which this most certainly wasn't; all he cared about now was his show.

Kuhn was an optimist at heart, and he remained convinced that hard work would guarantee success—eventually. He implored Vera, "If you believe in me, which you must, you must feel that it can't be very long before things will be straightened out." He continued, "Don't think for a moment that I am not perfectly alive to all conditions. Now *do* try to look a little more cheerful. For unless you do, I am helpless to make progress."[3] In his previous letter, he noted he had caught seven mice in the kitchen.

But even rodents, an exasperated wife, and cancelled reviews couldn't keep Kuhn down. He approached life with a sort of reckless bravado; at sixteen he promoted his first moneymaking scheme, a bicycle repair shop, by barnstorming country fairs.[4] Raised in New York in the dockside hotel run by his parents, he'd headed west in his early twenties, fetched up in San Francisco, and drawn editorial cartoons for five dollars a week. In 1901, he set off for Europe to train as an artist. He studied briefly in Paris and then enrolled at the Royal Academy of Art in Munich, where he frequented beer halls wearing a Stetson and carrying a mandolin.

He moved back to New York in 1903 and met Vera Spier, eight years his junior and herself an aspiring artist and jewelry designer, in 1909. They argued frequently, but their quarrels never lasted; Vera loved her husband, with his endless optimism and bottomless fund of ideas. Kuhn wrote her almost daily, the details of his work interspersed with queries about Christmas shopping and parental rejoicings over the baby's growth ("Hurrah for Brenda's tooth!"[5]).

The solo show had been Kuhn's latest attempt in his long struggle to get his work seen by potential buyers. The Academy was the only game in town, and unfortunately for Kuhn, he just wasn't an Academy man.

Only a few galleries in the city even showed nonacademic art. Academic art took its name from the academies of Europe, the older cousins of the National Academy of Design that had taught aspiring painters for centuries. Academies preferred their paintings with heavy-handed moral themes, subjects drawn from history or myth, and a smattering of nymphs. Kuhn wasn't aggressively modern—in this period, he produced mainly sun-drenched seascapes in an Impressionist vein—but he wasn't a nymph kind of guy. Kuhn was too proud and too stubborn to change his

style to suit the Academy—for which history, at least, would thank him. Without Kuhn's stubborn streak, the International Exhibition of Modern Art might never have happened.

———

The failure of his one-man show stung Kuhn, but he wouldn't let it bring him down. In the same letter to his wife where he bemoaned the pre-empted *Times* review, he also wrote, "It's quite likely there will be a revolution this winter and that a new society will form."

A revolution. Kuhn couldn't have known how right he was. Within two years, his new society would destroy the power of the Academy, introduce modernism to millions, and revitalize American art. It would change Kuhn's life and the lives of dozens of other artists; it would transform New York from sleepy backwater to the capital of the art world. It would shape how Americans thought—and still think—about creativity, originality, and the role of art in society. It would redefine art and what it meant to be an American artist.

A century later, Kuhn's revolution continues to reverberate beyond the art world, into the culture at large—influencing its attitudes, prejudices, and philosophies. His mention of a "revolution" in that letter to his wife is the first written reference to what would become, only two years later, the most important art exhibit in American history: the Armory Show.

———

In 1911, American artists had the deck stacked against them. As citizens of a young country without much of an artistic establishment or history, many Americans moved to Europe, where schools, galleries, and patrons were more plentiful. The late-nineteenth-century-artists James McNeill Whistler, Mary Cassatt, and John Singer Sargent studied in European studios, followed European trends, and succeeded on European terms. Of course, they then faced the charge that they weren't really American anymore—Sargent was routinely dismissed as American in name only.

The Academy offered the surest path to success for artists who wanted to stay in the States. Founded in 1825 as the New York Academy of Design, the organization modeled itself on the state-sponsored

academies of Paris and London that provided instruction to the young, exhibition venues to the aspiring, and prestige to the established.[6] Like its European predecessors, the American Academy prized the artistic heritage of the Greeks and Romans, the Renaissance geniuses, and the Baroque Old Masters. It emphasized the continuity of artistic tradition and sought to pass on that tradition unchanged to future generations.[7] Academies valued technique over creativity—in fact, they deplored too much creativity. "Originality is the bane of art," stated academic favorite William Ordway Partridge. "Art is a matter of evolution; a new note is not struck more than once in a thousand years."[8]

Cautious artists such as Partridge considered originality particularly dangerous for American artists, because it could expose the raw newness of the American artistic tradition. The American Academy wanted to create a credible American art establishment, but they feared their European colleagues would discount them as ignorant provincial wannabes. Their solution was to out-academy the European academies to prove that America was worthy to be admitted into the exclusive fraternity of Western culture. They sought to make art that had distinct Americanness but only within narrow limits—portrayals of American history were okay, as were scenes of American landscapes such as Niagara Falls—but when in doubt, they preferred that painters stick with traditional subjects. Better to be ultraconservative than to give evidence to Europeans that American artists were just kids goofing around without any respect for Western heritage.

So the system stifled innovation. Academies held annual exhibitions, with works selected by juries of established members—Academicians who had been elected by their peers. The institution was essentially an echo chamber: to succeed within the Academy one needed to please older Academicians, who would then allow the artist to become an Academician himself, so the artist could judge others trying to join the Academy. The self-perpetuating system cared about little more than upholding tradition and churning out faithful adherents.

Should American artists attempt to buck the system, the Academy had ways of shutting them down. Progressive artists—the catchall term for anyone bold and forward-looking, basically anyone outside the Academy—routinely failed to receive enough votes for membership; in 1907, only three out of thirty-six nominated artists were elected.[9] One outraged Academy member characterized the rejected as progressives who had

"broken away from the moribund conventions that are religiously followed by the conservatives."

Similarly, progressive paintings had to clear several hurdles to appear at Academy exhibitions. First, juries could reject works for any reason. Second, paintings could make it past the jury but not appear in the exhibit hall since the Academy routinely accepted far more paintings than it had room to show. Finally, even if they made it that far, artists might be devastated to find their paintings hung mercilessly next to the ceiling or above a poorly lit doorway. The Academy followed European tradition (impossible to imagine in today's art climate) of displaying paintings in multiple rows *as high as possible*. Academic favorites hung "on the line" or at eye-level, while less-favored paintings were "skied" in successive rows and almost impossible to see. Many artists arrived full of excitement at their first public exhibition to find their paintings barely visible—a sucker punch delivered with a smile.

It's not surprising, then, that academies faced periodic revolts. In 1793 French artist Jacques-Louis David successfully campaigned to close the Académie des Beaux-Arts by denouncing its practices as inconsistent with the democratic spirit of the French Revolution.[10] The Paris-based academy came back stronger than ever, however, and gained such power that one ambitious artist committed suicide in 1866 after his paintings were rejected from the annual Salon.[11] ("The members of the jury have rejected me, therefore I have no talent... I must die," wrote the forty-year-old Jules Holtzapffel in his logically suspect suicide note.) The hold of the French academy finally slipped in 1874 when the Impressionists, tired of rejection, set up their own exhibits. Throughout the next three decades, artists across Europe followed suit, and by 1900 the power of the academy in Europe had weakened significantly.

Isolated across the Atlantic, the U.S. Academy remained powerful, although it also faced occasional rebellions. In 1875 a group of Academy students formed the Art Students League in a frustrated response to the conservative curriculum. In 1877 another group broke away to form the Society of American Artists with the aim of holding a competing annual exhibition, but the entrenched Academy emerged from the conflict unscathed and in 1906 the Society re-merged with the Academy.[12] The Academy began the 1910s confident it could meet any challenge and comfortable with success—and with no idea its dominance would soon be threatened.

The threat would have to come from artists, since as far as most Americans were concerned, academic art *was* art. The United States didn't have a deep artistic tradition—the Puritans, after all, had opposed art as self-indulgent at best and blasphemous at worst. The few public art museums in American cities functioned as little more than shrines to the Old Masters. Most magazines and book publishers leaned conservative and featured only academic art, and in any case color printing was costly and color photography unheard of.

Not many Americans could afford to collect art, and those who did often bought paintings as a badge of wealth rather than an expression of taste; Gilded Age millionaires spent vast sums—up to $60,000 ($1.4 million in 2013 dollars)—on paintings by French academic favorites William-Adolphe Bouguereau and Jean-Louis-Ernest Meissonier. What little art that the average American did see was carefully selected by these same men with their dated tastes. The art of monuments and public spaces reflected these academic leanings since those same millionaires sat on the committees that commissioned these public works. It was—to use a modern phrase—a "closed network."

Yet anyone who followed the European art scene knew the art of Bouguereau and Meissonier was dead as a dodo. It had become passé as far back as the 1870s when the Impressionists—a circle led by Claude Monet, Edgar Degas, and Auguste Renoir—introduced an entirely new approach to painting. Incidentally, the names Monet, Degas, and Renoir are known to any college student in America, while only dedicated art historians have heard of Bouguereau and Meissonier. By 1911, the year Kuhn's solo show opened and closed with nary a whimper, European modernism had reached full swing, and most Americans knew nothing about it. Magazines and newspapers—the only mass media in 1911— sometimes reported on art trends, but reproductions were limited to black and white, and editors hesitated to print even those, considering modern art too shocking for their audiences.

The *New York Journal-American*, one of the city's most sensational tabloids, turned down a story on the Fauve artist Henri Matisse when the editor got a look at the photos, declaring "there had to be at least a semblance of intelligibility to things."[13] An alert observer who religiously read the *Times* might know something called Fauvism existed but would have no notion what it looked like. The Academy, alarmed by reports of insane European painters ("fauve" means "wild beast") and their bizarre canvases, was all too

happy to keep them in the dark. In fact, the Academy's influence, relevance, and future *depended* on keeping them there. This is one of the main reasons that the battle lines at the Armory Show would be so fiercely drawn—the Academy was defending its authority to determine American taste.

While the American public continued to hail the Academy as the leader of the art world, the institution squandered its reputation through an ill-conceived building plan. Academy leaders hoping for a new headquarters for the institution had ambitious ideas, seeking a full city block so skyscrapers couldn't overshadow the building, lots of room for the Academy school, and a large exhibition space. Academy leaders complained for years that no gallery in the city provided adequate room for exhibits; the reason it habitually accepted but didn't show works was to illustrate this point. Every year the Academy announced to the press the vast number of paintings it *had* to leave undisplayed—a total of 1,665 in the spring of 1910 alone. In 1909 the organization began lobbying for community support for a new structure and proposed the city donate the necessary land; in fact, the Academy suggested brightly, a slice of Central Park would be ideal.[14]

The public exploded, writing inflamed letters to newspapers demanding the artists keep their hands off the city's parks. At the time, Manhattan had not only the fastest-growing population in America but also the most jam-packed, with 2.3 million people jostled into not quite twenty-three square miles. New Yorkers considered parks not a luxury but a necessity—in a city where even the richest didn't own land, everyone spent their leisure time in parks. They were the city's backyard, front lawn, picnic location, and haven combined. The donation of parkland to the Metropolitan Museum of Art in the 1870s provided a precedent for placing a museum in Central Park, but critics saw this as a slippery slope that could lead to the gradual nibbling away of open space.

The Academy dithered, protested, and finally came up with an alternative location: a chunk of *Bryant* Park—as if proposing a different park solved the problem. New Yorkers erupted in rage. Newspapers described the Academy as attempting to invade New York parks and rallied opposition to the scheme with months of front-page headlines. The Academy backed off and eventually realized its own missteps had eliminated public support for a building, no matter what its location.

Such was the state of the Academy in 1911: a conservative, self-serving, embattled institution out of step with both young artists and the city as a whole. Artist Henry Reuterdahl summed up the situation nicely:

An Academy exhibition now looks like an exhibition of life-insurance calendars. The pictures are all painted on the academic formula. Unless a man paints accordingly[,] there is no place for him to exhibit in New York. The Academy is doing everything for itself and its members and nothing for American art. If it is the guardian of American art, as it pretends to be, it ought to give the young man a chance.[15]

———

Should an American artist refuse to paint according to the Academy's formula, another option remained: reject the Academy and go independent. This created a whole new set of complications. The Academy provided the only sure pathway to success. Collectors relied on the Academy's seal of approval and hesitated to invest in art from outsiders. In fact, even finding exhibition opportunities without Academy backing proved incredibly difficult, as Kuhn knew well. Only a handful of galleries showed progressive art in the city.

For example, the tiny Macbeth Gallery sometimes displayed progressive art, but it could only show about twenty paintings at a time. The Madison Art Gallery, established by Clara Potter Davidge and managed by Henry Fitch Taylor, both of whom would play roles in the Armory Show, focused on contemporary works—it was the location of Kuhn's one-man show. Despite excellent intentions and the financial backing of the socialite and art patron Gertrude Vanderbilt Whitney, who had *two* Gilded Age fortunes to draw upon, the gallery never attracted much attention. Pioneering photographer Alfred Stieglitz exhibited progressive artists at his gallery 291 (named for its address at 291 Fifth Avenue), but Stieglitz favored his select circle of disciples and hated publicity. In today's New York you can't throw a rock without hitting a cutting-edge gallery, but artists of Kuhn's era found it much harder to get their art in front of potential buyers.

Desperate to find an audience in this restricted market, some artists decided to organize exhibitions themselves. Most prominent among the self-promoters was Robert Henri (pronounced "HEN-rye"), an artist known for his tough-guy-Westerner attitude as much as for his vigorous, realistic paintings of urban American life. His rough-and-tumble background in the still-wild West (as a teenager, his family was in a range war straight out of *Shane*) made Henri suspicious of establishments and

institutions. To put it mildly, Henri was uncompromising in his quest for justice. He also painted sensitive portraits and inspired students with his charismatic teaching style.[16] By 1906 his fame had grown to the point the Academy had to admit him as a member, but he defied the institution from day one. In 1907 he landed a spot on the exhibition jury and campaigned to get the work of his students and other progressive artists admitted—only to see most of it rejected upon further review or accepted but not hung. The Academy made sure he was never on the jury again.

A disgusted Henri instead pulled together an exhibit of artists who became known as The Eight. The core five members—Henri, William Glackens, George Luks, Everett Shinn, and John French Sloan—had studied together in Philadelphia and adopted a similar realistic style.[17] The men focused on urban life and its hardships; Henri wanted, in the words of critic Robert Hughes, "paint to be as real as mud, as the clods of horse-shit and snow that froze on Broadway in the winter."[18] Paintings showed lines of washing hung outside tenement windows, crowded markets on Houston Street, and grimy bars on the Lower East Side. The artists believed these scenes of real life made their art more *American* than academic imitations of the Old Masters. There was nothing remotely American about nymphs and Greek goddesses and, as far as Henri was concerned, pretending otherwise only exposed the insecurity of the Academy.

The stark realism of Henri and his friends also provided a visual equivalent to the muckraking journalism of such writers as Upton Sinclair, who exposed the ugly reality of urban life in works such as *The Jungle,* a stomach-turner about conditions in a meatpacking plant. Henri and his colleagues believed they were fulfilling a social duty, but critics decried the sordidness and vulgarity of their subjects; in time, they would become known as the Ashcan School.

The remaining three of The Eight had little relationship stylistically to the other five but had also suffered at the hands of the Academy. Maurice Prendergast and Ernest Lawson created an American version of Impressionism, with Prendergast painting delicately colored urban scenes and Lawson vibrant landscapes. The art of Arthur B. Davies proves harder to classify—he favored dreamy nudes and magical landscapes. He was perhaps the last artist to paint unicorns without a hint of irony.

The Eight's 1908 exhibit at the Macbeth Gallery attracted press attention, mostly negative. The attacks foreshadow those that would be

hurled at the Armory Show a few years later—"The canvases of Mr. Prendergast look for all the world like an explosion in a color factory," noted one critic.[19] Not all criticism was aimed at the art, however. A number of artists—particularly younger ones outside of Henri's sphere—complained about his exclusivity. He rebuffed all requests to expand The Eight. Over the following years, as other independent groups attempted to form, Henri insisted on control or refused to participate altogether. His students profited from his promotion, but those outside his circle felt shut out and resented his assumption of the role of leader of all independent artists.

This is where things stood in 1911 when Kuhn sat down to write his wife about the failure of his one-man show. His career, like American art in general, had ground to a halt. His options—and the options of all other progressive artists—seemed to be to play the Academy's game or to play Henri's.

Kuhn had no intention of doing either.

———

"Now here's what I've been thinking," Kuhn wrote Vera on December 12, the day after his "demoralized" letter. "We certainly made good this time, but what we need now is *publicity*. The stuff is there but *everybody* must see it. Beginning the first of Jan. I am going to organize a new Society."[20]

The thought of creating an artists' association powerful enough to challenge the Academy would have daunted most people, but Kuhn seemed blithely confident of success. Somehow he recognized that the moment had come to strike at the institution and that he was destined to wield the blow. With equal parts optimism and egotism he strode into the fray, never entertaining the thought that he couldn't overthrow America's art establishment, an order that was not only firmly entrenched, but also had never even heard of Walt Kuhn. He believed in his timing, his luck, and his ability to seize the moment.

Considering the odds against him, Kuhn's assurance is breathtaking: "The thing must be started so that it can grow and be as big or bigger than the Academy in 2 or 3 years," he wrote Vera. And he never doubted his own importance in the scheme. The presidency, he decided, should go to someone prominent, but he would be the power behind the throne. "Don't worry, I'll be the real boss," Kuhn wrote his wife.[21] Only one point

seemed to concern him: how to contain Henri. "Of course Henri and the rest will have to be let in—but not until things are chained up so that they can't do any monkey business," he wrote.[22]

He got the show on the road by rounding up several like-minded artists. By December 19 they had roped in thirteen artists and organized a kick-off meeting. After some debate, they selected the name "Association of American Painters and Sculptors" (AAPS). Officers were elected; Kuhn landed the job of secretary. Henri wound up on the board of trustees where, presumably, Kuhn thought he couldn't cause any trouble. If only.

As Kuhn had intended, the group sought high-profile artists for president and vice president to give their fledgling association credibility. Both choices would come back to haunt them. J. Alden Weir, an established Impressionist, was elected president and sculptor Gutzon Borglum, famous for his oversized public memorial commissions, marvelous name, and volcanic temper, as vice president. Borglum would become a problem down the road, but Weir didn't last a month as president. After the AAPS's second meeting on January 2, the New York Times announced, "Artists in Revolt, Form New Society."[23] The article makes no bones about the AAPS's opposition to the Academy—it was said to be "openly at war with the Academy of Design." Kuhn also informed the paper the AAPS planned to construct a new building for itself at any desirable location but a city park—a dig at the Academy's hated building plan that was dead in the water.

Weir read the news the next morning and likely spit his coffee all over the Times. Curiously, he had agreed to the presidency without actually attending any of the meetings. Weir sent an open letter to the AAPS— and the Times—resigning his presidency, stating, "I have been a loyal member of the Academy for more than twenty-five years."[24] The presidency now sat vacant—and for a few days no one knew if the association would survive. Kuhn must have feared Henri would seize the job, but a less controversial choice was at hand and elected without controversy: Arthur B. Davies.

Kuhn likely saw Davies as a useful figurehead—valuable for fundraising and publicity but not an active participant. The forty-eight-year-old artist had a reserved, aristocratic bearing; famously shy, he would flee galleries if more than two or three people showed up. Above all he valued his privacy. He kept his phone number unlisted and rarely socialized in the city.[25] He once invited a critic to his studio on the condition that afterwards the critic completely forget his address.[26]

In turns out Davies had a fantastic reason for all the privacy—he was leading a double life with a second, secret wife. Davies married his first and only official wife, Virginia Davies, in 1892. Soon after, Virginia and her family bought a farm an hour's train ride north of the city. Virginia happily grew apples, gave birth to and then raised their two boys, and worked as a country doctor. Davies, however, found the farm uncomfortably crowded—Virginia's family thought it their right to stay there for months at a time—and ended up renting a studio in Manhattan where he lived during the week. He became a weekend dad, arriving on Saturday afternoons to play with his kids before returning to the city Sunday night.

Davies met the woman who would become his simultaneous wife in 1902: Edna Potter, a dancer and part-time model. The tall, slender Edna fulfilled Davies' aesthetic ideal, and he repeatedly painted her in the nude to the point that their "sessions" began to last all night. Such liaisons were dangerous business in an era not far removed from Victorian sensibilities. Several wealthy society women patronized Davies, and if a word of scandal reached them, his career would be over. He never considered divorce—if anything, ending the marriage would have been *more* shocking than having an affair. So Davies and Potter began a quiet life of illicit bigamy. They rented an apartment in an unfashionable neighborhood under the names Mr. and Mrs. David A. Owen.

As far as the neighbors were concerned, the mild-mannered Mr. Owen traveled frequently for his work as a civil engineer. Davies' life became one of constant juggling and endless anxiety—he likely *needed* privacy more than he *wanted* it. Although she stayed with him, Edna naturally felt she was getting a rotten deal; the couple couldn't be seen together in public, go to the theater or a park, or even invite friends to their home. She must have hated the isolation, particularly since Davies still made the trek up to see Virginia and the kids every weekend.

Whatever the reason, Davies' aloof manner hid a strong personality with a ferocious work ethic, excellent organizational skills, and an authoritarian attitude. Kuhn probably would have disliked him intensely if they hadn't been on the same side. Davies also knew more about European art trends than anyone else in the AAPS. He traveled regularly across the Atlantic, read foreign books and magazines, and collected as much French art as he could afford.

Davies expanded the vision of the AAPS to make foreign art essential to the upcoming show. Exhibiting European art had been on the

agenda from day one, but it had not been a major priority; Kuhn had been focused on overthrowing the Academy and creating exhibit opportunities for progressive artists. Davies wanted to do more: He wanted to educate all Americans, not just artists, on the seismic shifts in art under way across the ocean. Kuhn's agenda seems breathtaking, but Davies' was vast in a different way: Kuhn wanted to change American art, Davies wanted to change American culture.[27] The Armory Show wouldn't have had the same impact without them both.

With Davies on board, matters moved quickly. Their first priority was a show, but they couldn't have one without a space. Kuhn and Davies wanted a large site that would accommodate as many paintings and sculptures as possible (an intentional cut to the National Academy of Design and its practice of overbooking paintings). They rejected Madison Square Garden as too expensive and all the galleries in town as too small. Someone suggested a National Guard Armory.

Kuhn visited several locations and entered into negotiations for the 69th Regiment ("The Fighting Irish") Armory on Lexington Avenue between 25th and 26th Streets. The rent for one month cost an appalling $5,000 plus $500 for janitorial services (more than $120,000 in 2013 dollars). Kuhn, who might make $10 or $15 per cartoon, could never have managed it, nor could any of the other young men in the group, but Davies had connections. He never revealed who provided the money, but it appeared as needed. On May 25, 1912, Davies signed the lease.[28]

Now all they needed was the art.

CHAPTER 2

Gathering the Ammunition

It's up to me to get a bunch of fine things and if it can be done . . . I am going to do it.

—Walt Kuhn

September 20, 1912
Hoboken Docks, New Jersey

Chaos reigned. Crowds swarmed the pier and thronged the decks of the ocean liner *Amerika*. Travel guides warned passengers to arrive early, label their trunks, and avoid getting separated,[1] but news reports describe passengers leaving luggage and even family members behind.[2] Amid the hubbub stood Walt Kuhn, no doubt buzzing with excitement. The dejected figure of Arthur B. Davies loomed by his side; it would have been easy to guess which man was heading for Europe and which one was staying home.[3] As horns blasted and handkerchiefs fluttered, Davies shook Kuhn's hand. "Go ahead, you can do it!"[4] he yelled above the din.

Kuhn had taken adventurous journeys before, but this would be his most daring. Alone, he would navigate the European art market, negotiate with dealers, and select works for the Armory Show. He wasn't the obvious man for the job—others in the AAPS had better contacts and greater experience. He didn't even serve on the AAPS's foreign art committee. But Davies trusted him, and he could draw upon his personal fund of self-confidence. "It's up to me to get a bunch of fine things and if it can be done . . . I am going to do it," he wrote Vera.[5]

The luxurious ship—the first to provide passengers with electric elevators—steamed out of the harbor and onto the open ocean. Seasickness knocked Kuhn flat. Other passengers might have enjoyed the invigorating

promenades and Turkish baths recommended in the ship's brochure, but Kuhn clung to his berth. Rough weather dogged the journey, and surely no one on board could banish the thought of icebergs; the *Titanic* sank on this exact route only six months earlier. In fact, the *Amerika* had been a few hours ahead of the *Titanic* on April 14 and issued a warning of icebergs in the sea-lane.

Fortunately, Kuhn's voyage remained uneventful, and within a few days he had recovered enough to sketch his second-class companions for Vera. They included a chauffeur with big ears and a bigger cigar ("funniest man of the lot"), an elderly German woman with her hair pulled back in a tight bun ("the autocrat of my table"), and a California rancher ("tough and weather-beaten but no fool") with whom he played poker for one-quarter of a cent per chip ("I've won about 40 cents."). Nevertheless, he spent most of the journey in a "semi-comatose condition."

Kuhn must have been dazed aside from the rolling waves—a month earlier he had no notion he'd be leaving the country. The task ahead was enough to daunt even his determined spirit.

———

After the flurry of excitement surrounding the founding of the AAPS, the pace of activity slowed. During the summer, most artists left the city on painting expeditions. Kuhn found cheap lodgings on the Nova Scotia coast and basked in the sun with Vera and baby Brenda. His work that summer had new vibrancy, with bright colors and strong brushstrokes.

Davies remained in town, one of the few artists to stay behind. As usual, he could tell no one why: He had a new baby at his second, covert home. Edna and Davies's daughter, Helen Ronven (known as "Ronnie"), had been born on April 14, 1912—the night the *Titanic* went down. Her birth certificate recorded her father as David A. Owen, civil engineer.

Davies still trotted up to see Virginia and the boys every weekend, and Edna felt isolated and overwhelmed. She clung to her putative husband, and when he proposed going to Europe to select art for the exhibition, she dug in her heels. She hadn't even wanted him to accept the presidency of the AAPS. Now she insisted Davies help with the baby, not go gallivanting across the Atlantic.[6]

But *someone* had to go to Europe. It's not clear why Davies didn't ask Elmer MacRae to tackle the job. MacRae had been named chairman of

the foreign exhibits committee, but there's no evidence he was ever consulted. On the other hand, someone apparently suggested Robert Henri could handle the task while on a previously planned trip to Spain and France. A press report from June says members of the AAPS asked Henri to select paintings for the show while in Paris. Henri replied he would act for the group only if given full authority to select whatever he wanted; the AAPS, perhaps wisely, refused to grant this blanket permission.[7] Obviously, Kuhn was unwilling to give carte blanche to a man he distrusted.

Matters came to a head in early September when Davies learned about a show under way in Germany. A friend of his had attended the Sonderbund exhibition in Cologne and had passed along a catalog of its massive selection of Post-Impressionist and modern art to him. Davies contacted the one man he trusted for the job: Kuhn. He wrote Kuhn in Canada urging him to hotfoot it to Germany before the show closed on September 30. Davies likely provided funding for the journey from one of his anonymous patrons—Kuhn certainly couldn't have afforded it on his own dime. An excited Kuhn sent Vera and Brenda to his in-laws and invested in a new suit and pair of shoes. Three weeks later, he boarded the *Amerika*.

At least he would start his journey in familiar territory. Kuhn, the son of a German immigrant, spoke the language fluently and had trained in a Munich art school. He planned to revisit his old stomping grounds and look up his former instructor, Heinrich von Zügel. Von Zügel pioneered Impressionism in Germany, although his works have a more agricultural feel than those of the Parisians Edgar Degas or Auguste Renoir. Von Zügel's fame, such as it was, rested on his paintings of cows.

Kuhn intended to invite von Zügel to exhibit at the show and looked forward to showing off the work of a man he had described in 1901 as "the best painter in Europe."[8] Time would tell if he would continue to stand by this claim.

———

Kuhn sailed to a continent that was brimming with confidence, convinced it was entering an era of peace and prosperity. Intellectuals argued the wars that had wracked Europe were a thing of the past. In his 1910 book *The Great Illusion*, economist Norman Angell proved (on paper, at least) the futility of war in modern Europe, claiming that conflict would ruin

the economies of interdependent European nations. The Balkans provided frustrating counterevidence to this rosy outlook as they again teetered on the brink of war—fighting would break out in early October—but that corner of Europe fought so many wars so often that no one paid much attention. Meanwhile, armies across the continent, convinced great and decisive conflict would soon sweep across Europe, continued preparations for war. Generals turned out to have a more realistic view of the future than economists, although even they would underestimate the eventual horrors of World War I.

Germany, Kuhn's first stop, hadn't yet reached the half-century mark as a nation. Previously a loose confederation of states and principalities, it was still adjusting to its status as an empire. Kaiser Wilhelm II poured vast sums into making his capital, Berlin, a worthy rival to Paris, London, or Vienna—with mixed results. The architecture satisfied his grandiose dreams—the kaiser loved boulevards, balconies, and balustrades, the more extravagant the better—but the populace failed to live up to his expectations. He knew foreigners laughed at the uncouth manners and unfashionable clothes of Berliners, so he issued orders to smarten up his people. He instructed staff at the royal opera to turn away guests not dressed in evening clothes and to discourage patrons from bringing their own snacks. Rules even specified how to walk down the street: Pedestrians were instructed not to swing their umbrellas and forbidden to whistle.[9]

The kaiser prided himself on his refined artistic sensibility. He regularly attended opera rehearsals, sitting at a table with the score open and a stack of sharpened pencils at hand. At every unpleasing note, an aide would halt the performance so the emperor could lecture the singers.[10] He also instructed sculptors on the proper design of statuary, which he liked big, classical, and patriotic. He commissioned nearly one hundred white marble figures of his Prussian ancestors, then presented the lot as his gift to the nation. The nation failed to appreciate the gesture. Berliners disdained the boulevard of statues, known as the Siegesallee ("Victory Avenue"), as vulgar and wondered why their emperor had honored such unheroic figures as Otto the Lazy. Artists hated Siegesallee; sculptor Max Liebermann, whose studio overlooked the boulevard, lamented, "It is a life sentence."[11]

The kaiser disapproved of modern tendencies in art, starting with Impressionism, which he considered not merely worthless but downright wicked.[12] He particularly objected to the Secession, a movement of

German-speaking artists who tried to break the grip of conservative art academies. Inspired by the revolt of the Impressionists in France, Germans and Austrians established new art associations in Munich, Vienna, and Berlin. (Kuhn, Davies, and other progressive American artists were inspired by the revolutionary spirit of the Secessionists.) Cologne's secessionist group, the Sonderbund—which translates as "Special League" or "Separate League"—formed in 1909.

The kaiser lacked the authority to shut down Secession groups, but he could limit their reach. He stacked the jury for the German art pavilion at the 1904 St. Louis World's Fair with academics he could count on to select conservative paintings. Meanwhile, the kaiser's loyal wife was reportedly bewildered anyone would paint in a style her husband deplored. The *Times* reports the empress asking, "I do not understand what the artists want. Has not the Kaiser told them how to paint? Why do they not do it? Why do they want to paint in another manner?"[13]

Courageous German modernists continued to defy their emperor, and in 1912 the Sonderbund organized the most ambitious exhibition of progressive art ever seen in Germany.[14] It would challenge everything Kuhn knew about art and give him powerful new ammunition for the fight back home.

———

Kuhn landed in Hamburg on September 29, 1912. He was exhausted from days of seasickness but didn't have time to rest—the Sonderbund show was to shut down the next day. He immediately caught a train for Cologne, went from the train station straight to the exhibit hall, and then spent several hours touring the show before it closed. At the end of the day, he tracked down the business manager and got permission to come back the following morning as the show was packed up. Kuhn spent the day prowling the gallery floor, skipping around workmen, avoiding piles of lumber and straw, and watching paintings disappear into packing cases.

The scale of the show amazed Kuhn. Sonderbund organizers had assembled more than six hundred works, including both contemporary art and retrospectives of the three most significant Post-Impressionists: Vincent van Gogh, Paul Gauguin, and Paul Cézanne.[15] Kuhn could not have seen any of it before. The contemporary paintings had never left Germany, neither van Gogh nor Gauguin had been shown across the Atlantic,

and it's unlikely Kuhn had attended the two small Cézanne exhibitions that had been held in New York. In a postcard he dashed off at the show, Kuhn told Vera, "Sonderbund great show. Van Gogh + Gauguin great!"[16] A few days later, he expanded his assessment: "Van G. and Gauguin are perfectly clear to me. Cézanne only in part. His landscapes are still Greek to me, but wait, I'll understand him before I get home."[17]

———

To fully appreciate what Kuhn saw at the Sonderbund, it helps to go back a few steps. Post-Impressionism, as the name implies, began as a reaction to Impressionism, which itself began as a reaction to academic art. Impressionists believed in painting what they saw. As uncontroversial as that sounds, in the 1870s it was both radical and shocking. For example, Impressionists believed colors should be as bright and clear as in nature, whereas Academies had taught for centuries that paintings should be as dark and shadowed as those by Rembrandt or Raphael. This was not only limiting but also strangely misguided—most Old Master canvases were filthy with centuries of soot and grime. Nineteenth-century artists admired the brownish tone of uncleaned paintings, believing it was a patina that great works acquired with age, and they did their best to create a similar shadowy atmosphere in their own works.[18] (A member of the British Royal Academy once chastened the Pre-Raphaelite artist William Holman Hunt for painting grass green instead of the accepted yellow and brown.)[19]

Further, painting what they saw prevented the Impressionists from depicting the Academy's favorite subjects, history and myth—gods and goddesses being unobservable. Impressionists also tried to capture the artist's "impression" of a moment in time. This effort shaped their process down to how they applied paint to the canvas. Academics took their time and depicted fine details using brushstrokes so small they're practically invisible, but Impressionists moved quickly, working with short, thick strokes of paint clearly visible to the viewer.

The Impressionists couldn't foresee that their revolution would spark a never-ending chain reaction of counterrevolutions. Just as the Impressionists rebelled against the Academy, the Post-Impressionists rebelled against their immediate forbearers. Gauguin had no desire to paint what he saw; he was more interested in what he imagined. In the late 1880s and 1890s, he

created dreamlike paintings that seemed to bubble out of his subconscious. He felt drawn to myth and folklore but believed the Western tradition was tapped out. In search of the exotic, he sailed for Tahiti and appropriated another culture's tradition. He painted Tahitian idols, dramatized Tahitian myths, and adopted the simple geometric forms of Tahitian wood carvings in his own work. These unfamiliar symbols inspired generations of artists to look outside their own traditions for ideas.

Van Gogh, on the other hand, painted not only what he saw but also what he felt, bringing a highly personal and emotional aspect to art. He shared the Impressionists' interest in nature but wanted to infuse his landscapes with emotion. He expressed his feelings through color; yellow represented not just the actual color of sunflowers but also feelings of delight and joy. He painted with brushstrokes even thicker and freer than the Impressionists. In fact, one can stand at a right angle to a van Gogh and actually *see* the paint bulging from the canvas.

The third Post-Impressionist master, Cézanne, wanted to paint *exactly* what he saw, but in an entirely new way. He wrestled with the problem of conveying a sense of three-dimensional space on a two-dimensional canvas. To this day painters rely on the rules of linear perspective developed centuries ago in the Renaissance—rules based on the observation that objects appear smaller the farther away they are. Cézanne believed these rules failed to capture the complexity of actual vision. He developed a new approach in which depth is implied not through lines or shadows but through variations of color and multiple planes that overlap and create a sense of space. The results confounded viewers. In Cézanne's canvases, apples seem about to topple out of the frame, pitchers and bowls loom and recede from the viewer, and tables seem flat on one end and tilting at an extreme angle on another—yet the apples, pitchers, bowls, and tables appear remarkably solid. Kuhn wasn't alone in failing to grasp his work on first viewing; time has shown Cézanne to be one of the most difficult masters to grasp.

These three artists were dead by 1912, but they had only begun to transform Western art by pointing artists to new and exciting innovations. All of the major modern art movements can be traced back to the Post-Impressionists. Cézanne inspired future painters to experiment with depth, form, and perspective, van Gogh encouraged them to express emotion and employ vivid color, and Gauguin prompted them to paint not only what they saw but also what they dreamed and imagined.

———

Davies seems to have tasked Kuhn with borrowing as many van Goghs, Gauguins, and Cézannes as possible, so that's where Kuhn concentrated his efforts. Since Davies wasn't interested in obtaining more recent art on display at the Sonderbund, Kuhn largely ignored those pieces.

The Sonderbund featured a range of contemporary work from across Europe but emphasized a new movement that had coalesced in Dresden and Munich: Expressionism. Expressionists combined Gauguin's interest in painting from the imagination with van Gogh's exaggerated colors and heightened emotions. They created dramatic figures and scenes that they used to express emotional states rather than depict physical reality. The results can only be called intense: Thick black lines, stark colors, and subjects full of angst.

Kuhn saw several galleries of Expressionism at the Sonderbund. He even met Edvard Munch, the Norwegian artist who helped start the movement. (Munch remains most famous for *The Scream*, his 1893 painting and etching of a figure shrieking in existential horror—one version of the work sold for a record *$120 million* in 2012.) Kuhn described Munch as a "tall nervous sort of fellow with a handsome head" who paints "big wild figure things, very crude but extremely powerful."[20] He invited Munch to dinner, and Munch promised Kuhn several paintings for the show. Besides this, Expressionist art didn't seem to impress Kuhn for reasons that are simply unknown.

On the whole, Kuhn and Davies's judgment in selecting work for the Armory Show has stood the test of time, but the two men tripped up in bypassing Expressionism. They missed other contemporary movements, but generally only those they had no opportunity to see. Kuhn had no excuse for ignoring Expressionism—the work was right there in front of him—and it remains a mystery why both Kuhn and Davies dismissed it. The best explanation comes from an article in *Harper's Weekly* written by the critic Frederick James Gregg, a close friend of Kuhn's. While the Armory Show was in progress, Gregg noted:

> *It was found by Mr. Davies and Mr. Kuhn . . . that very little of what [German modernists] had done had any real significance. A German of Cologne, speaking of the tendency of his fellow countrymen, said that they were becoming "ultra-intellectual" as distinguished from*

"ultra-intelligent"; that they went so far, deliberately, as to make their work "sickly." [21]

Maybe Kuhn simply disliked the art, or maybe it was a step too far. He was only beginning to process the huge leap made by the Post-Impressionists, and modernism makes more sense with that intervening step. In any case, the Armory Show would have to do without German Expressionism, and Kuhn and Davies were revealed to be fallible in their judgment.

———

Back in New York, little Ronnie Owen turned six months old. Davies sought donations for the show, reporting to Kuhn that he was "gently working a millionaire friend" for funds. [22] He secured credentials for Kuhn since no one in Europe had ever heard of the AAPS. He also arranged for an insurance policy, putting up his home and farm as collateral against financial losses from the show. This was a risky and even fraudulent step, since the farm wasn't in his name but rather his wife's. Davies now had a new motivation to ensure the show's success: On no account could he expose the fact that he had risked his wife's property without her knowledge or permission. [23]

Mostly, Davies wished he hadn't stayed behind. His first letters to Kuhn sound mournful. By mid-October, he was vaguely hinting that if "matters of the domestic character clear up," he could leave town. On October 23, he announced he had booked his passage. Edna's response is unrecorded; either she conceded defeat or Davies left an outraged wife and mother in Manhattan.

The Sonderbund show, meanwhile, had more to teach Kuhn. He learned from its organizers how to pull off a successful modern art exhibition.

Lesson one: *Allow generous space for the art.* The Sonderbund employed the then new (and surprisingly radical) practice of hanging paintings in a single row with space around each work. [24] Every gallery and museum in the world does this now, but in 1912 this innovation shocked audiences and annoyed academics, who insisted on cramming paintings jigsawlike on the walls.

Lesson two: *Explain what you're showing.* Organizers printed a guide to the exhibition that offered brief introductions to the art and the artists.

Lesson three: *Use every available tool for marketing.* Sonderbund organizers ran ads, displayed banners and posters, and printed postcards. Postcards provided fast, cheap communication before telephones became commonplace—as well as an inexpensive way to spread a message.

Kuhn would put these lessons to good use back in New York, and over time they would be adopted around the world. When people go to galleries or museums today, they're seeing art as the Sonderbund showed it.

Kuhn wrapped up his discussions with dealers and, a few days later, headed for The Hague, apparently relieved to see the last of the expensive Cologne hotel Davies had recommended. (A room was a shocking $1.50 a night.) In the Netherlands, he negotiated the loan of several van Goghs and encountered the art of Odilon Redon for the first time. Completely unknown in the United States, Redon's art defied labels. His paintings and etchings range from conventional still lifes to fantastical drawings of spiders with men's faces, skeletons with branches sprouting from their heads, and hot-air balloons with bulging eyeballs.

Redon achieved only modest recognition in his lifetime—no one seemed to know what to make of him—but Kuhn found him transfixing, calling him a "wonder." The artist was Kuhn's first real "find" in Europe. This success gave him the confidence to confess to Vera his earlier jitters: "Up to this I had been nervous and of course worried. In fact I had the willies all the time."[25] It's one of the few moments when Kuhn admits to carrying any doubt.

Kuhn headed to Berlin, where his hotel was even "sweller" than the one in Cologne, with the luxury of a telephone next to every bed. Setting out on a tour of area galleries, he unexpectedly ran across an exhibit of von Zügel paintings. Here were the works of the man Kuhn had once proclaimed the best painter in Europe. Since then, Kuhn had spent ten years with progressive artists in New York and had just emerged from a crash course in Post-Impressionism. Understandably, von Zügel now struck him quite differently. He wrote Vera:

> *Today Zügel looks to me like a man with a lot of knowledge and hardly anything else—it was another shock. It showed that I haven't spent the last 10 years in vain anyway. Zügel's color today looks to me like mud, and even the drawing is mechanical and simply clever. . . . I'm sorry, now, that he was invited to our show.*[26]

More embarrassment awaited him in Munich, his next stop. Von Zügel greeted his former student warmly, took him to visit to the Royal Academy, and treated him to dinner. Kuhn was courteous, but he cringed at the outdated style of von Zügel and his students. Nevertheless, Kuhn stood by his invitation and supplied his teacher with shipping instructions for the show. When all was said and done, however, the Armory Show catalog listed no entries by von Zügel. Perhaps the old teacher recognized the gesture for what it was: A kindness by a former pupil too loyal to hurt a man he once so admired.

As for Kuhn, he had been transformed by his first encounter with Post-Impressionism and modernism. A bell had been rung that couldn't be unrung. He now saw color, line, form, and subject in new ways. He had been excited about the Armory Show before, of course, but now he brought to it the enthusiasm of the newly converted. He wanted to share his discoveries—not only with the New York art world but with the entire country.

CHAPTER 3

Recruiting Allies

We have not been able to judge at home, what this thing over here really means. You have no idea of the enormity of it.

—WALT KUHN

November 1912
Paris, France

Guests crowded into the Paris flat. They squeezed between carved Italian chairs, tripped over spindly legged antique tables, and bumped into the cast-iron stove. Voices in a dozen or so languages rose into the air, talking endlessly about every subject from boxing to palm reading to comic strips; about the upcoming season at the Ballets Russe and the prospect of war with Germany; about the music of Claude Debussy and the physics of Albert Einstein.[1]

Gertrude Stein, the party's hostess, sat with her legs crossed beneath her like a corduroy-clad Buddha. She talked quietly to the artist Pablo Picasso, the two of them oblivious to the seething crowd. Her heavy, broad-shouldered form dwarfed the five-foot-four artist with his lithe body and enormous brown eyes. Picasso's entourage surrounded the pair, among them the painter Georges Braque, tall, imposing, and puffing on a pipe, and the poet Guillaume Apollinaire, exquisitely dressed and laughing aloud at his own stories.

The petite Alice Toklas, Stein's partner, hovered in the background, her dark hair cut in heavy bangs above her deep-set eyes and too-wide mouth. Overwhelmed female visitors found her a reassuring presence, always interested in ordinary chitchat about housekeeping and children. The far more alarming Leo Stein, Gertrude's brother, conducted a lecture

on another side of the room. Bearded with a receding hairline, he talked nonstop about the theory and practice of modern art, gesturing wildly at his own collection to illustrate his points. Without warning, he would throw himself in a chair and prop his legs high on a bookcase—treatment for his irritable digestive system. Leo had as many theories about diet as about art and shared them just as determinedly.[2]

Glimpses of paintings could be caught over the heads and between the shoulders of guests. Art covered the walls, jammed together and skied as high as at a Salon exhibition—except none of these works would *ever* be admitted to an academic Salon. A Cézanne still life hung alongside a Renoir nude, Cézanne's red and gold apples balanced on a brown background, Renoir's pale-skinned young woman outlined against a blue sky. High on the wall the shimmering colors of a Matisse canvas flickered in the gaslight—pink and pale green figures embracing on a yellow and blue field. Nearby a somber-colored Picasso of flat planes and intersecting angles hung in an oval frame, the words "MA JOLIE" written inexplicably on the canvas.

In the midst of this remarkable scene stood the shell-shocked Walt Kuhn and Arthur B. Davies. They seemed to have been stunned by the entire experience, by the people, the conversation, the art—especially the art. "We have not been able to judge at home, what this thing over here really means," Kuhn told Vera. "You have no idea of the enormity of it."[3] The people were amazing, but the art was even more remarkable, and it was the art that left Kuhn speechless.

———

Kuhn had arrived in the cultural, intellectual, and technological capital of the world. Paris was home to not only the most radical visual artists but also the most adventurous composers, dancers, choreographers, writers, and filmmakers. The ballet impresario Serge Diaghilev and his troop the Ballets Russe premiered works in Paris that reinvigorated ballet and launched the modern dance movement. Diaghilev partnered with the era's greatest composers, including Debussy, Maurice Ravel, and Igor Stravinsky, to create music for his productions. Debussy's *L'après-midi d'un faune* (*Afternoon of a Faun*), danced by Vaslav Nijinsky, had scandalized audiences the previous May with its explicit eroticism; the Paris police attended the second night of the ballet out of concern for its alleged obscenity. At the same time, the film industry took its first steps toward becoming an art movement with

filmmakers like Georges Méliès inventing special effects such as animation, time-lapse photography, and double-exposure. They were able to create fantastic scenes of astronomers landing on the moon, demons appearing from puffs of smoke, and ghosts haunting castles.

Paris also hosted scientists such as Marie Curie, who received multiple Nobel Prizes for her work with radioactive elements, and philosophers such as Henri Bergson, who explored the mysteries of human perception of time. Engineers flocked to the city, creating revolutionary new airplanes, dirigibles, and automobiles; French planes flew farther, their balloons soared higher, and their cars went faster—up to 78 miles per hour!—than anyone else's.[4] Even the looming threat of war with Germany failed to pierce French confidence, for no one doubted that the glorious French army would defeat the kaiser's troops and reign victorious over Europe.

Artists from around the globe made their way to Paris, the art world's mecca, to study, work, and argue. They were a contentious lot. The fight between the French academy and the Impressionists had entered its fourth decade, with academics refusing to admit defeat despite widespread acceptance of Impressionism among the public. In 1894 the Academy tried to refuse the bequest of the Impressionist Gustave Caillebotte of more than sixty paintings by Edgar Degas, Paul Cézanne, Claude Monet, and other Impressionists on the grounds, according to one Academy member, that "when the state accepts that sort of muck, then we know we are in the grip of a real moral decline." (The artist added, "God save the Republic, France is doomed.")[5]

For their part, the Impressionists fought with the next generation of artists, unreasonably believing younger painters should be content to follow in Impressionist footsteps rather than develop artistic innovations of their own. Young artists quarreled with everyone—academics, Impressionists, and one another. They formed movements, wrote manifestos, argued, split up, formed new movements, and wrote new manifestos; keeping up with their shifting alliances required as much exhaustive effort as convincing the Académie des Beaux-Arts to admit modern artists into its ranks.

———

Fortunately, Kuhn and Davies had a guide to this bewildering world, an American painter who would become critical to the success of the Armory Show: Walter Pach.

Davies had arranged for Kuhn to meet Pach as soon as Kuhn arrived in Paris. Kuhn spoke only a smattering of French, not enough to negotiate the business of the exhibition, and Davies knew the fluent Pach would make an ideal guide. The thirty-year-old New Yorker had lived in Paris off and on since 1907, supporting himself writing articles for American newspapers and magazines.[6] A former student of Robert Henri, he'd grown disgusted with the conservative American art scene after personally experiencing the soul-crushing practices of the National Academy of Design. In 1909 the jury approved six of his paintings for the Academy exhibition, but not a single one was displayed at the show.[7] In early 1912, he read a newspaper report about the formation of the AAPS and wrote Davies volunteering his assistance, noting he could provide introductions to the most important artists, collectors, and dealers in Paris.[8]

Pach didn't exaggerate. The young artist with a luxurious mustache and an unruly head of hair—his childhood nickname had been "Mopsy"—was a genial and fearless extrovert. Pach ignored rigid French social rules with such charm that people were too delighted to be offended. He once convinced the aging, reclusive Impressionist Auguste Renoir to give an interview by simply knocking on his door.[9] He had friends in most artistic circles in Paris and effortlessly moved between cliques. He also understood the modern movement as well as anyone. The new art had baffled Pach at first—he described Henri Matisse as "a blow between the eyes"[10]—but years of study had converted him into a passionate advocate for all things modern.

When Kuhn arrived in Paris, Pach put his knowledge, his address book, and his excellent command of French at the service of the AAPS. By the time Davies joined the pair on November 6, Kuhn and Pach had a list of potential works ready for his review. The three men set out the next morning to encounter the future of art.

———

Pach began by taking Kuhn and Davies to meet the Steins, who operated their homes as combination galleries/graduate seminars/indoctrination centers for modern art.

Paris society considered the Steins eccentric, intellectual millionaires. They were right about everything but the wealth—the Stein

siblings lived in comfort, but not luxury, on their father's investments.[11] In 1903, Leo and Gertrude settled in Paris, where Leo toyed with becoming an artist and Gertrude took up writing. The pair became well-known figures in the city, often seen attending art exhibits and browsing bookshops while dressed in matching brown corduroy suits—the fabric wore well and didn't show dirt—and custom-made orthopedic sandals that the French found horrifying. Sometimes waiters at cafes refused to serve them on the basis that people in sandals couldn't afford to buy drinks.[12]

Michael Stein and his wife Sarah (known as Sally) joined Gertrude and Leo in France in early 1904; they settled around the corner in a flat that had been a small Lutheran church. Michael, the oldest of the siblings, actually worked for a living and impressed people as steady, reliable, and gracious—traits those who knew the rest of his family found refreshing. Sally, on the other hand, could out-Stein the Steins with her obsessions and her passionate conviction that she was always right.

In 1907 when Toklas met the Steins on a trip to Europe, she and Gertrude became inseparable companions. She joined the Steins as Gertrude's partner, moving in with Leo and Gertrude in 1910. Gertrude and Alice weren't "out" in the twenty-first-century sense of the word—such a concept didn't exist—and in public they presented themselves simply as friends, but those within their circle understood theirs was a committed relationship.[13]

———

The Steins became dedicated patrons of the avant-garde in the fall of 1905 at the Salon d'Automne, an exhibition organized, like so many of that era, in opposition to the conservative French academy. That year a loosely affiliated group of artists headed up by Matisse exhibited together. The circle drew inspiration from the way Vincent van Gogh used color to convey emotion, but over time they experimented with color for color's sake. Like a child trying out every crayon in the box, they played with combinations of every hue. In Matisse's *Woman with a Hat*, a woman faces the viewer against a background of purple, yellow, green, and pink splotches. The woman's enormous purple hat hints at ribbons and flowers with swirls of red, black, and dark green. Atop her bright orange neck, a vivid green streak courses down her nose.

Salon d'Automne organizers placed Matisse and his colleagues in a gallery with several sculptures, including a traditional Renaissance-inspired work. One day a critic walked in the room and, struck by the contrast, exclaimed, *"Donatello au milieu des fauves!"*—"Donatello among the wild beasts!"—a reference to the famed Renaissance sculptor. The phrase caught on, and soon the artists were labeled Fauves.

The unexpected colors of *Woman with a Hat* fascinated the Steins. Day after day, Leo, Gertrude, Mike, and Sally returned to sit in front of the painting. The press teemed with stories about the exhibit; painters called Matisse a maniac, critics wondered if the work were an elaborate joke, and Émile Loubet, president of the French Republic, refused to dignify "such daubs" with his presence.[14] Ignoring the uproar, at the end of the exhibition Leo and Gertrude bought the painting. "It was a tremendous effort on [Matisse's] part, a thing brilliant and powerful, but the nastiest smear of paint I had ever seen. It was what I was unknowingly waiting for," Leo said.[15]

The Steins had no idea of the effect their purchase would have on the Matisse family. That fall, the thirty-six-year-old Matisse and his wife, Amélie, were flat-out broke. They sent their sons to live with relatives, and Amélie opened a small millinery shop to bring in cash. The sale of *Woman with a Hat* quite literally clothed the Matisse family that winter. The grateful Matisses soon met their patrons and surprised the Steins with their typical bourgeois lifestyle and appearance. French press about the "King of the Wild Beasts" led most people to envision Matisse as a lunatic with paint-stained clothes and a matted beard. In fact, the artist always appeared eminently respectable in a tweed suit and gold-rimmed glasses.[16]

More sales followed, especially to Mike and Sally. Sally fixated on Matisse as her latest obsession, and no one could obsess like Sally. She bought every canvas she could afford and pestered her friends to buy what she couldn't. She even convinced Matisse to open an art academy; she supplied the cash to get the enterprise off the ground and became his most attentive student.[17]

———

While Sally embraced all things Matisse, Leo and Gertrude became fascinated with another artist—a young Spaniard named Picasso. Only

twenty-four, Picasso was a genuine prodigy who had been admitted to a Spanish fine arts academy at age thirteen. He moved to Paris in 1904, settled in the bohemian suburb Montmartre, and took rooms in a building nicknamed Le Bateau-Lavoir for its resemblance to the creaky washing boats that plied the Seine. Like Matisse, his first few years in the city were a struggle. Conditions grew so grim the coal seller suspended credit and Picasso's menagerie of pets had to fend for themselves; when one enterprising cat came home with a length of sausage, it fed the entire household.[18] Gertrude and Leo's interest came at as crucial a time for Picasso as Mike and Sally's support of Matisse. The siblings realized the depths of Picasso's poverty on his first dinner at their apartment, when Picasso snatched away a piece of bread Gertrude tried to pick up. Gertrude burst out laughing, and Picasso had the grace to look embarrassed, but he had revealed the desperation of a hungry man.[19] The Steins bought endless sketches and paintings from Picasso, allowing him to heat his apartment, feed himself and his animals, and retrieve his mistress Fernande's gold earrings from hock.

In late 1905, Picasso asked Gertrude if he could paint her portrait, in part as a gesture of thanks, in part because he thought she had an interesting head. Every week for months, Gertrude took the horse-drawn omnibus to Picasso's apartment to model for the painting, and he quickly completed the majority of the work. He depicted Gertrude sitting cross-legged and leaning forward as if listening intently to a conversation. But Picasso struggled to complete the face. After weeks of work, he painted over the head, telling Gertrude, "I can't see you any longer when I look."

Around the same time, Picasso visited the Paris cultural and anthropological museum, the Musée d'Ethnographie, and encountered prehistoric and tribal sculpture, particularly African masks. Picasso studied their flat surfaces, exaggerated shapes, and hollow eyes. When he returned from vacation in the fall of 1906, he took up Gertrude's portrait and gave her face the sharp angles and flat planes of the masks. Friends were horrified by the strange painting, but Gertrude loved it. She proclaimed in her convoluted, pretzel-like prose, "for me, it is I, and it is the only reproduction of me which is always I, for me." When friends complained Gertrude didn't look like his painting, Picasso shrugged his shoulders and said, "She will."[20]

Gertrude's portrait marked a transformation in Picasso's art. The artist continued his experimentation with African masks with *Les Demoiselles d'Avignon* in 1907. In the work, Picasso breaks the bodies of five nude women into disjointed shapes with crude triangles for breasts. Two of the women have the almond eyes, pursed mouths, and swooping noses of the African masks. The painting's power lies in its aggressive ugliness. For centuries, beauty had been the purpose of art. Picasso's women, in contrast, are anything *but* beautiful. He challenged centuries of the very definition of art by making his painting so deliberately hideous.

Toklas saw *Les Demoiselles* on her first visit to Picasso's studio and thought it shocking. One collector saw it as the end of Picasso's career and mourned to Gertrude, "What a loss to French painting!"[21] Matisse laughed out loud. Leo hated it.

But *Les Demoiselles* intrigued one artist: a shy young Frenchman named Braque. Braque saw in *Les Demoiselles* an echo of his own recent work, and the two men started working side by side. Their jumping-off-point was Cézanne and the way he tried to create a new method of adding depth to paintings. Picasso and Braque exaggerated Cézanne's approach and painted landscapes in which buildings, trees, and mountains resemble a child's building blocks.[22] (Hence the name "Cubism.") Then Picasso and Braque took an artistic leap. Instead of trying to *enhance* perspective in their paintings, they would *ignore* perspective. They overturned a basic tenet of art since the Renaissance: the illusion that a painting is a window into three-dimensional space. A painting such as the *Mona Lisa* strives to convince viewers they are seeing into a real world, one they could reach into. Techniques have been refined over centuries to hide one simple truth: A canvas is flat.

Why pretend? asked Picasso and Braque. *Why not simply let the canvas be flat?* "Scientific perspective is nothing but eye-fooling illusion," scoffed Braque. "It is simply a trick—a bad trick—which makes it impossible for an artist to convey a full experience of space."[23] Once they abandoned perspective, the men realized they could do whatever they wanted. In *The Architect's Table* from 1912, Picasso's perspective shifts unpredictably—sometimes the viewer seems to look down at a table from above and sometimes at a right angle from the side. Amid jumbled blocks of brown and green, a whitish rectangle reads "Gertrude Stein." One day

while Picasso was working on the painting, Gertrude visited Picasso's flat, found him absent, and left her card. On his return, Picasso painted the card into the work.[24]

Picasso and Braque's Cubists paintings require effort. At best, they challenge conventions about the nature of painting and create intriguing puzzles for which there is no solution. At worst, they annoy viewers with their obscurity. Many people in Picasso's circle disliked Cubism, among them Leo Stein, but Gertrude embraced the movement. She even saw a way to mirror it in her prose with Cubist word portraits, scrambling language the same way the artists scrambled the image of their subjects. In her portrait of Picasso, she described his art as "a clear thing, a complicated thing, an interesting thing, a disturbing thing, a repellant thing, a very pretty thing."[25] Only Gertrude would have dared to call Picasso's paintings "pretty."

———

The remarkable collection assembled by the Steins made the two households magnets for anyone interested in modern art. In fact, their homes provided the only reliable opportunity to see the work of Picasso and Matisse in Paris. While the two men participated in international exhibitions, they no longer entered their work in French shows; they made enough money through their dealers to ignore the contentious exhibitions. The lure of art brought guests to the Steins' doors at all hours. The family enjoyed visitors—French society found it *gauche* that they were so willing to let strangers into their homes without introduction or invitation—but they grew tired of dropping what they were doing at any moment. Their Saturday evening salons began as attempts to limit intrusions to one night a week.

At Michael and Sally's, guests would find Sally sitting on the sofa dressed in elaborate Oriental gowns and antique jewelry as a hush filled the room. Sally seemed to have converted the former Protestant church to a new house of worship—Matisse was god and Sally Stein his prophet. Sally and Gertrude had developed a passionate rivalry over their mutual favorites, and praising the wrong artist in the wrong house was an appalling faux pas. In the more raucous environment at Leo and Gertrude's could be found somber Germans with punctilious

manners, gregarious Americans with effusive manners, and Spanish bohemians with no manners at all. No one could explain the presence of so many Hungarians.

Only a handful of writers visited the salon, most of them French. (Gertrude would not mentor American authors such as Ernest Hemingway until the 1920s.) A genuine Spanish princess visited once, overcoming her fear that the Steins would enact some revenge on her for the Spanish-American War.[26] The elderly American Impressionist artist Mary Cassatt arrived one evening, took one look at the art, and demanded to be taken home. Regulars to the salon enjoyed people-watching as much as conversation. A family friend wrote, "One very fantastic lady went all around the room with her lorgnette fastened first on one picture and then on another until they finally landed on me. . . . I supposed if I am not there the next time she comes she'll take it for granted I've been sold."[27]

Pach could be found among the regulars at both Stein households. With characteristic ease, he maintained friendships with all members of the family and avoided their squabbles. He joined Mike and Sally on their holidays in Italy. He admired Leo's discourses on modernism, and he "sat" for one of Gertrude's word portraits. He even befriended Toklas, something many artists never bothered to do. When he learned Toklas loved music, he invited her to join him at concerts and recitals.[28]

Pach escorted Davies and Kuhn to the Stein residences, where it is likely that Sally held forth on Matisse, Leo explained Cézanne, and Gertrude praised Picasso. Both households agreed to lend paintings to the show. Davies particularly appreciated Mike and Sally's magnificent collection and ardent support of Matisse. Pach wrote, "I remember how, in 1912, when I had left the Steins' apartment in the Rue Madame with Arthur B. Davies, that extraordinary appreciator made a respectful bow to them—on the other side of the door."[29]

———

At some point, maybe at his studio, maybe at the Steins', Picasso wrote a list for Davies and Kuhn. He scribbled it on a scrap of paper with an artist's charcoal pencil. It read:

Juan Gris

. . .

Metzinger

Gleizes

Leger

Ducham

Delaunay

Le Fauconnier

Marie Laurencin

De La Fresnay

Underneath, Kuhn added the single name "Braque."[30]

The list contains Picasso's (sometimes misspelled) suggestions for artists to invite to the Armory Show: Juan Gris, Jean Metzinger, Albert Gleizes, Fernand Léger, Marcel Duchamp, Robert Delaunay, Henri Le Fauconnier, Marie Laurencin, and Roger de La Fresnaye. Of the names on the list, only Gris, Laurencin, and the afterthought Braque belonged to Picasso's circle. The rest made up the rival Puteaux Group. Picasso and Braque disliked Puteaux Group artists, whom they dismissed as *"les horribles serre-files,"* a French military term for troops who guarded the rear—the opposite of the avant-garde.[31] However, Picasso could be generous even to his enemies if he thought they had talent.

Of course, Pach would have taken Davies and Kuhn to meet the Puteaux Group in any case. Pach particularly liked the group's founders, the Duchamp-Villon brothers. Three members of the family lived in Paris; to confuse matters, each had a different last name. The eldest brother, Gaston Duchamp, graduated from law school only to adopt the pseudonym Jacques Villon and become a painter. Raymond trained to be a doctor but also abandoned his profession for art and became Raymond Duchamp-Villon, keeping his family name while also indicating his relationship to his brother. Youngest brother Marcel never bothered with any other subject but art and remained, simply, Duchamp. Villon and Duchamp-Villon settled in houses with a shared garden in Puteaux, a suburb west of Paris in 1906. Friends gathered every Sunday afternoon under a big chestnut tree for chess and conversation

accompanied by several sleek Siamese cats and an elderly, overweight collie named Omnibus.[32]

Puteaux Group artists practiced Cubism, although not Picasso and Braque's Cubism. Around 1909, rumors circulated about Picasso and Braque's new experiments, but the tight control of their work by their dealer, Daniel-Henry Kahnweiler, meant few people had seen it. One day Léger and Delaunay visited Kahnweiler's gallery to study Picasso and Braque's latest canvases. Within weeks they produced their own Cubist art. To avoid confusion, art historians call their style Salon Cubism, while the work of Picasso and Braque is known as Gallery Cubism.

Salon Cubists first produced straightforward portraits and landscapes in which objects are reduced to simple shapes like spheres, cubes, and cones. Some of these early experiments flopped—in Gleizes' *Woman with a Phlox* from 1910, a woman's tubular fingers resemble sausages. The style quickly evolved, however, as artists began thinking of their paintings as a way to play with *time*. Historically, painters emphasized art's ability to record an instant. Cubists argued technology made this aim superfluous; a camera could capture an instant of time better than any painter ever could. Art should offer a more insightful representation of reality by combining multiple viewpoints of a subject—like assembling a portrait from a variety of snapshots taken from different angles. The painter's vision weaves together all these varied glimpses into a meaningful whole.

Salon Cubists exhibited in Paris' many shows, with the result that when the public thought of Cubism at the time, it thought of the Puteaux Group, not Picasso or Braque. One of the group's major exhibitions closed only a week or so before Kuhn arrived in Paris. Kuhn likely read about it while he was in Germany—in letters from Munich he told Vera he was learning more about "these freak cubists."[33]

As interest in the Cubists grew, so did their rivalry with a coalition of Italian artists, the Futurists. The group focused on depicting contemporary subjects (cities, train engines, bicycles) and portraying movement. Again, what mattered was *time*—the Futurists wanted to incorporate time into art by showing subjects in motion. In Futurist art, a train plunges out of a station, a soccer player explodes in a kick, and the legs of a little dog form a black blur below a flicking tail. Tensions between the Futurists and the Salon Cubists grew in the years leading up to the Armory Show. At one point the Futurists accused the Cubists of "an obstinate attachment to the past," possibly the worst thing one modernist could say about another.

Critics often confused the groups, and members furiously denied they had anything in common.

It was in this heightened atmosphere that Marcel Duchamp submitted his new painting *Nude Descending a Staircase* to the Salon des Indépendants in spring 1912. Duchamp, only age twenty-five at the time, impressed people as handsome, smartly dressed, and sophisticated, but that doesn't mean anyone knew what to make of him. He loved his family and enjoyed his friends, but he also vanished from their sight for weeks on end, once abandoning Paris with no warning to spend two months alone in Munich. He never invested too much in relationships, ending friendships and love affairs as effortlessly as he began them.

Duchamp mostly stayed above artistic squabbles and ignored the theoretical discussions that obsessed his brothers' friends. He listened politely and nodded at the right times, so artists such as Gleizes thought he was shy; the reality was that he just wasn't paying attention. Duchamp didn't yet share his views, but he had come to believe art shouldn't be purely "retinal," i.e., visual. Instead it should appeal to the mind. Then as now, most people think of art as fundamentally visual, so moving art into a new direction, away from the realm of the eye, would be tough. In fact, it would require all of Duchamp's ingenuity.

Duchamp's *Nude* was both one of his first mature works and one of his first attempts at this "retinal" art. In the work, a nude moves down a flight of stairs in a series of glimpses, as in stop-motion photography. Duchamp indicated the arms, legs, and torso in simplified shapes, with joints appearing as gaps between "bones." Lines indicate the direction of motion just as they would in an engineering drawing or comic strip. Arguably the most important part of the painting is the title, which Duchamp wrote in block letters along the bottom of the canvas. Duchamp wanted to make the audience *think* about a nude walking down stairs as much he wanted to show the motion—this is what he meant by intellectual instead of retinal art.

More than a century later, the idea of a nude descending stairs has lost its power to shock—artists have made nudes do far worse during the last hundred years—but in 1912 it prompted open gasps. Nudes had been a staple of high art since the Greeks ruled the Mediterranean, and their depiction followed certain conventions: nudes might hold urns, but they never wandered around the house. Duchamp knew his title was inflammatory, which was the whole point.

Duchamp intended to shock with the painting, but he didn't anticipate the howls of outrage that greeted the work when he submitted it to the Salon des Indépendants, particularly from Gleizes and Metzinger. The keepers of the Cubist cause couldn't believe Duchamp had depicted a subject *in motion*, like one of those hated Futurists. They were also shocked he had portrayed a nude doing anything as mundane as clattering down a flight of stairs. They huffed, "a nude never descends the stairs—a nude *reclines*."[34] [Emphasis added.]

Gleizes and Metzinger convinced Duchamp's brothers the painting hurt the Cubist movement, so the older men dressed in formal black suits (as if for a funeral, Duchamp said) and called on him at his studio. They begged him to at least change the title. Duchamp didn't argue, he just took a taxi to the show and withdrew the work. But he never forgot that his art had been sacrificed in a quarrel he alone seemed to recognize as petty. "It was a real turning point in my life," he said years later. "I saw that I would never be much interested in groups after that."[35]

Duchamp withdrew from the art world after the Salon des Indépendants debacle. In fact, that fall he enrolled in a training course to become a librarian. And so when Pach, Davies, and Kuhn arrived in Puteaux, Duchamp was off studying book cataloging, of all things.

The Americans appreciated the work of all the brothers, but the art of Duchamp impressed them the most—Davies exclaimed, "That's the strongest expression I've seen yet!"[36] Pach selected four of Duchamp's works for the show, including, quite presciently, *Nude Descending a Staircase*. In fact, paintings of most of the Salon Cubists made it to New York. The art of the entire group would shake up the New York art world, but Duchamp's much-derided *Nude* would make the biggest splash.

———

Davies spent more than a week in Paris with Kuhn and Pach, and the men worked from dawn until late at night to put together the Armory Show. One of the few evenings Kuhn had time to write Vera, he moaned, "I am so foot-sore and weary, and tired of 'seeing.'"[37] It took the best traits of all three to get the job done: Pach's sociability opened doors, Kuhn's capacity for hard work kept them plowing ahead, and Davies' confidence assured dealers the AAPS could be trusted.

Toward the end of the week, the weary artists visited a studio just down the block from Pach's flat, that of sculptor Constantin Brancusi (pronounced "bran-KOOSH," though no one bothers). The son of Romanian peasants grew up in a two-room cottage in an isolated village. His family put him to work at age seven as a shepherd, and he ran away from home at age twelve. In time, well-to-do citizens noticed the young man's remarkable talent—he could make anything, once shaping a violin out of an orange crate. Patrons supported his education first at a regional art school and then at the Bucharest Academy of Fine Arts, where Brancusi studied traditional sculpture. In 1904 he decided to test his skills on a wider stage and set out for Paris—on foot, since he couldn't afford train fare.[38]

After a series of menial jobs, he landed a position in the workshop of legendary sculptor Auguste Rodin. A contemporary of the Impressionists, Rodin shocked the conservatives of his day with his lifelike marbles and bronzes. Rodin's fame rested on his ability to add emotion and drama to figures such as his *Thinker* of 1902, in which the effort of thought is expressed in every muscle of the male's body down to his clenched toes. He operated a large workshop and employed dozens of assistants, but after a few weeks at this dream job, Brancusi quit, saying, "Nothing grows under the shadow of big trees."

Brancusi had an entirely different kind of sculpture in mind, something far removed from the heightened naturalism of Rodin. Like Picasso and Braque, he had no interest in creating lifelike figures; just as the Cubists discarded the illusion that a painting is a window into three-dimensional space, Brancusi discarded the illusion that a sculpture is something real frozen into metal, stone, or clay. Similarly, while Picasso and Braque broke their subjects into simple forms, Brancusi reduced his subjects to their essential shapes. For example, his 1908 sculpture *The Kiss* is a solid block in which two barely outlined figures press face to face, eye to eye, lip to lip. The sculpture ignores anatomy—the corners are barely curved and the separation between the two figures only marked by a shallow groove. It is, quite literally, cubist. Yet for all its simplicity, *The Kiss* feels intimate. The lovers fuse into one, the halves of their two eyes becoming a single gaze and the curve of the woman's breast fitting into the chest of the man like a puzzle piece.

The bohemian art world adored Brancusi, viewing him as an exotic outsider from the land of vampires. He wore Romanian native dress, clattered around his studio in wooden clogs, and grew an exuberant, distinctly

non-Parisian beard. In fact, Brancusi cultivated the image of himself as a naive peasant, possibly to drive up sales, possibly because he found it amusing. Pach fell completely for his shtick and described Brancusi as a "hermit, so intent on his job, so oblivious of all the machinations of the *arrivistes*."[39] An equally entranced Davies announced, "That's the kind of man I'm giving the show for," and then bought a small marble torso on the spot. It would become one of four Brancusi works in New York.[40]

It didn't seem to occur to Kuhn and Davies that by selecting sculptures they violated the constitution of the AAPS, which specifically gave the sculpture committee alone this authority. Back in the United States, others would notice and make their displeasure known.

———

On November 12, Pach escorted Kuhn and Davies to one last location: the Paris train station. Pach, now the AAPS's official European representative, would handle the rest of the work of arranging shipping and coordinating with insurance agencies. After initially declining to attend the show, he told the men on the train platform, "I guess I'll have to go over to New York and see that show." Davies slapped Kuhn on the back and said "Didn't I tell you we'd get him?"[41] Kuhn and Davies recognized that without Pach's help, they would never have accomplished so much in Paris. A few days later during the sea voyage, Kuhn wrote Pach, "Mr. Davies and I have just taken a vote and the result is: that you are a brick of the best Cubist make."[42]

Kuhn and Davies made a brief trip to London, and compared to Paris, it must have seemed tame, although the members of the Bloomsbury Group tried hard to create their own modern revolution. This circle of intellectuals included the writers Virginia Woolf and E.M. Forster, the economist John Maynard Keynes, and the artists Vanessa Bell (Virginia Woolf's sister) and Roger Fry.

Davies and Fry had been acquainted since at least 1906, when Fry became curator of paintings at the Metropolitan Museum of Art in New York. An enthusiastic promoter of French art in general and Cézanne in particular, Fry coined the term "Post-Impressionist" at a 1910 exhibition at London's Grafton Galleries. Like the Armory Show, that exhibit began as a challenge to the English academy and expanded into a showcase of Post-Impressionist and modern art.[43] As significant to London as the

Armory Show to New York, Woolf believed the show ushered in a new era of modern consciousness. Her bold claim didn't mince many words: "On or about December 1910, human character changed."[44]

Kuhn and Davies arrived in time to see Fry's second Post-Impressionist exhibit at the Grafton Galleries.[45] Kuhn and Davies acted appreciative, but Kuhn said, "I could see in the glint of Davies' eye that we had nothing to fear by comparison."[46] He put the matter bluntly to Pach: "Talking about London, it has about as much modern art as Paducah Ky."[47]

Kuhn felt confident their show would be better than the Grafton Galleries, better even than the Sonderbund—"We already have a better Cézanne and Gauguin collection than Cologne only in Van G's they beat us. Our sum of other material is much better."[48] Kuhn seemed awed by all the art the three men had assembled. "No such thing as this show has ever happened to America before," he told Vera. "I am simply overwhelmed by the big-ness of the whole thing."[49] Kuhn's only anxiety centered on the U.S. portion of the show. After his exposure to European modern art (he said he felt as if he had "crowded an entire art education into those few weeks"),[50] Kuhn realized the American annex would be "a sad affair."[51]

That was a problem for another day. As they boarded the RMS *Celtic* and sailed for New York, Kuhn and Davies pondered the explosive cargo they had arranged to ship home.

Kuhn marveled, "It will be like a bombshell."

CHAPTER 4

Planning the Attack

There will be a riot & a revolution & things will never be quite the same afterwards.

—MABEL DODGE, ARTS PATRON

December 20, 1912
New York City

Walt Kuhn sat at an office desk surrounded by scribbled designs for posters, floor plans of the Armory Building, letters from artists, telegrams from shipping companies, and boxes of stationery the printer had just delivered. Vera had gone down to Washington for Christmas. He pulled out a sheet of the new letterhead to write to her and likely heaved an exasperated sigh.

"I just noticed that the printer has misspelled 'American,'" he wrote. "Mind you yesterday we returned the first batch because he had Sculptors spelled with an e."[1]

Kuhn and Arthur B. Davies had returned from Paris a month earlier, and they hadn't stopped working since they landed. They had three months to select work from U.S. artists, promote the exhibition, and transform a National Guard armory into a welcoming gallery space. Everything had to be created from scratch, and nothing could be left to chance. Tensions were rising within the group of artists responsible for the show—some members of the AAPS fumed about Kuhn and Davies's leadership—and the bills were piling up.

Though Kuhn's spirits were soaring, a hint of panic had crept into his letters. He seemed for the first time to realize what a massive project he was responsible for and to glimpse the possible consequences of success or

failure. "Every body is awed by the enormity of the undertaking," he told Vera. "It's the chance of our lives."[2]

———

Whether Kuhn was fully conscious of it our not, the country—or at least New York City—was ripe for something this large and groundbreaking. Kuhn and Davies returned to an America in the midst of unprecedented change. Fantastic growth transformed the population. More babies were being born than ever before, and improved nutrition and health care meant more of them survived into adulthood. At the same time, immigrants flooded in from abroad. During the first decade of the twentieth century, more than eight million people landed on U.S. shores.

They poured into the cities, particularly New York, where they entered a chaotic and brutal world of tenements and sweatshops. On the Lower East Side, they jammed themselves into ill-lit, poorly ventilated apartments—the population density of some blocks reached *a thousand* people per acre. (Population density in Manhattan today—not particularly spacious by anyone's standards—averages about 110 people per acre.) Immigrants slept four or five to a bed, if they had beds; many got what rest they could on pallets, chairs, or doors removed from their hinges. Some slept in shifts.[3]

Likely they were exhausted enough to sleep anywhere—life meant unrelenting toil. New York textile workers, Pittsburgh steelworkers, and Chicago meatpackers put in a minimum twelve hours a day, seven days a week. For their efforts, the average American family received, according to a 1905 Census Bureau study, $523.12 per year—less than $14,000 in 2013 dollars. It wasn't enough. Sociologists agreed a decent standard of living required at least $800 a year. Everyone able to work had to pitch in. In 1913 about 20 *percent* of children in America earned their own living.[4] An investigation of labor conditions at a cannery in western New York found children as young as five and six toiling alongside their mothers. Their workday ended when they passed out from exhaustion, yet laws to limit child labor consistently failed both in state legislatures and in Congress.[5]

Workers attempted to improve their lot by organizing into unions and were fought every step of the way. By 1913, 1.9 million people belonged to the member unions of the American Federation of Labor (AFL), but

workers continued to be locked out, harassed, threatened, jailed, and beaten for organizing or striking.[6] Labor issues made front-page news throughout 1913; the New York legislature was in the process of passing a sweeping set of labor and workplace safety laws, the result of one of the most horrifying workplace disasters in New York history: The Triangle Shirtwaist Fire.

On March 25, 1911, flames broke out in a Greenwich Village factory that produced women's blouses (known as shirtwaists). The ten-story building had no alarm system or sprinklers; panicked employees pounded on doors that had been locked to prevent theft. As the smoke and heat rose, they jumped down elevator shafts and threw themselves from the windows. One hundred and forty-six workers died in the fire, 123 of them women. The horror of the fire gave politicians the backbone to push through reforms.[7]

While the miserable conditions endured by immigrants and industrial workers would have been alien to the middle-class artists of the AAPS, the experiences of the plutocrats who fought the unions and controlled the wealth of the nation would have been equally unknown. The lives of the rich bore little relationship to those of everyone else, and ordinary people boggled when they read about the 100-motorcar garage at William K. Vanderbilt's estate on Long Island, the artificial fruit made of fourteen-carat gold that William Fahnestock hung from the trees around his Newport "cottage," and the two-ton tub cut from a solid block of marble that Mrs. John Astor installed in her bathroom.[8]

New York in 1913 would seem a foreign place to twenty-first-century Americans. The skyline was lower, the streets crowded with horses (and horse dung), and newspapers the only form of mass media. On the other hand, signs of change could be seen everywhere. Skyscrapers were still radical innovations, but the Woolworth building would set a new record for tallest building in the world at 792 feet in April of that year. Horses still plodded down city streets, but those who could afford it drove motorcars instead—the number of cars registered in the United States leapt from 8,000 in 1900 to 458,000 in 1910.[9] Newspapers might have been the only mass media, but more than a dozen English-language dailies competed in the city, not to mention papers in Yiddish, German, Italian, and Chinese.[10]

Change was everywhere Americans looked. In the spring of 1913, Grand Central Terminal opened as the world's largest railroad station, the

Sixteenth Amendment was ratified authorizing the federal government to collect income tax, and the Woman Suffrage Parade brought more than 5,000 women trooping through Washington, D.C. demanding the vote.

The country had just lived through a dramatic three-party presidential race in which incumbent Republican William Howard Taft ran against Democratic nominee Woodrow Wilson and Progressive Party candidate Theodore Roosevelt. Roosevelt had already served one partial and one full term as president, taking office in 1901 when William McKinley was assassinated. The less politically savvy Taft had been Roosevelt's handpicked successor in 1908, but when Roosevelt grew frustrated with Taft's pro-business policies, he single-handedly created the new Progressive Party with a pro-labor agenda. The Democratic platform differed little from that of the Progressives, so the race between the two focused on the finer points of policy; Wilson, a former political science professor at Princeton, thrived on this sort of debate. For its part, the Republican Party offered opposing positions that were generally more business-friendly.[11]

Campaigning kicked off in August—the election season lasted a mercifully short three months back then—but was interrupted in October by a near-disaster. While Roosevelt campaigned in Milwaukee, a deranged bartender shot him in the chest on his way to a speech. Despite having a bullet lodged in his chest, Roosevelt gave the speech anyway. He spoke for ninety minutes, blood seeping onto his shirt, and commented, "I can tell you with absolute truthfulness that I am very much uninterested in whether I am shot or not." (That Roosevelt was not declared president on the spot for sheer bravado is a testament to the democratic process.) When all was said and done, however, Wilson won easily. Despite his fortitude in the face of trauma, Roosevelt had split the Republican Party and guaranteed a loss both for himself and Taft.

———

The big surprise of the election was the success of the Socialist Party candidate, Eugene V. Debs, who received more than 900,000 votes, six percent of the total—the largest share ever won by a Socialist candidate before or since.[12] This was thrilling news for those New Yorkers who believed revolution was right around the corner, particularly the bohemians of Greenwich Village.

The queen of the radical set in downtown New York was the thirty-four-year-old Mabel Dodge, hostess of a popular salon. Dodge got the idea for her gatherings from a familiar source: Gertrude Stein, whom Dodge met while living in Europe. When she moved to New York in the fall of 1912, Dodge decided to create her own salon in imitation of Stein's and began inviting guests to her Greenwich Village apartment for her "Evenings."[13] In contrast to the Steins' art-focused get-togethers, Dodge was open to anyone and anything, and the only essential for an invitation was that a person be interesting.

Dodge welcomed political radicals and social activists alongside writers and artists—regulars at Dodge's salons included "Big Bill" Haywood, a radical labor organizer; Margaret Sanger, a sex-education advocate who had been arrested numerous times for spreading information about birth control (she would go on to establish Planned Parenthood); and Jack Reed, a charismatic journalist and impassioned socialist (played by Warren Beatty in his 1981 film *Reds*).[14] Word spread about the salon; newspapers began covering it, reporting in shocked tones that not only were society women in evening gowns socializing with anarchists, they were also violating social norms by smoking cigarettes.[15]

Even the most successful of Dodge's parties only attracted a limited audience. Far more popular was the theater, where offerings ranged from the refined to the spectacular. High art took the form of sixty-nine-year-old theater legend Sarah Bernhardt's French performances from *Camille* and *Phèdre*. More explicable—and more popular—were extravaganzas at the Hippodrome, a five-thousand-plus-seat theater that stretched an entire block on Sixth Avenue. Opening night in 1905 featured 280 chorus girls, 480 soldiers, multiple elephants, a trapeze act, a ballet, and a cavalry charge through a lake.[16] Movies provided a cutting-edge entertainment alternative, and for five cents audiences could drop into their local nickelodeon and watch thrilling dramas, nail-biting adventures, and raucous Keystone Cops comedies.

Even the thrills of film and theater paled in comparison to the true craze of 1913: dancing. The infectious new ragtime music required a new way of dancing, and a host of vigorous, bouncy romps such as the Turkey Trot, the Grizzly Bear, the Bunny Hug, and the Kangaroo Dip sprang up to meet the demand. Young people danced every chance they got—hotels and restaurants began offering dinner dances every evening, then added tea dances, and then instituted noon dances so workers could squeeze in a

round or two on their lunch hour—although fifteen female employees of the *Ladies' Home Journal* were fired for dancing on their break.[17]

Ministers, mayors, social workers, and society matrons were horrified by the Turkey Trot, which they declared indecent, unfeminine, immodest, and likely to lead to the downfall of civilized society. The wonderfully named Committee on Amusement and Vacation Resources for Working Girls decided to investigate and invited some six hundred concerned citizens to a Turkey Trot conference at the Delmonico Ballroom. Entertainer Al Jolson and a chorus girl demonstrated the dance; when Jolson snapped his fingers and pulled his partner close, the audience audibly gasped.[18] The committee was fighting a losing battle. Determined youth Turkey Trotted every chance they could get, and once the debutantes in the high-society haven of Newport convinced their mothers to allow the dance at private balls, the war was as good as over.[19]

———

Kuhn didn't have time to Turkey Trot, or do much else for that matter. He and Davies had stepped off the ocean liner into a whirlwind of work.

"The ball is on now and there will be lots doing," Kuhn wrote Walter Pach. They rented office space at 122 East 25th Street and hired a typist. Designing the AAPS logo stumped them for a while, but then Kuhn had a brainstorm one morning before even getting out of bed. He proposed the organization adopt the pine tree flag, a popular symbol for Massachusetts rebels during the Revolutionary War that would signal the independence of the AAPS and its revolutionary ideas. Davies drew the tree symbol himself.[20]

Kuhn was in his element, working night and day to promote the show, although he tried to hide his enthusiasm for marketing, afraid it was unseemly for an artist. "All this [publicity work] is not to my personal taste. I'd rather stay home and work hard at my pictures,"[21] he told Pach in an utterly unconvincing disclaimer. In fact, he was having the time of his life. He considered advertising in streetcars and even investigated the cost of renting a billboard in Times Square—a sign company offered the AAPS the relatively low price of $900 for six weeks because "a member of the company was so interested in the cause," but such an expense was out of the question.[22] Instead he tried low-cost promotions that encouraged word of mouth. He printed up posters and sent them to university

art departments as well as artists in East Coast cities from Boston to Baltimore; art students were recruited to distribute the posters around New York and told to put them "in every gin mill on Second, Third, and Ninth Avenue" to reach people who wouldn't ordinarily be interested in art exhibitions.[23]

Kuhn handed out postcards in packets of ten and encouraged people to use them for ordinary correspondence. He even invested $50 in 25,000 buttons with the pine tree logo.[24] Kuhn wanted to hand out the buttons to "*everybody*—from bums to preachers—art students—bartenders—conductors etc. Ought to make an immense hit—and get every body asking questions."[25] Kuhn's strategy was to generate buzz decades before "buzz" became a marketing term and an essential part of selling anything. He also worked the press, creating anticipation in advance of that February's show. Kuhn deluged newspaper and magazine editors with details of the exhibition; intrigued, some publications planned special issues.

Other publicity strategies were the brainchild of John Quinn, an attorney, art collector, and close friend of Kuhn's. The forty-three-year-old Quinn, tall, balding, and with piercing blue eyes, had his fingers in many pies; as well as running a busy corporate law practice (his clients included the New York Stock Exchange) and wielding power behind the scenes in the New York Democratic Party, Quinn was also one of the biggest promoters of modern art and literature in America. He befriended important writers—William Butler Yeats and James Joyce were close friends—and purchased manuscripts from authors including Joseph Conrad and T.S. Eliot. He also collected as much art as he could afford—more art, in fact, than he could display in his apartment. The walls were crowded all the way to the ceiling, but still Quinn bought more paintings, to the point that they had to be stashed in bedrooms and closets.

While Quinn owned fine examples of Post-Impressionist art, he specialized in contemporary paintings from Ireland and France—he found "real pleasure in the recognition and appreciation of a contemporary who is doing fine work."[26] He and Kuhn had become friends in 1911 after Quinn bought some of Kuhn's paintings. Kuhn consulted Quinn before founding the AAPS; Quinn served as the organization's unofficial legal advisor and drew up the papers for its incorporation.[27]

A savvy politician, Quinn recognized the power of celebrity. Quinn was behind the scheme to have the AAPS appoint honorary vice presidents so the organization could use their names in publicity materials.[28]

Claude Monet, Auguste Renoir, and Odilon Redon were duly elected and notified of an honor bestowed by an organization they had never heard of. Quinn also led the effort to invite political figures to the show's opening. "I am going to have the Mayor of the town, the Governor of the State, and United States Senator Root and the French Ambassador," he declared.[29] Letters of invitation went out to all of the above plus the president of the United States. However, neither President Taft nor any of the other politicians chose to attend. Quinn was unworried, for he still had one card he intended to play: a long-standing personal friendship with Theodore Roosevelt.

While Kuhn and Quinn handled marketing, Davies concentrated on fund-raising. He worked his network of society women, among them Abby Aldrich Rockefeller, the wife of John D. Rockefeller Jr., heir to the Standard Oil fortune. He also relied on the aid of Clara Davidge, an enthusiastic art supporter and the former owner of the Madison Gallery where Kuhn had his one-man show. The daughter of the former Episcopalian bishop of New York, Davidge turned to her society connections, including Gertrude Vanderbilt Whitney and her sister-in-law Dorothy Whitney Straight, who each contributed $1,000.[30] More than $10,000 in donations was recorded in the AAPS account books, and additional funds to rent office space, insure the show, and ship art to and from Europe— more than $25,000—were channeled anonymously through Davies.[31] When asked where he got the money, Davies would simply say he "knew a lot of rich old ladies."[32]

Davidge also approached Dodge, who kicked in $700.[33] The show became one of Dodge's passions, and she was determined to help it succeed. Not realizing Stein knew all about the Armory Show, Dodge wrote her a typically Mabelesque letter full of exaggerations—she declared the show was "the most important public event that has ever come off since the signing of the Declaration of Independence—& it is of the same nature." She described the art, praised the AAPS, and confided, "The academy are frantic. Most of them are left out of it. . . . Things will never be quite the same afterwards."[34]

———

Collecting art remained the most important task in the lead-up to the show. European paintings and sculptures began arriving in early January,

although storms at sea delayed one shipment and raised the collective blood pressures of AAPS organizers. Importing art from Europe required complex negotiations with tax authorities, since at the time, U.S. law imposed a tariff on all imported art less than twenty years old, a tax that in effect penalized collectors of contemporary art. (Quinn considered the tariff uncivilized.)[35] The Customs Service moved notoriously slowly, and all of the show organizers came to dread any work involving the tariff.[36]

To further strengthen the European portion of the show, Davies asked American collectors of modern European art to lend work. Most members of this small circle of known enthusiasts eagerly cooperated, with Quinn supplying seventy-seven works from his vast reserves. One wealthy collector, however, declined to lend two paintings because it was the height of the social season and his wife didn't want her living room decorations disturbed. (Davies scribbled a sarcastic "So helpful!" in the margin of the letter.)

Alfred Stieglitz contributed several works, including drawings by Henri Matisse and a bronze bust by Pablo Picasso. Stieglitz had a complex relationship with the AAPS and Armory Show organizers. On the one hand, he despised the Academy, supported young progressive artists, and deeply appreciated European modern art. The fifty-one-year-old Stieglitz, a small man with a large mustache, was a pioneering modern photographer who helped introduce photography as an art form to the United States. Stieglitz ran a gallery at 291 Fifth Avenue that began as a venue for art photography but soon expanded its scope to include modern drawings, paintings, and sculptures. The first American exhibitions of Paul Cézanne, Matisse, and Picasso were held at 291.[37]

However, Stieglitz's prickly personality limited his effect on the American art world as a whole. He sought to keep 291 "devoid of all commercial taint"—in fact, Stieglitz raged at anyone who referred to him as a dealer or 291 as a business. He sold paintings or photographs only to people he believed worthy of owning them, sometimes conducting lengthy interviews of potential owners as though they were adopting a child, and sometimes refusing sales outright. That was fine for Stieglitz—he had a wealthy wife who paid the bills—but his anticommercialism annoyed artists just trying to get by. Stieglitz found the promotional angle of the Armory Show distasteful; he supported the show, but he kept his distance.[38] And for some unspecified reason, Stieglitz couldn't *stand* Kuhn.

Meanwhile, the Domestic Committee began the task of assembling the American art section. The original intention had been to exhibit work by invitation only. However, as word of the show spread, requests poured in from artists seeking to be included. The group faced a conundrum. Excluding young hopefuls would signal the AAPS was as rigid as the Academy, but allowing unknown work would mean establishing a jury to review submissions. The thought sent a shudder through the souls of most progressive artists—juries were the bane of the Academy system, a powerful tool of conservative artists to keep out upstart moderns. Eliminating juries was one of the reasons the AAPS had been established in the first place. But the committee felt they had little choice.

Hundreds of paintings and drawings poured in, and over six days the committee reviewed every work and accepted at least one example from about half of the artists who submitted. On the whole, the judgment of the jury has stood the test of time. They didn't bypass anyone notable, and they accepted several outstanding artists. Among those who got a break at the show was future American icon Edward Hopper, who had entered a painting of a sailboat cutting through the waves on a bright, clear day. In 1913, the unknown Hopper made his living drawing illustrations for magazines, but in coming decades he would become famous for his paintings of city life. His 1942 work *Nighthawks*, a depiction of customers in a twenty-four-hour diner, would become one of the most frequently reproduced paintings of the twentieth century.

The AAPS had been eager to find highly original art free from academic restraints, and its call for entries requested work in which "the personal note [is] distinctly sounded." The association was remarkably open-minded about what this might include. In an era when art was usually strictly limited to established mediums of paintings, drawings, and sculptures, the Domestic Committee encouraged "the result of any self-expression in any medium that may come most naturally to the individual."[39]

This call was heeded, and entries to the show included a case of decorated china and a piece of embroidery. Both of these works were submitted by women, Jean Eells and Fannie Miller Brown, respectively—and beyond that, history has recorded nothing about either the artists or their art. It's unfortunate that these projects have vanished so completely—it would be fascinating to know what kind of embroidery was considered progressive enough to be included in the Armory Show.

Despite the success of the impromptu jury, many AAPS members weren't happy with the decision of the Domestic Committee. In fact, many members weren't happy about a lot of things. Decisions were being made without consulting the membership, the executive committee, or anyone else. While Kuhn told Vera most members appreciated his and Davies's handling of the show—"Everybody is loyal and willing to leave it in the hands of Davies and me."—Davies' high-handed rule actually surprised many artists. They had expected the shy, retiring painter to remain aloof. Instead, he revealed himself to be decisive and determined. One artist described in bitterness how Davies as president was "a dictator, severe, arrogant, implacable" and compared him to Ivan the Terrible.[40] Members muttered among themselves, but Davies had the support of the board of the directors; moreover, he controlled the flow of cash. One scholar of the Armory Show believes that as long as Davies kept bringing in donations, most members weren't going to argue with him running the show as he liked.[41]

Gutzon Borglum wasn't most members. The AAPS vice president thrived on confrontation and was fundamentally incapable of letting someone like Davies run the show. A friend said of the sculptor, "Gutzon was for war, for all sorts of war, six wars at a time. People weren't wrong; they were crooked. People didn't disagree with him; they cheated him."[42] Borglum conducted his fights in the pages of newspapers; he was one of the most famous artists in America in part because he was so contentiously quotable. Kuhn and the AAPS founders wanted Borglum as a member for his prestige, but they must have known he caused trouble wherever he went. He only lasted a month in the National Sculpture Society before publicly denouncing the association as a disgrace.[43]

Knowing Borglum's tendencies, Davies resolved to keep a close eye on him and appointed himself to the three-man Sculpture Committee with Borglum and sculptor John Mowbray-Clarke. Due to the expense of shipping heavy bronzes and marbles, the committee decided to choose works in person from New York–based sculptors. The studio excursions didn't go well from the start. Borglum, well-off from his lucrative public commissions, volunteered to drive the committee in his car. As they climbed in the vehicle, Borglum cheerfully remarked that if Davies were a sculptor he, too, could buy a car. Davies coldly replied, "I could, if I were that kind of man."[44]

Things went downhill from there. Borglum escorted the committee to highly conservative sculptors, most of them active members of the Academy. American sculpture in 1913 was even more behind the times than American painting. This was, in part, a function of the market; few collectors bought contemporary sculpture. Artists had to make a living by producing monuments, and the committees that commissioned public sculpture were notoriously resistant to anything new or unusual.[45] Borglum would have shown Davies and Mowbray-Clarke example after example of stern generals on horseback, sentimentalized Native Americans, and allegorical themes such as "justice."[46] These works didn't fit the aim of the show—they didn't represent "the new spirit" in art—and most were so large they would have overwhelmed the galleries. The two men accepted only small pieces from several artists and vetoed others altogether.

Borglum was outraged. These were his friends Davies was dismissing. He tried to shift the balance of power in his favor by increasing the number of people on the Sculpture Committee, but the Board of Directors shot him down. Borglum erupted—sculpture's Old Faithful, right on schedule. He targeted his wrath on the way Davies ran the operation. He declared "hardly a tenet" of the AAPS constitution had not been broken.[47]

Particularly egregious, in Borglum's eyes, was the European trip, where Davies, Kuhn, and Pach selected sculpture without consulting the Sculpture Committee or even reporting on their activities. Borglum railed about Davies "surreptitiously" inviting favorites to exhibit. Since a fight wasn't worthwhile unless the newspapers were involved, on February 6 Borglum sent a resignation letter to the press in which he repudiated the "three or four men that pretend to be the Association."[48] The AAPS issued a generally dignified letter in response, only descending into bitterness in the last paragraph, where annoyance seems to have gotten the better of the writers: "For the rest, we are too much engrossed in putting the finishing touches on our part of the work to waste time in controversy with one who seems to prefer to rush to the papers with his fancied grievances instead of conferring in an orderly manner with his colleagues."[49]

While Borglum was undoubtedly frustrated by Kuhn and Davies's leadership, the real cause of his fury likely had more to do with aesthetics than constitutional protocols. European art was pouring into the AAPS offices—they had to rent space in a nearby stable to store it—and when

he saw the work of Brancusi and other European modernists, Borglum would have been horrified.

Borglum spent his career perfecting a style of sculpture designed to make his audience *feel*. For example, in his *Bust of Abraham Lincoln*, the 1908 work that secured his fame, the head of the president is lined and his eyes downcast, but the set of the jaw makes the figure as stern as he is solemn. The work is undeniably Lincoln, but it is also our *idea* of Lincoln, and it evokes sorrow, respect, and admiration. In contrast, Constantin Brancusi was interested in shapes and forms, not emotions; in *The Kiss*, he wanted to see how much detail he could remove and still convey the concept "lovers kissing." Borglum didn't get the point—in *The Kiss,* he saw only a clumsily handled chunk of plaster. Borglum dismissed modern sculpture as "commonplace, in bad taste, vulgar, and mediocre in execution."[50]

———

Association members were relieved to have Borglum gone. As far back as December, Kuhn had anticipated trouble and been pleased most members sided with him and Davies. "If G.B. gets gay the bunch is loaded to bull-moose him,"[51] he colorfully informed Vera. However, the AAPS wished he hadn't thrown his tantrum two weeks before the show opened. This was not the sort of press attention Kuhn wanted. But in the end, the kerfuffle didn't hurt the association. Borglum had cried wolf one too many times, and no one gave his charges credit. The *American Art News* sighed, "how Borglum does love the limelight,"[52] and the *Globe* wished that "Mr. Borglum walked to the battlefield upon ankles not quite so thick, and touched his adversary with a lighter hand."[53]

Nevertheless, Borglum's reaction to the art piling up in the rented stable hinted at what was to come. As the artists handled last-minute duties—arranging for a coat-check service, hiring security guards, renting fire extinguishers—they must have wondered about the response of the public to the work about to go on display. Some within the inner circle were already unhappy. Jerome Myers, one of the AAPS founders, got an early glimpse of the European art, and it shook him to the core:

Davies himself felt that he was conferring a blessing upon America in thus making it acquainted with these newest aspects of foreign art. I can still see his keen, eager face alight with enthusiasm when he said

to me, "Myers, you will weep when you see what we've brought over."
And when I did see the pictures for the first time, my mind was more
troubled that my eyes.[54]

If artists themselves were this disturbed, how would the public react?

In the dim and dusty stable, hidden away in propped-up packing cases, the art awaited display—as dynamite awaits a match.

Part II

Storming the Armory

CHAPTER 5

Opening the Offensive

*This man Davies has started something. I'm afraid it may be more of a
calamity than a blessing, though it's a damn good show.*[1]
— LEON DABO, AMERICAN ARTIST

February 17, 1913
New York City

Guests started arriving at the 69th Regiment Armory about eight o'clock
in the evening. They walked up the concrete stairway, through a wide
brick arch, and into the main hall, a vast space used for drill practice.
Voices echoed in the high room as visitors circulated through the galler-
ies, gazing at a landscape by Vincent van Gogh, a Cubist composition by
Georges Braque, a painting of a child by Robert Henri.

John Quinn was likely annoyed. He had continued to invite high-
profile politicians to opening night, and the French ambassador and a
member of the New York Board of Aldermen had promised to attend, only
to send regrets at the last minute. Clara Davidge, on the other hand, must
have been delighted that many of her society friends had accepted her invi-
tation. Grace Vanderbilt, queen of the New York social scene, and Anne
Morgan, daughter of banking mogul J.P. Morgan, moved among the galler-
ies. Of course, Mabel Dodge was there—nothing could have kept her away.
Artists arrived in droves; even J. Alden Weir, whose brief presidency of the
association had ended so unpleasantly, made an appearance.[2]

Arthur B. Davies' shyness overcame him in the crowd, and he
retreated behind several large screens by American artist Robert Chanler
in the first gallery. One friend spotted Davies as he entered the show: "He
immediately emerged and, approaching me with swiftness and stealth,

whispered in my ear, 'New York will never be the same again,' and with equal swiftness vanished again behind the screen."[3]

At ten o'clock, Davies emerged from his hiding place. He rapped a gavel, and a hush fell over the four thousand or so people in the hall. After a few words of welcome, Davies introduced Quinn, who delivered the opening speech:

> *The members of this association have shown you that American artists—young American artists, that is—do not dread, and have no need to dread, the ideas or the culture of Europe. They believe that in the domain of art only the best should rule. This exhibition will be epoch-making in the history of American art. . . . The members have had no axes to grind, no revenges to take. They have been guided by one standard—merit—and they have had the courage of their convictions.*[4]

Everyone applauded.

Quinn was being somewhat disingenuous—Walt Kuhn and the organizers certainly had axes to grind, and many artists in the audience openly dreaded the effect of European art on American culture. But nothing could diminish the spectacle of the evening. One artist wrote the next day, "The opening night of the International Exhibition seemed to me one of the most exciting adventures I have experienced."[5]

"Sensational is the only word to apply," wrote the *New York Sun*.[6] Kuhn, Davies, and Walter Pach, authors of the sensation, had succeeded after months of planning, talking, traveling, and working to bring the show to life—and to bring the world of art to New York City.

A trumpet blasted a fanfare, and Quinn declared open the International Exhibition of Modern Art.

———

It hadn't been easy. The last few days had been a nonstop sprint for AAPS organizers. The association received the keys to the Armory on February 15, giving them roughly seventy-two hours to transform a drill hall into an art gallery, hang more than a thousand paintings, position dozens of sculptures, and handle a multitude of other last-minute chores.

Kuhn and Davies's goal was to imitate the example set by the Sonderbund, and overall they succeeded—although some tasks proved harder than others. For example, the catalog had been intended as an educational

guide to the show, and a team of artists worked on it day and night, but Kuhn finally declared the project simply impossible.[7] Artwork trickled in until opening day, and despite waiting until the last minute to go to print, they couldn't list everything in the final document. In fact, no one knows exactly how many works were on display; scholars usually place the total between 1,200 and 1,300, although Pach later set it as high as 1,600.[8] Realizing the catalog was an inadequate guide to the show, the AAPS recruited dozens of art students and deputized them as guides: They were given information badges, told to memorize the layout of the exhibition, and asked to do their best explaining modern art to an overwhelmed and skeptical public.

For design of the hall, Davies relied heavily on Davidge, one of the country's first professional interior decorators.[9] Davidge and Davies divided the room into eighteen octagonal galleries constructed out of ten-foot-high partition walls covered with light gray burlap. Garlands of greenery were draped across the top of each partition. The high ceiling was made less starkly utilitarian with yellow fabric streamers, and an arc-lighting system supplemented skylights. Potted pine trees were positioned around the room to brighten the mood and evoke the association's symbol of artistic liberty.

To save time, Davies determined the arrangement of each gallery well ahead of time and painted watercolor sketches showing each wall.[10] In two days, 2,400 running feet of wall space were covered with art. As at the Sonderbund, most paintings were hung in a single row with ample space around each work—a rejection of the Academy's practice of skying paintings in rows all the way to the ceiling. Even the youngest, most unknown artists found their work thoughtfully hung with room to breathe. Despite the enormous number of paintings to hang and the tight schedule, everything was ready right on time.

Davies and Pach carefully organized the show in a way that it told a story. The exhibition demonstrated the progression of art from the nineteenth century through Impressionism and Post-Impressionism and into modernism. He wasn't able to borrow many examples from the early 1800s, but he showcased major figures such as Eugène Delacroix, Jean-Auguste-Dominique Ingres, and Francisco Goya with at least one work each.[11] Impressionists were well represented by Edgar Degas, Auguste Renoir, Claude Monet, and Mary Cassatt. They were followed by the Post-Impressionists van Gogh, Paul Cézanne, and

Paul Gauguin and the modernists Henri Matisse, Pablo Picasso, and Marcel Duchamp. As Davies planned from the beginning, an entire room was devoted to the Cubists. The Futurists, however, were missing; schedule conflicts and internal divisions prevented the Italians from sending their work to the show.[12] The term "Futurist" nevertheless reached the newspapers and erroneously became used as shorthand for anything modern.

Through this organization of the show, Davies made a visual argument that *art evolves*. Art isn't handed down unchanged from generation to generation as the academies claimed. Every step of art's evolution has been resisted, rejected, and denounced. In time, however, what was radical for one generation is understood and accepted by the next. It is then built upon by the following generation. As one collector of the period noted, "It always takes just about so many years. . . . What happened with Impressionism, will happen with Post-Impressionism; what will happen with Post-Impressionism will surely happen with post-post-Impressionism."[13] Davies reminded the audience that the Impressionists had once seemed as revolutionary as the Cubists; he asked them to have faith that the new art would make sense in time. Of course, it was an open question whether or not the audience would be willing to make this leap.

Despite all the curiosity and hoopla swirling around European art, two-thirds of the works on display fulfilled the original mission of the AAPS to provide a forum for progressive American artists. In fact, many works were remarkably modern, though less inflammatory than the European contingent. Oscar Bluemner's *Hackensack River* has cubelike buildings as bold as anything by Cézanne, and William Glackens' *Family Group* is as colorful and intimate as any painting by Renoir. Among John Marin's contributions were scenes of Manhattan in daubs of watercolors that are as simplified as any Cubist work.

Not surprisingly, most of the American sculpture on display was less progressive than American painting, since sculpture in the United States seemed stuck in the nineteenth century—although the sharp angles of Andrew Dasburg's *Lucifer* had a Cubist feel. One of the most prominent American sculptures was George Gray Barnard's *The Prodigal Son*, a large Rodinesque marble that was positioned at the entrance to the first gallery. Several strikingly modern sculptures had arrived from Europe, however, including a male torso by Raymond Duchamp-Villon and *The Kiss* by Constantin Brancusi.[14]

All of the major players in the AAPS were well represented. Pach contributed a landscape, a portrait, and several etchings, and Kuhn showed two of his Impressionist-inspired seascapes. Davies exhibited several dreamlike landscapes as well as a drawing of a young woman (clearly Edna) reading in bed; the work is both charming and racy—the woman is nude from the waist down.

The show was open from ten a.m. to ten p.m. on weekdays and Saturdays and two to ten p.m. on Sundays. Guests paid twenty-five cents for admission except weekday mornings until noon, when they were charged a dollar—an attempt by Davies to keep mornings quiet and uncrowded for serious collectors.[15] Journalists and students could get in free, although the AAPS eventually had to limit student passes since so many aspiring artists eager to see the show threatened to clog the galleries.

Elmer MacRae, Kuhn, and Pach spent almost every waking hour of the next month at the show. Davies was there too, although he stayed behind the scenes as much as possible. MacRae took care of finances, Pach managed sales and acted as a general guide to the art, and Kuhn filled in wherever needed. Probably it was best that Pach was responsible for interactions with the public; he treated even the most ridiculous questions about art with courtesy and humor. Kuhn, on the other hand, argued with total strangers about the evolution of art and was described by one newspaper as stalking the galleries as the "light of the unconquered idealist gleamed in his penetrating eye."[16]

———

After all the hustle and chaos, the first week of the show was a disappointment. Attendance was steady, but Kuhn was frustrated that crowds weren't breaking down the doors.[17]

Then the newspaper reviews started to appear.

Kuhn's publicity efforts paid off from the start. Several papers ran articles in the weeks leading up to the show. The *New York Journal-American* published a long piece by Alfred Stieglitz in which he tried to encourage audiences on the right attitude to approach the art: "Put yourself in an unprejudiced mental attitude, in a receptive mood." Unfortunately, he ended up insulting several major figures in the art world as well as the audience itself; he predicted that after the show New Yorkers would go back to their habitual worship of mere externals.[18] Articles covering

opening night were glowing. The *New York Times* insisted, "No one within reach of it can afford to ignore it" and the *Sun* asserted, "It is an event not on any account to be missed."[19]

In fact, early reports were so positive they convinced one would-be thief the show was worth his effort. The *Sun* reported, "Any fear that the weird paintings of the Post-Impressionists, Cubists and Futurists . . . would not be appreciated in this country was dispelled" when an enterprising man attempted to snatch a still life. Fortunately, all the valuable paintings had been firmly screwed to the wall. The aspiring criminal had good taste—better, in fact, than the critics who ignored the art of Frenchman Henri Rousseau. Rousseau paintings have sold recently at auction for up to $2.8 million.

However, when detailed reviews began appearing a few days later, they represented such widely varying reactions that New Yorkers must have wondered if all the critics had attended the same show. Responses ranged from exuberant to vitriolic. While the *Journal-American* marveled the show "is making its presence felt in a way that probably no previous exhibition in the country has ever done,"[20] the *Evening World* proclaimed, "No Imagination Outside the Psychopathic Ward of Bellevue or the Confines of Matteawan [State Hospital for the Criminally Insane] Can Conceive Without Actually Seeing It What a Cubist Picture Is Like."[21]

Many critics found the art thrilling. Joseph Edgar Chamberlin of the *Evening Mail* praised the show as "getting at the vital in art" and applauded organizers' efforts to search out distinctive voices: "They have made no attempt to get up a pretty exhibition. They are not assembling the work of a lot of men who all paint more or less alike."[22] Hutchins Hapgood at the *Globe* fell over himself with enthusiasm, writing that at the show "the skyscrapers of prejudice were shaken and the static buildings of outworn tradition were set on fire."[23] Other newspapers heartily disliked some aspects of the show but thought the positives outweighed the negatives; the *Sun* declared it "A Remarkable Affair, Despite Some Freakish Absurdities."[24] Almost everyone praised the organization of the exhibition, the transformation of the Armory, and the hard work of the AAPS. Many critics saw the show as a rebuke to the Academy's campaign for a new building since the AAPS had proven it was possible to hold a large show in an existing facility.

Other critics reveled in attacking the exhibition. One gleeful headline proclaimed "Nobody Who Has Been Drinking Is Let In To See

This Show." Some reviews simply laughed at the radical art. Nixola Greeley-Smith of the *Evening World* smirked, "the next time the baby builds his blocks into a nice castle and then knocks them down you must have the resulting chaos photographed and call it 'Nude Exercising on the Trapeze' or the 'Empress Taking a Bath in Pink Molasses Surrounded by Centipedes.'"[25]

Others lashed out in anger. Modern art flat-out offended critic Royal Cortissoz of the *Tribune*; he was particularly put off by modernism's lack of technique and refinement. Cortissoz called Cézanne ineffectual, van Gogh crude, and Gauguin mediocre, and he dismissed Cubism altogether by refusing to offer it "the flattery of argument."[26] "According to the Spanish proverb it is a waste of lather to shave an ass, and that criticism of the Cubists is thrown away which does not deny at the outset their right to serious consideration," Cortissoz sniffed.

Some of the most antagonistic reviewers rejected the show out of deeply held conservative beliefs about what defines art in the first place. Artist and critic Kenyon Cox didn't crack jokes about the show—he considered it too tragic for comedy. "This thing is not amusing," he wrote, "it is heartrending and sickening."[27] Cox realized that art since Impressionism was becoming increasingly abstract—in other words, it was moving away from being about the depiction of things (landscapes, people, or flowers) and becoming about the composition itself (lines, colors, and shapes).

While most artists at the show avoided the leap into total abstraction, American Marsden Hartley had stepped off the cliff with drawings that abandoned "all pretense of representation or even of suggestion." Cox found the trend horrifying—he called it "nothing else than the total destruction of the art of painting." Cox's reaction was extreme, but many critics and artists—among them Picasso—rejected abstraction as lifeless. Another critic argued that the paintings on display shouldn't be considered art because they weren't beautiful, writing in the *Tribune*, "Does art imply beauty in some manner? Is it not necessary that there be beauty either of form or of thought expressed in masterly fashion?"[28] Most artists in 1913 would argue art did *not* imply beauty, but the general public wasn't convinced.

———

What confused hostile critics the most was *why*: Why would anyone *want* to paint in a modern style? They couldn't grasp that artists would choose

to be Cubists or Post-Impressionists out of genuine artistic exploration. No, there had to be an ulterior motive, and critics settled on two possible explanations: "Sheer insanity or triumphant charlatanry." Insanity was a popular explanation—works were termed "studies in paranoia" that could be found in the "consultation-collections of asylums."[29] Cortissoz pitied van Gogh, well-known to have suffered from mental illness, and implied one *should* expect madness and suicide from anyone who painted so strangely.

At least Cortissoz believed van Gogh was sincere in his efforts—he and like-minded reviewers refused to grant Matisse and his contemporaries that much credit: Contemporary modernists must be engaged in a cynical scheme in search of fame and fortune. "These men have seized upon the modern engine of publicity and are making insanity pay," Cox insisted. Various publications declared modern art "vaudevillian," "a clever hoax," and the result of "over-ingenious pursuit of novelty and notoriety."[30] Even the *Times*, which liked to keep above the fray, noted that Matisse "has been freely called a charlatan, which implies willful eccentricity in pursuit of sensation," although the anonymous critic quickly added, "but our business is not with his motives."[31]

In support of the charlatan theory, the *Evening World* recycled a story from the 1910 Paris Salon des Indépendants when pranksters tied a paintbrush to the tail of a donkey named Lola and backed her up to a canvas. The resulting work was titled *Sunset over the Adriatic* and entered in the salon as an example of the "new school" of Excessivism.[32] The hoax was exposed a few weeks later to much hilarity and deep satisfaction from critics who had always believed modernism was a joke. While the *Evening World* claimed the work had been hailed as a masterpiece and originated the entire Post-Impressionist movement, in fact the painting had been ignored. Its sole effect on art history was to reinforce prejudices and provide ammunition for critics who could henceforth claim even an ass could paint in the modern style.

Some artists were disregarded entirely while others were singled out by critics. Matisse provoked the greatest outrage. Critics saw his deliberate simplicity as a rejection of thousands of years of Western culture—the *Times* described him as "turning humanity back toward its brutish beginnings."[33] Cubism, on the other hand, received grudging respect from reviewers who recognized that it represented a rigorous—if unusual—technique. The *Press* drily noted that the Cubists "at least can draw accurately"[34] and the *Times*

described their work as presenting a "very theoretic and an entertaining experiment, demanding intellectual activity and balance."[35]

Generally, the Cubists who attracted the most attention were members of the Puteaux Group. Today, Picasso is probably the most well-known artist of the twentieth century, but he received only glancing notice when he was introduced to the American public at the Armory. Several forces conspired to weaken his showing. His dealer had sent an unimpressive selection of works, saving the good stuff for a big show in Germany; like most European dealers, Henry Kahnweiler didn't think much of the U.S. market. The AAPS weakened Picasso's impact by placing his drawings and paintings in separate galleries. And Picasso's works baffled audiences who had no context for his Cubist style and simply couldn't process what they were seeing. On top of this, the catalog listed him, oddly, as "Paul" rather than "Pablo" Picasso.

One Cubist painting did attract the attention of almost every reviewer: Duchamp's *Nude Descending a Staircase*. Removed from the context of Cubist/Futurist art squabbles and presented to an audience that had no idea Duchamp was small fry in Paris, the painting achieved instant, immediate fame. The verbal gymnastics devoted to describing it must have left editors exhausted. "A pile of shingles that had been struck by lightning," declared the *Evening World*, while the *Evening Journal* described it as "a spider's web, with a few propositions from plane geometry superimposed."[36] The most popular description, originally from the *Times* but repeated everywhere, was an "explosion in a shingle factory."[37] What baffled both the press and the public was the title. The *American Art News* claimed, "Up to date no one has been able to discover in this curious composition either a figure of any kind or anything that resembles a stairway, and the wonder grows as to how and why the producer of this so-called work of art devised the title for his canvas."[38] To solve the conundrum, the magazine proposed a contest, offering ten dollars to anyone who could elucidate the mystery of the painting in fifty words or less.

———

This sort of press was irresistible and thrilled organizers. The AAPS hadn't expected this level of hysterical reaction, but they didn't mind as long as the show kept appearing in the papers. Crowds began arriving, first in a trickle, then a torrent. MacRae, the treasurer, kept a tally of the day's

ticket sales in his diary, and the numbers steadily rose as the days went on. February 19: $515.90. February 26: $645.65. March 5: $941.65. On March 7 they broke the thousand-dollar ceiling with $1,010.65.[39] Someone had to go back to Standard Ticket Company twice to stock up.[40]

Kuhn's mood transformed from disappointed to jubilant. "You haven't any idea how this confounded thing has developed," he wrote a friend in Europe. "Every afternoon Lexington Avenue and the side streets are jammed with private automobiles, old fashioned horse equipages, taxicabs and what not."[41] The Cubist room, quickly dubbed the "Chamber of Horrors," was always full of spectators. They gaped at canvases from Braque, Albert Gleizes, and Robert Delaunay, but what drew them was Duchamp's *Nude*. People stood in rows seven or eight people deep in front of the canvas, and it took several minutes of craning over shoulders to get to the front for an unobstructed view. A spontaneous game arose with one objective: Find the nude. The *Evening Mail* described crowds clustered around the painting as individuals announced, "There is her neck!" and "I've found her eyes!"[42]

Kuhn did his best to feed press demand for information about Duchamp and his brothers. Fortunately, Pach had penned short biographies of the men and taken a photo of the trio sitting in the garden in Puteaux [*see photo insert*]. What the press really wanted, of course, was to talk to Duchamp himself, an impossible task since he was holed up in Paris, pursuing a career as a librarian. Completely oblivious to the consternation his art was provoking in New Yorkers, he blithely shelved research volumes and considered giving up painting altogether.

However, another artist had recently arrived in New York who could stand in for Duchamp. The press wanted a radical artist to explain the new art, and they found one. In fact, he was the perfect source to do it.

———

The thirty-four-year-old Francis Picabia was the son of a wealthy Cuban diplomat and a French socialite. He enjoyed a hedonistic lifestyle in Paris with his beautiful, fiery-tempered wife, Gabrielle. Unlike Matisse or Picasso, who sometimes struggled to buy canvases and heat their homes, Picabia's riches allowed him to indulge costly habits like collecting sports cars; he always had the latest, fastest model and loved nothing more than spontaneous, cross-country road trips. If Gabrielle woke up to find Picabia

hadn't come home the night before, she would likely get a telegram a few hours later that he had taken off for London or the Mediterranean or the northern French coast.

Picabia made his name as an Impressionist in the early 1900s before moving onto Cubist-inspired modernism. Despite his prolific work at the easel, he had an irreverent streak that made him treat painting less as an aesthetic exercise and more as a game.[43] He and Duchamp became close friends in 1911. The two shared a love of the ridiculous and a delight in wordplay so intricate it is literally impossible to translate into English. When Duchamp decided to get a paying job, it was Picabia who suggested he become a librarian and got him a job at the research institute run by his uncle.[44]

Naturally, Picabia and Pach were friends, since Pach was friends with just about everyone; Pach helped convince Picabia he should visit New York for the show.[45] Picabia considered the journey a marvelous adventure and a chance to explore a new continent. He was also the only Cubist who could afford such a jaunt. Most of his colleagues still struggled to make a living selling their art; even Picasso, who had recently become secure enough to move from his disreputable digs in Montmartre to a proper bourgeois flat, couldn't have financed a trip to the United States.

Picabia and Gabrielle stepped off the boat into the welcoming arms of New York journalists. The press was delighted to find a representative to speak for modern French artists—whether those artists would have chosen Picabia as their mouthpiece is another matter entirely. Nevertheless, Picabia took on his role with unadulterated relish.

Picabia's behavior over the next few weeks is probably best understood as performance art. He presented himself as an ultraserious artist devoted to his craft. "At no time in the conversation did M. Picabia smile at the reporters," noted the *Sun*—one wonders if his French friends would have recognized him.[46] (The *Sun* added in surprise, "M. Picabia does not look like a really improper person, and his wife is the quintessence of propriety.") Realizing reporters would believe anything he told them, he portrayed himself as the most important artist in Europe. The *Times* proclaimed, "To have outfutured the Futurists, to have outcubed the Cubists—that is the achievement of Picabia, the latest 'Thing' in modern French art."[47] Few details in the resulting news stories had basis in reality, and all the facts varied widely from reporter to reporter.

Picabia may have enjoyed toying with the press, but his comments about painting were remarkably insightful. He compared modern art to music. A composer, he noted, might write a sonata inspired by a walk in the country, but the music would not attempt to convey the actual sounds heard in the countryside; rather, the music would capture the *feeling* of being in nature. Similarly, Picabia said he tried to convey his feelings about a subject rather than the appearance of the subject itself. Of a recent painting he completed in the city, Picabia said:

> *I saw what you call your "skyscrapers." Did I paint the Flatiron Building, the Woolworth Building when I painted my impressions of those "skyscrapers" of your great city? No! I gave you the rush of upward movement, the feeling of those who attempted to build the Tower of Babel—man's desire to reach the heavens, to achieve Infinity.*[48]

The public embraced this explanation, and likely it helped many Americans get a handle on modern art. It also might help make sense of Picabia's interactions with the press. Some mix-ups can probably be traced to language confusions, since Picabia didn't speak a word of English, but his performance can also be seen as a post-impressionistic interpretation of Picabia's actual life. Facts mattered less to Picabia than conveying the overall *feeling* of being Francis Picabia.

However, his musical interpretation also misled many into thinking *all* modern art had this aim. Most Cubism had nothing to do with the artist's feelings about a subject. As a close companion of Duchamp's during the painting of *Nude Descending a Staircase,* Picabia knew very well his friend wasn't trying to paint "the mood produced in the painter's memory by a view of a nude descending a flight of stairs."[49] In fact, this explanation absurdly supposes Duchamp had observed an actual nude walking down an actual flight of stairs. Once again, Picabia seems to have been enjoying himself at the expense of truth and all the credulous reporters.

In any case, Picabia was having the time of his life. He and his wife settled into a hotel in Greenwich Village and extended their stay beyond the planned four weeks. They became a regular fixture at the Armory as well as Stieglitz's gallery 291 and Dodge's salons. Picabia even seems to have considered staying in New York indefinitely to open a studio "to teach the American people—the artists—the true method of painting." Or maybe he intended nothing of the sort. There was just no way of knowing.

Crowds poured into the Armory daily. Celebrities attended, among them the famous Italian tenor Enrico Caruso, who took a break from rehearsals at the New York Metropolitan Opera to tour the show. He bought a handful of postcards, covered them with his own "Cubist" sketches, and handed them out to adoring fans.[50]

Davidge continued to invite her society friends. Mrs. Ava Astor, ex-wife of John Jacob Astor IV, came every day after breakfast.[51] Industrialist Henry Clay Frick, whose magnificent art holdings would become the esteemed Frick Collection, was so moved by the show he was tempted to buy a Cézanne. He was talked out of it by his dealer in Old Masters, who feared for his income if Frick switched his allegiance to modern art.[52] Though some members of high society embraced the new movement, not all of them appreciated modernism. J.P. Morgan Jr., heir to the Morgan fortune and one of the richest men in all of American history, wanted his twenty-five cents back.[53] James A. Stillman, another millionaire banker, commented with eerie prescience a year and a half before World War I broke out: "Something is wrong with the world. These men know."[54]

Morgan and Stillman were likely appalled by some of the other guests at the show, particularly those accompanied by Dodge. Dodge brought her radical Greenwich Village friends to the show, and some observers remarked on the unsavory characters on the edge of AAPS circles. Artist Charles Vezin noted in a letter to the *New York Tribune*, "The hatred for the academic makes strange bedfellows. There rest under the same blanket (or rather, toss feverishly) anarchists, terrorists, degenerates, rowdies, scavengers, dreamers, poets, liberators, and patriots,"—a fair description of the Dodge circle.[55] Dodge may have been a dilettante in both art and politics, but she had foresight that many critics lacked. She saw parallels between new movements in politics and art; she used the language of class warfare in her descriptions of the show, even sparing a little pity for the old-guard Academicians: "It was tragic—I was able to admit that—but the old ways must go and with them their priests," she wrote.[56]

On the other hand, some critics only saw what they wanted to see. Louis C. Fraina, a founding member of the American Communist Party, flipped Dodge's assessment on its head, writing in the socialist monthly *The New Review* that Cubism was a degenerate and pathological

expression of capitalism. (He concluded with the warning, "Socialist art must not adopt the tools of the bourgeois!")[57] Fraina's position notwithstanding, some in the public feared modern art would usher unwholesome European-tinged radicalism into America. In a hint of how the rest of the country would react to modern art, the *Journal-American* quoted one female guest saying, "Pictures like this are a menace to morals."

———

Artists from other fields also visited the show, seeking inspiration for their literary or musical efforts. The modern poet William Carlos Williams was delighted by *Nude Descending a Staircase* and its assault on tradition: "I laughed out loud when first I saw it, happily, with relief."[58] Williams and other modern poets were as eager to overthrow tradition as their artist colleagues, and seeing the confrontation played out in paint was thrilling for them.

Artists from the entire East Coast took pains to visit the show. Art students rejoiced that they didn't have to travel to Paris to receive this introduction to European modernism. Most die-hard Academicians stayed away, but many esteemed elder statesmen of art came for a look, among them Albert Pinkham Ryder, an aging and reclusive painter of moody, symbolic canvases. The show was among the first to recognize Ryder's importance in American art—it exhibited ten of his paintings. If the organizers had hoped for a sign of gratitude, they were disappointed. Ryder arrived in a ratty, old-fashioned coat with his beard in disarray and merely nodded when shown works of art, giving no more reaction to his own paintings than anyone else's.[59]

Some older artists were surprisingly accepting. Edward Lamson Henry, a painter of rural American scenes, was nearing the end of his sixty-year career when AAPS member Jerome Myers escorted him around the galleries. Henry carefully studied various works—a challenging task, since he suffered an impairment to one eye that required him to hold up his eyelid to see. At the end of the tour, Henry announced, "Mr. Myers, they told me there was a lot of crazy wild art here, but I have really found it wonderfully interesting and I am very glad to have seen it."[60]

Other artists were less gracious, shocked by the European portion of the show—and vocal about it. Maurice Prendergast, an American Impressionist, commented in the too-loud tones of a man losing his hearing, "Too much Oh-my-God! art here."[61] Some deeply and fundamentally

disagreed with the aims of modern painting. John Sloan, a member of the Ashcan School, had spent his career painting scenes of working-class life and believed artists had a duty to create socially relevant art that exposed injustice. He deplored the tendency of modern artists to ignore society's ills. What mattered to the Europeans was originality and creativity—not message or meaning—an approach Sloan and other realists found down-right irresponsible.[62]

The greatest unease, however, came from artists who believed the show damaged the *cause* of American art. Despite the preponderance of American works on display, they feared all anyone would remember in the months and years to come would be European modernism. (As it turned out, they were dead-on about this.) They fretted that critics would ignore their work and collectors would stop buying American paintings. "Davies had unlocked the door to foreign art and thrown away the key," said Myers. "More than ever before, our great country had become a col-ony; more than ever before, we had become provincials."[63]

The most frustrated artist—and the one who would stir up the most trouble—was Henri. Henri had always believed in promoting a uniquely American form of art—art by Americans that addressed American themes. Now in an exhibition that had promised to be a showcase for American artists, everyone talked about European works.

Henri was also offended on a purely personal level. He had watched Kuhn and Davies maneuver to keep him on the sidelines. Worse, after years as the leader of American progressivism, he found himself classed as a conservative. In his article promoting the show, Stieglitz tarred Henri with the same brush as the conservative president of the National Acad-emy of Design, John White Alexander. "Oh, yes," Stieglitz wrote, "the Henri Academy and the Alexander Manufactory will go on doing busi-ness at the old stands. Sometimes the dead don't know they're dead."[64]

A painful encounter brought home the growing rift between Henri and the AAPS leadership. Two days before the show opened, Henri and a student visited the Armory. Paintings were still being hung, but the out-lines of the show were clear. As they toured the galleries, an icy silence fell. At one point the student asked Henri's opinion of van Gogh, to which he replied, "If you don't mind, I'd rather reserve my opinion."

The two rounded the corner of a partition and came face-to-face with Davies and Pach. For a moment they stood without saying a word. Then

Henri, who always had an opinion and expected it to count, asked, "Don't you think these pictures are hung a little low?"

Davies didn't answer.

Henri pushed, "If they were raised ten, eight, or even six inches, the visitors could see them better." Davies ignored him.

Finally, Henri snapped at Pach, his former student, "I hope that for every French picture that is sold, you sell an American one."

Pach replied, "That's not the proportion of merit."

The men stood in awkward silence, and then Davies and Pach walked away.

Henri called after them, "If the Americans find that they've just been working for the French, they won't be prompted to do so again!"[65]

Henri attended the opening-night festivities two days later. On the surface all must have been calm. But Kuhn and Davies had made a flesh-and-blood enemy. Kuhn had worried about Henri from the beginning, and he was right to be concerned. Henri was a fighter, and he knew how to round up an army. He would pick the right time to take his revenge, and he wouldn't forget he'd been frozen out and insulted.

As February turned to March and crowds surged every day at the Armory, many artists must have agreed with artist Leon Dabo's comment about the show: "This man Davies has started something. I'm afraid it may be more of a calamity than a blessing, though it's a damn good show."[66]

CHAPTER 6

Planning the Counterattack

There is no reason why people should not call themselves Cubists, or Octagonists, or Parallelopipedonists, or Knights of the Isosceles Triangle, or Brothers of the Cosine, if they so desire; as expressing anything serious and permanent, one term is as fatuous as another.

—THEODORE ROOSEVELT, FORMER PRESIDENT
OF THE UNITED STATES

March 8, 1913
New York City

About three dozen men sat around long tables in the Log Cabin Room at Healy's restaurant at 66th Street and Columbus Avenue. Arthur B. Davies sat the head of the table, with Walt Kuhn, Walter Pach, and John Quinn at his side. Robert Henri positioned himself on the opposite side of the room. Art critics from the city's major newspapers and art journals surrounded them. The AAPS had taken a break from the Armory Show to throw a beefsteak dinner in honor of "our Friends and Enemies of the Press."[1]

Healy's beefsteak dinners were an institution. Guests—all men—donned white butcher's aprons. Waitresses sang and danced while delivering food and drinks. Tenderloin steaks were roasted on huge grills and eaten without utensils—hence the aprons. It was all-you-can-eat, all-you-can-drink, and an uproarious time for all.

The idea of a press dinner was brilliant—it was a way for the AAPS to thank the papers for their coverage of the show, celebrate its success, and blow off steam after the exhausting run-up to the event. Since the Armory Show had opened three weeks earlier, 160 works had been sold

for about $26,000 (roughly $595,000 in 2013 dollars). More than 50,000 guests had toured the exhibition. The organizers had reason to be proud. The *Globe* described Davies as smiling "in deep satisfaction at the success of the experiment." Kuhn was also beaming—portrayed as a hero, "big, strong, energetic, a glutton for work, with no end of business intelligence in addition to his artistic endowment … [he had] fought against croakers and pessimists and, with the others, had gone into the venture with never a dollar in sight."[2]

After dinner, the jokes began. Toastmaster Frederick James Gregg delivered a speech he claimed he had intended to give at the opening—it poked fun at all the politicians who had been invited but not attended. Kuhn read a series of fake telegrams: One confirmed Davies' order of a primer-level art instruction book, since he (and the other artists) obviously needed to learn the basics of oil painting. Another was a request from the California Consolidated Ostrich Farms to reserve Constantin Brancusi's sculpture *Mlle. Pogany* as a nest egg for their hatchery. (It had been widely observed that the sculpture bears a strong resemblance to an oversized egg.)[3]

Royal Cortissoz, who had penned scathing reviews of the show, offered a few words. "Gentlemen, you have no enemies in the press; you have only friends," he said. He then chose a decidedly violent analogy to drive home his point: "Don't you remember the words that Pete Dunn gave Mr. Dooley at the time of the Boer War? 'I tell ye, it's a terrible thing, Hennessey, when ye come into camp of an evening, and have to scrape what's left of your best friend off the side of your breeches.'"[4]

As the evening wore on, inhibitions fell and spirits rose. Perhaps inspired by the dancing waitresses, artist D. Putnam Brinley, who stood nearly seven feet tall, began a high-kicking contest, which he unsurprisingly won. Then the short, bearded sculptor Jo Davidson joined him on the floor, and he and Brinley danced a tango.[5] A heavy knock was heard at the door and in walked a doddering old man in a long white beard and an old-fashioned stovepipe hat. He introduced himself as The National Academy of Design, then joined Davidson and Brinley in a riotous Turkey Trot.

John Sloan took the opportunity to pull Quinn aside for a few quiet words. Sloan had been a colleague of Henri's for years, and he was bothered by the shabby treatment his friend was receiving from Davies, Kuhn, and Pach. Quinn shrugged off Sloan's concerns. The AAPS had simply

found a more effective way of promoting progressive art. Henri would have to live with it.[6] Down the road, Quinn might have wished he'd listened to Sloan—Kuhn and Davies's treatment of Henri would eventually come back to bite them.

Finally, the evening wound down and the men emerged into the March night, some likely glad the next day was Sunday and the show didn't open until the afternoon. Treasurer Elmer MacRae paid the $234 tab—more than $5,000 in 2013 dollars, but well worth it. The men had challenged the entire U.S. art establishment and brought the future to American shores—and they considered a high bar tab a small price to pay in the big picture. They were making history. As they headed home, surely some remembered Cortissoz's concluding words: "It was a good show," he said, "but don't do it again."

———

The Armory Show had become nothing short of a sensation. Everyone *had* to see it. Friends stopped by the Armory on their way to the theater, and couples visited *Nude Descending a Staircase* after dining out. Schools encouraged their students to see the show; a public school in Brooklyn closed night classes one evening to give students an opportunity to study the art.[7] Kuhn described people arriving in limousines and in wheelchairs. "Even a blind man was discovered, who limited to the sculptures, nevertheless 'saw' by the touch of his fingers. Actors, musicians, butlers and shopgirls, all joined in the pandemonium," he wrote.[8]

The success may have been thrilling, but days at the show were long—even Pach's legendary geniality was pushed to the limit, particularly by endless questions about Marcel Duchamp's *Nude*. He was asked so many times to identify the nude in the painting that he developed an illustrative counterquestion: "Can you see the moon in the Moonlight Sonata?"[9]

Pach and the other artists developed a habit of dropping into a nearby saloon after the show closed and soon befriended the bartender, "an old Irishman," who Pach said developed "quite a paternal friendliness toward his unaccustomed visitors." One day the bartender decided he wanted to see what all the fuss was about and visited the show in the company of several artists. They expected him to be bewildered by Duchamp's *Nude*, but instead he stood a long time before the canvas and said, with apparent sincerity, "Well, that fellow certainly knows how to paint."[10]

Some of the biggest headaches of the show arose out of disputes with artists about how their work had—or hadn't—been exhibited. One day in early March, American artist Samuel Halpert marched into the Armory with a telegram from his friend French artist Robert Delaunay authorizing Halpert to remove the two Delaunay canvases on display. Davies, Kuhn, and Pach huddled in a tight knot while Halpert waved his telegram. Delaunay had submitted three paintings but only two had been displayed. The third, unhung work, *Ville de Paris*, was a huge canvas at twelve by nine feet, much larger than any other painting at the show. Delaunay considered it his masterpiece, and Pach had agreed to include it. However, when the work arrived in New York, Davies decided such a big canvas would upset the balance of the exhibition and refused to display it.[11]

Delaunay had a legitimate complaint—Davies hadn't even notified him of the change in plans. (This was exactly the sort of dictatorial behavior from Davies that drove New York artists up the proverbial wall.) Nevertheless, Kuhn told Halpert that the AAPS would not take down the other Delaunay paintings. Kuhn argued that the works had been lent without restrictions and the AAPS could do as they saw fit.

Halpert complained to the *New York Tribune*, claiming Delaunay was more important than "all the other painters of the revolutionary school put together."[12] He also brought up the case of Max Weber, an American radical closely associated with Alfred Stieglitz and 291, who had submitted ten works to the Domestic Committee; Weber was so offended when they chose only two that he withdrew from the show completely.[13] Halpert described Weber as "the pioneer post-impressionist in this country"—Halpert seems to have blindly accepted the assessments of Weber and Delaunay about their stature in the art world—and railed that he had been slighted in favor of inferior artists. Halpert insisted, "The society is very biased against the younger painters, especially those in this city"—an ironic charge, considering the whole raison d'être of the AAPS was to support young artists.

Pach tried to defuse the situation with conciliatory statements to the press but didn't succeed in soothing Halpert, Weber, or especially Delaunay, who carped that he had been mistreated by the Americans. The Paris art magazine *Montjoie* attacked the show as using French art as "bait for the public" and concluded, "'The New Spirit' is the motto of

this exhibition. It appears that this boasted 'new spirit,' however is a very old one—namely the spirit of business."[14] The charge of commercialism was unfair—it's not like French artists didn't want to sell their paintings, too—and it seems unreasonable to complain about being "bait" in some nefarious American scheme when Pach could barely keep up with the sales of French paintings. Davies had slighted Delaunay, but on the whole, French artists couldn't have received a bigger, better introduction to American audiences. This dispute passed over quickly in the United States, though Pach would have fences to mend back in France.

———

With all of New York focused on the show, the attention of the rest of the nation soon followed. Newspapers around the country began running stories on the strange new art, with articles in dailies from Medford, Oregon, to Atlanta, Georgia, to Bemidji, Minnesota. In contrast to the New York papers, where several critics had applauded modernism, regional papers were almost universally antagonistic. The *St. Louis Globe Democrat* proposed that anyone could take up Futurism by painting with a blindfold on, while the *Tacoma Times,* under the headline "Snapshot of a Real Nightmare," added arrows to *Nude Descending a Staircase* indicating the top, bottom, right, and left of the painting.[15] An *El Paso Herald* editorial opined:

> *To paint cubist pictures requires great genius and self-restraint. The painter must abandon all previous ideas of art, nature and religion and paint as nearly as possible in straight lines. This can best be done in the ordinary straight jacket, so popular in our leading institutions for the regulation of advanced and explosive thought.*[16]

Most writers scattered around the country had never laid eyes on modern art, so editors combed their cities for anyone who had seen the show. Student reporters in the journalism department at the University of Missouri caught a scoop when they learned a member of the art department had seen the exhibit. They rushed to interview Professor M.C. Carr, whose informed and learned view was that the paintings were "weird."[17]

Art associations and museums across the continent also took an interest, and many requested all or part of the exhibition. Letters poured in from

Cleveland, Pittsburgh, Baltimore, St. Louis, Atlanta, and Los Angeles; Canada was represented with pleas from Montreal and Toronto.[18] Only two other cities succeeded in signing deals to extend the show: Chicago and Boston, who had begun discussions with the AAPS several months earlier. To every other institution the AAPS replied that the loaned works of art had to be returned as soon as the Boston show closed in May. European dealers had only agreed to loan their stock for that long, and AAPS organizers, already worn out from months of hard work, didn't want to commit to shows that would cut into their summer vacations.

Newspapers ran stories about almost anyone associated with the show. To satisfy curiosity about Henri Matisse, the *New York Times* ran a story by a French-based American artist named Clara MacChesney based on an interview she had conducted with the artist the previous summer. A large part of the article consisted of MacChesney's amazement that Matisse was not a paint-smeared radical living in a hovel. Matisse registered her surprise, which he encountered often enough, and begged her, "Oh, do tell the American people that I am a normal man."[19]

Other publications ran articles about Gertrude Stein and her connection to the French modernists. They were aided by an essay by Mabel Dodge that ran in *Arts & Decoration* magazine in which Dodge described Stein as "doing with words what Picasso is doing with paint."[20] Dodge quoted from some of Stein's "Cubist portraits" in which she approached her subjects with language as fractured, oblique, and confounding as a Cubist painting. The *Times* weighed in on Stein's prose, noting, "Certain after-dinner speakers talk that way, and they are always applauded when—and because—they stop."

A *Chicago Tribune* columnist wrote a poem that not only conveyed many popular ideas about Cubism but also highlighted Stein:

I did a canvas in the Post-
 Impressionist style.
It looked like Scrambled Eggs on Toast;
 I, even, had to smile.
I said, "I'll work this Cubist bluff
 With all my might and main,
For folks are falling for the stuff,
 No matter how inane."
I called the canvas *Cow With Cud*,
 And hung it on the line.

Altho' to *me* 'twas vague as mud,
 'Twas clear to Gertrude Stein.[21]

Poetry was a popular response to current events in 1913—a phenomenon that seems ridiculous in the twenty-first century, unless you consider it the equivalent to Twitter and other social media. Where today individuals tweet and caption photographs in response to popular events, in the 1910s they wrote poetry—vast reams of it, on every subject from the weather to fashion, foreign wars to the suffrage movement.

That the Armory Show generated so many rhymes is proof that, in contemporary terminology, it had become a "meme." The same *Tribune* columnist also penned these lines, which at least are humble about the difficulty of understanding modern art:

I do not say that Futurism
May merely be astigmatism.
I do not urge the Futurist
To hasten to the oculist;
If this or that I can't divine,
It's eight to five the fault is mine.[22]

Most of the poems were the most deadly sort of doggerel, but a few stand out. The *Omaha Bee* published a lengthy work titled "A Cubist Romance" that has an element of charm:

The Cubist married the Matisse Maid—
 A Post-Futurist marriage—
And honeymooning went, 'tis said,
 In a wheelless, horseless carriage.
A lovely picture was the bride.
 She carried pea-green tulips;
Her neck was in a bow-knot tied,
 And brilliant were her blue lips.[23]

One of the best verses was the product of the *American Art News* contest to explain *Nude Descending a Staircase*. The magazine received hundreds of entries, some of which took the challenge seriously and tried to actually explain the painting. The winning entry, however, was more tongue-in-cheek and read:

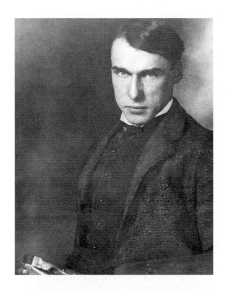

Clockwise from top left: Artist Walt Kuhn (1877–1949), photographed in 1904 or 1905, became the driving force behind the Armory Show; artist Walter Pach (1883–1958), photographed around 1903, provided invaluable aid in bringing radical European art to the show; artist Robert Henri (1865–1929), photographed around 1900, began as a reluctant sponsor of the Armory Show but became its most implacable enemy. artist Arthur B. Davies (1862–1928), photographed in 1907, hid an iron will behind his placid demeanor.

American audiences were stunned by the art of the French brothers (l-r) Marcel Duchamp (1887–1968), Jacques Villon (1875–1963), and Raymond Duchamp-Villon (1876–1918). They were photographed, probably by Walter Pach, in the garden where they entertained artist friends in early 1913.

The official name of the show was the "International Exhibition of Modern Art," but everyone called it the Armory Show after its location at the 69th Regiment Armory.

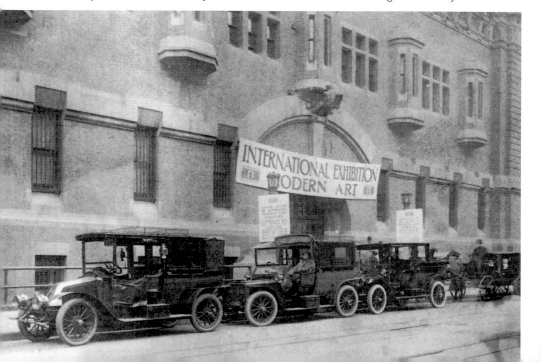

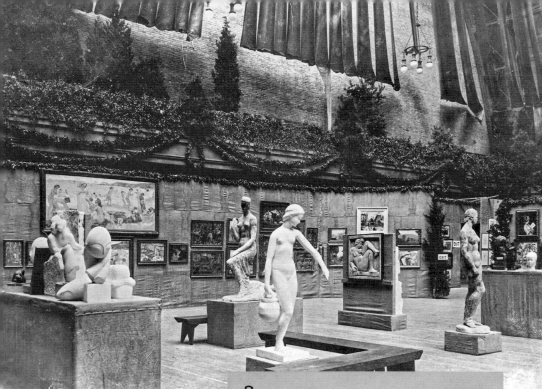

Armory Show organizers transformed the stark drill hall into an elegant gallery that put the art center stage.

Organizers went to great lengths to promote the Armory Show. Art students were sent out with stacks of posters and told to display them "in every gin mill on Second, Third, and Ninth Avenue" to attract people who wouldn't normally visit an art gallery.

CREDIT: ELMER MCRAE PAPERS, COLLECTION ARCHIVE, HIRSHHORN MUSEUM AND SCULPTURE GARDEN, SMITHSONIAN INSTITUTION, WASHINGTON, DC. GIFT OF THE JOSEPH H. HIRSHHORN FOUNDATION, 1966. PHOTOGRAPHY BY LEE STALSWORTH.

American writer Gertrude Stein (1874–1946) assembled a remarkable collection of modern art while befriending and encouraging generations of artists and writers. She's seen here in a photograph taken in 1930 in her Paris apartment below Picasso's famous portrait of her.

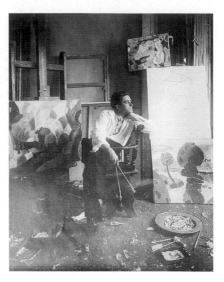

French artist Francis Picabia (1879–1953) enjoyed his lifestyle as an international playboy as much as his role as provocateur and revolutionary artist. He's seen here in his studio sometime between 1910 and 1915.

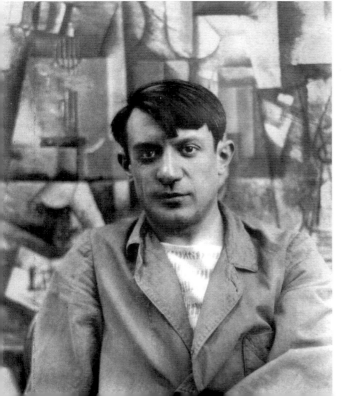

Spanish painter Pablo Picasso (1881–1973) marked his transformation of traditional art with this photo of himself standing before his Cubist canvas in 1912.

On the following pages, newspaper headline writers and editorial cartoonists had fun making the Armory Show seem as ridiculous as possible.

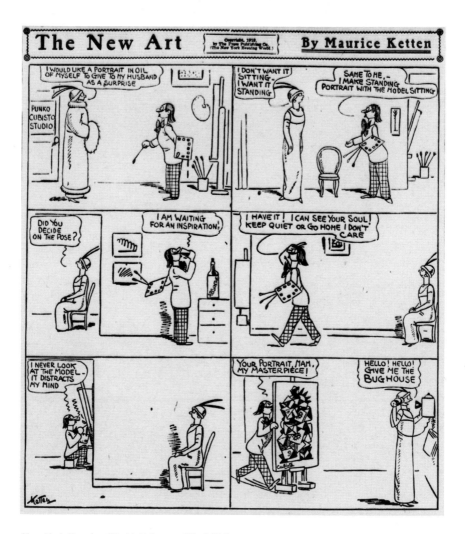

New York Evening World, February 21, 1913

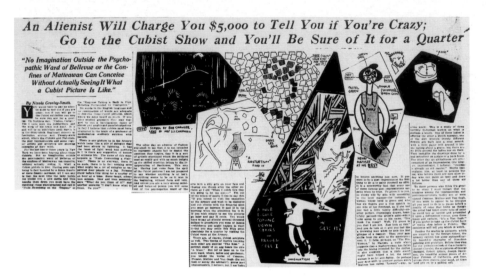

New York Evening World, February 22, 1913

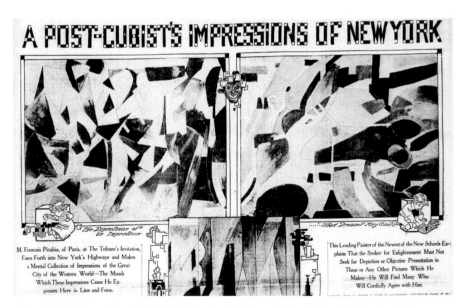

New York Tribune, March 9, 1913. French artist Francis Picabia's arrival in New York prompted a flurry of glowing news stories.

As Futurist and Cubist Artists See the National Game By Baer

Washington Times, March 28, 1913.
Cubism became such a popular topic
of conversation it even reached the
sports pages.

Numerous cartoonists re-imagined
and re-interpreted Duchamp's
famous *Nude Descending a
Staircase.*

Painting "The Nude Descending the Stairs."

WHAT CESARE SAW AT THE ARMORY ART SHOW

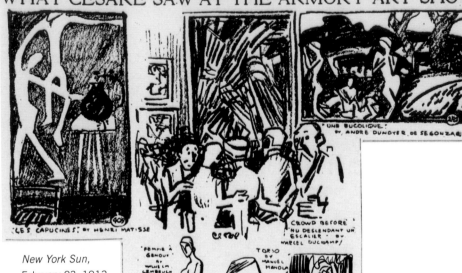

New York Sun,
February 23, 1913.

SEEING NEW YORK WITH A CUBIST

New York Evening Sun,
March 20, 1913. "The
Rude Descending a
Staircase (Rush Hour at
the Subway)."
© THE MUSEUM OF MODERN
ART/LICENSED BY SCALA/ART
RESOURCES, NY

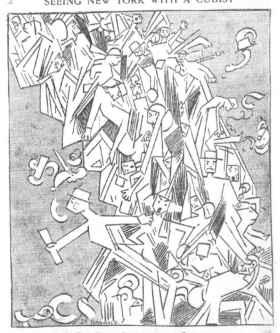

The Rude Descending a Staircase
(Rush Hour at the Subway)

You've tried to find her,
And you've looked in vain
Up the picture and down again,
You've tried to fashion her of broken bits,
And you've worked yourself into seventeen fits;
The reason you've failed to tell you I can,
It isn't a lady but only a man.[24]

The author had a point. American audiences had assumed the figure in Duchamp's painting was female, but Duchamp's title used the male form of the word "nude," "nu," rather than the feminine "nue," though none of this is particularly helpful in identifying the figure.

Cartoons were as popular a response as poetry. Newspaper artists relished transforming art at the show into caricatures, and an abundance of mock Cubism flooded the papers. The *Evening Sun* ran several panels on "How to Become a Post-Impressionist Paint Slinger" while the *Journal-American* depicted the "New Art" of the "Nuttists, Dope-ists, Topsy-Turvyists, Inside-Outists, and Toodle-Doodle-ists."[25] The same paper showed Old Masters such as Rembrandt fleeing the exhibition in horror. Popular awareness of the show was so prevalent that in the *Washington Times*, Cubism made it over to the sports page with a comic called "As Futurist and Cubist Artists See the National Game."[26] The most popular comic about the show was a frame showing a chaotic scene of angry faces and flying hats titled "The Rude Descending a Staircase (Rush Hour at the Subway)."[27]

The success of both poems and comics about the Armory Show prompted the publication of a mock children's book called *The Cubies ABC* that featured three pyramid-headed creatures painting, sculpting, and writing Stein-inspired poetry. The book was dedicated by the Cubies to the Association of American Painters and Sculptors in thanks for their "incubation."[28]

———

Those truly excited about the new art could embrace a trend sparked by the show: Cubist fashion.

Women's clothing was in the midst of a major transformation from the stiff, ornate fashions of the late 1800s to the softer, cleaner lines of the

1910s and 1920s. Belle Époque styles popular at the turn of the century emphasized an hourglass shape achieved with tight corsets; fabrics were limited to muted, dull colors and layered with lace, ribbons, and jewels. However, fashion was evolving rapidly. New designs favored a slim, boyish figure and soft, draping fabrics. Clothes became simpler, without all the fussy trims of earlier styles, as well as far more practical—women couldn't even walk fast in long, tight Belle Époque skirts.[29] Modern clothes suited the active lifestyles of modern women, allowing them to ride bicycles, play tennis, or even operate typewriters without billowing, lace-draped sleeves getting tangled up in the mechanism.

Some designers excited about Cubism proposed strange, blocky dresses with stiff tubes for sleeves, but no one seems to have ever worn these adventurous outfits.[30] Instead, new "Cubist" clothes featured not only the simplified silhouette of modern clothes but also bright colors and striking patterns. An ad from Wanamaker's department store proclaimed "*Color* is the vital thing. With the gown as palette, the world has been painted over, intensified, vivified, made luminous, by putting it into dresses which express the color visions of the Modernists."[31]

Some of the color combinations sound frankly hideous—a fashion article from the Windsor, Ontario *Evening Record* describes what sounds like a nausea-inducing outfit of bright yellow, red, and purple.[32] However, the fashion world clearly decided that riding the Armory Show's coattails was good for business. Declaring a gown "Cubist" seems to have been a surefire sales strategy at least for a few months, and the trend brought a welcome shot of color into women's wardrobes.

Excitement over all things Cubist spread into every aspect of modern life. It spilled over into the social sphere when adventurous hostesses threw Cubist parties. The *New York Times* reported in its City Social Notes column that Mrs. T.J. Kidder held a post-impressionist contest at a luncheon party. "The contestants were blindfolded and produced their pictures from subjects which were assigned to them," the *Times* said. "Mrs. Clarence West won the prize with her likeness of a cat."[33]

At a Cubist party, what else would one serve but Cubist food? "Nowadays everything at the dinner table takes on the cubist outline," noted the *Grand Rapids Press*. Recommended menus included fruit salads with melons and bananas cut into cubes. Loaf cakes could also be cut into squares and served alongside ice cream. In such a way "the influence of the cubists ... reached the dinner table."[34]

Organizations jumped on the Armory Show bandwagon with parties and mock exhibitions. The New York Architectural League held a "smoker" (a stag night with lots of cigars) in which the architects teamed up to create Cubist paintings; judges awarded prizes to any painting for which they could not even guess the meaning.[35] Members of Les Anciens de l'Académie Julian, an association of artists who had studied together in Paris, held a Cubist competition at their annual meeting. Benjamin A. Francke won first prize for his "octagonalist" painting titled *Lady Walking in Fifth Avenue in the Sunlight*.[36]

The largest mock event was a fund-raiser held to benefit the New York Lighthouse for the Blind titled the Academy of Misapplied Art. While most of the Armory spoofs were in fun, some of the figures associated with the Misapplied Art exhibit saw it as a chance to attack the AAPS—major players included John White Alexander, president of the National Academy of Design, and Kenyon Cox, the critic who had described the show as "heartrending and sickening."[37] The *Sun* described Misapplied Art organizers as "sore" and said they created their academy "to show the public that the cubists were merely impish children and that any child with a few tubes of color, a brush and a square of canvas could turn out as good soul stuff as any Matisse or any Picasso."[38] Most of the two hundred mock paintings produced for the show sound tedious (although the title *Emotions of a Maiden of Sixty-Three on Roller Skates* has potential). First prize was awarded by a judging committee composed of the policeman on the beat, the janitors of the building, and the blind residents of the institution.[39]

———

The most famous guest to tour the Armory arrived at about noon on March 4: former president Theodore Roosevelt.

After weeks of trying to lure political heavyweights, Quinn finally nabbed his old friend T.R. Curiously, Roosevelt attended the show on Inauguration Day, entering the exhibit hall at almost the same time his former opponent Woodrow Wilson took the oath of office—perhaps Roosevelt wanted to distract himself from disappointment that he had lost in his fatally flawed third-party bid for office. Davies, Kuhn, and Pach escorted the Colonel through the show. Pach described Roosevelt as being in good spirits—a "'school is out' frame of mind"[40]—although he seemed

skeptical of modernism. Roosevelt commented on the composition of a nude, and Davies replied, "All built up geometrically, Mr. President, just full of pentagons and triangles on the inside."

The straight-talking former president replied, "I dare say, and I dare say the *Venus of Milo* has a skeleton on the inside, and that's the right place to keep it."

A few weeks later, Roosevelt presented his views of the show in an article that appeared in *The Outlook* magazine—and, as was T.R.'s way, he didn't mince words. The ex-president dismissed contemporary European art as self-conscious, pretentious, and ridiculous. He described modernists as the "lunatic fringe" and suggested they were scam artists of the same ilk as showman and circus-founder P.T. Barnum. T.R. was disgusted and confounded by the deliberate simplicity of Matisse; perhaps not surprisingly for a Progressive, the former president deplored what he termed "retrogression." As for the Cubists, Roosevelt said:

There is no reason why people should not call themselves Cubists, or Octagonists, or Parallelopipedonists, or Knights of the Isosceles Triangle, or Brothers of the Cosine, if they so desire; as expressing anything serious and permanent, one term is as fatuous as another.

Roosevelt then compared *Nude Descending a Staircase*, which he referred to as "A naked man going down stairs," to a Navajo rug he kept in his bathroom. The rug, he said, was infinitely ahead of the painting in term of decorative value, sincerity, and artistic merit.[41]

However, Roosevelt had nothing but praise for the American art in the exhibition. Perhaps this is to be expected—smart politicians always root for the home team—and Roosevelt's praise predictably focused on the strength and individuality of American artists. "There was one note entirely absent from the exhibition, and that was the note of the commonplace," he wrote of the American section. "There was not a touch of simpering, self-satisfied conventionality anywhere in the exhibition."

The former president wasn't alone in specifically praising the American art at the Armory Show. Several newspapers ran reviews on just the American section, and their response was almost universally positive. Joseph Edgar Chamberlin at the *Evening Mail* proclaimed American artists "are by no means unworthy to appear in the company of the European

men" and highlighted the work of artists including Davidson, Brinley, William Glackens, and Kuhn.[42] The *New York Press* saluted the vitality of American artists while *American Art News* fumed that crowds were rushing past excellent work by Americans to gawk at Futurist "freaks."[43] The *Times* also applauded American art, although not necessarily in terms American artists would have appreciated; the anonymous critic declared Americans produced better art because they were "nicer" than the French.[44]

Armory Show organizers feared American art would suffer in comparison to European works. Glackens, the committee chairman in charge of selecting paintings for the American portion of the show, worried out loud in a preshow issue of *Arts & Decoration* magazine that "the American section of this exhibition will seem very tame beside the foreign section."[45] Initial reviews did focus on European works, but coverage increasingly shifted to the American side; far from dismissing American art, critics applauded it. The myth of the Armory Show that arose in the next decades held that American artists were totally ignored at the show, but in fact they held their own against the Europeans.

———

Amid all the excitement and publicity, the AAPS never forgot why they were there: to sell art. Pach racked up deal after deal as the weeks went on. Quinn made the first purchase of the show the day after the opening and continued to add to his collection throughout the exhibition— although he complained he had no room left in his apartment to display anything new. Another purchaser the second day was Lillie P. Bliss, daughter of a wealthy politician and a passionate collector of modern art. Davies served as her personal art guide, and she bought almost anything he recommended.

New York society women from families such as the Astors and the Vanderbilts made numerous purchases, as did several of the artists themselves; both Davies and Stieglitz added to their personal collections.[46] Edward Hopper made the first sale of his career when a dry goods merchant bought his painting *Sailing* for $250 (about $5,800 in 2013).[47] The sale provided an enormous boost to Hopper's confidence as an artist, although not enough to sustain him through the years of professional failure that followed. In fact, he wouldn't sell another painting for a full decade.

Duchamp triumphed at the show. *Nude Descending a Staircase* was purchased for $324 by C. Frederic Torrey, a San Francisco–based gallery owner. Collectors, annoyed at having missed out on the most famous work of the show, snatched up Duchamp's other paintings and began buying the works of his brothers.

The sale of which the AAPS was most proud was that of a Paul Cézanne landscape by the Metropolitan Museum of Art, the first painting by the Frenchman to enter an American museum collection. Not everyone associated with the Met was happy about the purchase. Sculptor and museum trustee Daniel C. French visited the Armory after the painting had been selected, and the best he could say about the landscape was that it was less objectionable than a Cézanne portrait hanging nearby.[48] French had been one of Gutzon Borglum's friends snubbed by the Sculpture Committee, so perhaps his antagonism was motivated by more personal than aesthetic considerations.

As the show entered its last days, the crowds swelled. The last week was packed, almost overflowing, and uniformed police had to clear the galleries—especially the Cubist room—every night at closing. One guest tried to make conversation with the police officer escorting her away from *Nude Descending a Staircase*. "Wouldn't it be awful if someone got locked in here over night!" she said. The officer simply twirled his finger beside his forehead.[49]

The last Saturday, March 15, shattered every attendance record. All day long people poured into the Armory, and between two and four o'clock the entrance was so mobbed many people left without getting into the show. Press reports put attendance around 10,300.[50] All the AAPS members arrived, along with a jubilant group of collectors and art students as well as a good portion of the 69th National Guard Regiment, who seemed to feel ownership over the event. When ten o'clock struck, police herded guests to the door, leaving the organizers, patrons, students, and guardsmen behind. Then the party started. Jerome Myers declared it "the wildest, maddest, most intensely excited crowd that ever broke decorum in any scene I have ever witnessed."[51]

The fife and drum corps struck up a beat; the irrepressible Brinley borrowed the drum major's baton and bearskin hat to lead the artists and their families, the guards and the guides, the ticket-sellers and the coat-check staff in a joyous dance through each of the galleries. Champagne arrived, courtesy Quinn. As corks popped, the secretaries danced with

the art students as Kuhn, Davies, and Pach toasted one another's efforts. Another artist shouted, glass held high, "To the Academy!" Quinn leapt to his feet and declared, "No, no! Don't you remember John Philip of the *Texas?* When his guns sank a Spanish ship at Santiago, he said, 'Don't cheer boys, the poor devils are dying!'"[52]

The party probably would have lasted all night, but workmen had started trickling in to pack up the art, demolish the gallery partitions, haul away the pine trees, and take down the streamers. The 69th Regiment needed its Armory back in time for St. Patrick's Day celebrations less than two days away, and the art was expected in Chicago in a week. The students and ticket-sellers gathered their coats and hats and headed for home; the sound of the band was replaced by that of hammers and chisels. Kuhn stayed all night to supervise the work.

The next morning the regimental band returned, surprising the tired carpenters and an exhausted Kuhn. They paraded into the emptying Armory playing a rousing Irish march—a last salute to the New York Armory Show before it shipped out. The band had no idea how appropriate their send-off would be—Kuhn would need all the encouragement he could get. The Armory Show was headed into enemy territory.

CHAPTER 7

Raiding Enemy Territory

Nasty, obscene, indecent, immoral, lewd, and demoralizing.
—W.C. STRAUSS, CHICAGO SCHOOLTEACHER

March 24, 1913
Chicago, Illinois

Frank Granger Logan, acting president of the Art Institute of Chicago Board of Trustees, stalked alone through empty galleries on a private preview of the Armory Show. He stared in revulsion at an adolescent girl in a canvas by Paul Gauguin and then turned away from a woman brazenly striding toward the audience in a painting by Robert Henri. Neither of them had on a stitch of clothing. Artists called them nudes, but in Logan's mind they were stark naked. Logan hadn't wanted to bring the scandalous Armory exhibition to Chicago in the first place, but he had been overruled. Now, seeing the art in person, he knew he had been right all along.

The show was to open in a matter of hours, so he had to act fast. Logan located four other members of the board and convened a closed-door meeting to discuss the "propriety and policy of taking out some of the pictures offered." Logan didn't argue with the aesthetics of the show but rather its *morals.* These paintings, Logan believed, were no better than pornography. He had a responsibility to the Institute; he could not allow smut on its walls.

Logan challenged three paintings in particular: The nudes by Henri and Gauguin and a work by American artist Charlotte Meltzer titled *Loverene,* probably also a nude, although the painting itself has been lost to history. To Logan's disgust, he was outvoted—again. The paintings stayed. The show opened that afternoon at 3:00 p.m. to a glittering assembly of Chicago elite with the three works still on the walls.[1]

Walt Kuhn and Walter Pach, who had traveled to Chicago a few days before, didn't know about the board meeting. It was probably for the best. The Illinois leg of the show had gotten off on the wrong foot before the paintings even left New York. Most of the staff of the Art Institute protested the organization's sponsorship of the exhibit, and the press had been unremittingly negative. Kuhn had already developed a profound dislike of the Windy City. "The Chicago people," he informed Vera, "are vulgar low-brows."[2] Kuhn had the native New Yorker's disdain for the Midwest and was convinced no one who lived west of the Hudson River could appreciate true culture. Considering his prejudices, it's surprising his hopes for the show were so high. He assured Vera, drawing on his apparently bottomless well of optimism, "Prospects for a big success here are the finest." Kuhn brimmed with confidence at the start of every enterprise, but it took willful blindness for him to ignore the warning flags that greeted him in Chicago.

Events over the next three weeks would confirm Kuhn's deepest prejudices and shatter his unfounded optimism. Chicago would be a very different show from New York—nothing back home could prepare the artists for the over-the-top reactions to the show in the Midwest. Art that intrigued and puzzled New Yorkers provoked anger, even rage, in Chicagoans. Kuhn and Pach had no idea what they were getting into—or how hard-pressed they would be to defend the morals of modern art.

———

Chicago was a big city, but it was a Middle American city in an era before mass media blurred regional differences. New Yorkers like Kuhn considered Chicago provincial, narrow-minded, and hog-tied by stuffy Victorian scruples. Chicagoans naturally took a different view of the matter—they thought of themselves as hardworking, self-reliant, and God-fearing. In their opinion, they weren't shackled to an outdated ethical code, rather they had a moral backbone—something those bohemian, possibly godless, more than likely anarchist Easterners might want to learn about.

While New York lagged behind Europe artistically, Chicago in turn lagged behind New York. Chicago had only been introduced to Impressionism in 1893 at the Chicago World's Fair, and European Post-Impressionism and modernism remained virtually unknown. The instructors at the School of the Art Institute set the tone in the city, and

they prided themselves on their rigid academic standards—they still considered the Pre-Raphaelites, English artists of the 1840s, extremists. Essentially, paintings that didn't look at least one hundred years old were considered suspect.

Furthermore, all arts in Chicago had to pass moral judgment by a cadre of self-appointed arbiters of public integrity—a group of ministers, schoolteachers, and society women whose standards were impossibly high and judgments absolute.[3] As the only major arts organization in the region, the Art Institute dominated Chicago even more than the National Academy of Design dominated New York. It was a closed circle, and European radicalism was going to be a hard sell.

The Armory Show traveled to Illinois at the instigation of one man who had the courage to buck the system: Arthur T. Aldis, a wealthy real estate developer and governing member of the Institute. Kuhn, Pach, and Arthur B. Davies met Aldis in November on their Paris trip, and Aldis immediately embraced the mission of the AAPS and resolved to bring the show to Chicago. In fact, he was so enthusiastic about it that he committed the museum to the exhibition without consulting anyone else at the Institute. Perhaps he thought his fellow citizens would actually appreciate the art, or maybe he wanted to shock them out of their aesthetic complacency.

Aldis returned home to Chicago and announced his plans to the surprised and irritated staff at the Art Institute. William M.R. French, the director, particularly resented Aldis' interference; he had scheduled a full slate of exhibits for the same period, and he didn't like what he had heard about the AAPS. When he asked a friend in New York about the organization, he was told that it was run by troublemakers with no other motive than the downfall of the National Academy of Design.[4] French's opinion of the organization declined precipitously when Davies and the Sculpture Committee rejected the work of his brother, sculptor Daniel C. French, a friend of Gutzon Borglum's.

Nevertheless, French bowed to Aldis' authority and opened negotiations with the AAPS for the show. These dragged out over months; Kuhn and Davies, overwhelmed with the New York show, could spare little attention for the Chicago one. Finally, French decided to go to New York, see the show, and talk to Davies and Kuhn in person. He arrived on February 22, and what he saw at the Armory sank his spirits. "I at first thought it would be a good thing to satisfy the curiosity of the public, and

as I visited the exhibition for the first time I felt a sort of exhilaration at the absurdity of it," French wrote.

Absurdity certainly wasn't what the AAPS had in mind, but he wasn't the only one to have that reaction, so no matter. However, with return visits he "became depressed to think that people could be found to approve methods so subversive of taste, good sense and education; of everything that is simple, pure, and of good report." He decided hosting the show would be a mistake and an insult to the people of his city who counted on the Institute to be the guardian of taste: "We cannot make a joke of our guests."[5]

Nevertheless, a few days later the Art Institute submitted a contract to the AAPS. Aldis' power within the Institute must have been vast; he was somehow able to convince others to side with him against French. French conceded, but he wasn't happy, nor were others at the Institute. The opposition made their position clear in a statement in the official *Bulletin of the Art Institute of Chicago*. The statement dismissed the merits of the art in the exhibition by characterizing the artists as ranging from "the sincere, and usually eccentric, person who has revolted from conventionalism" to the "reckless, and often ignorant, fellow who seeks easy notoriety and hopes to impose upon the public."[6]

The Institute explained it was hosting the show to satisfy the curiosity of Chicagoans—the Institute "has always been willing to give a hearing to strange and even heretical doctrines, relying upon the inherent ability of the truth ultimately to prevail." In other words: *This is art by crazy people and hucksters, but we're going to show it to you because we know you're going to see it for the joke it really is.*

Plans for the show were formalized in early March, and Davies selected the art that would make the trip to Chicago. The Art Institute had enough room for 634 works, about half the total in New York. Davies left behind the entire historical section, which was represented in the Institute's permanent collection anyway, and about half the American works. The Chicago exhibition would emphasize European Post-Impressionism and modernism as well as a cross section of progressive American art, thus guaranteeing a reaction by promoting the most extreme works.

On March 20, Davies wired Chicago that the art was on the way and Kuhn and Pach would follow the next day. (Davies stayed in New York, ostensibly to manage the AAPS office; it's also likely that, as a confirmed introvert, he was exhausted by the New York show. The extroverts Pach

and Kuhn were happy to handle Chicago.) It had been less than a week since the blow-out party the last night at the Armory.

At least French didn't have to stick around to witness the exhibition: he had long-standing plans for a lecture tour and vacation on the West Coast that would take him out of Chicago until after the show closed. He packed his bags and washed his hands of modernism and whatever chaos it was bound to cause. The same day the art left for Chicago, French boarded a train for California, prompting this verse from one newspaper:

The cubists are coming, ho, ho, ho;
The cubists are coming, ho, ho, ho;
The cubists are coming from stately Manhattan;
The cubists are coming, ho, ho.

The art director has gone before,
He's said goodbye for a month or more;
The cubists are coming, and that's enough;
He cannot stand the futurist stuff.[7]

As Chicago receded in the distance, French was likely relieved to leave the Armory Show and its headaches behind. He would observe the hysteria of the next few weeks from the safe distance of California and escape any blame for bringing modernism and its "loose morals" to a woefully unprepared Middle America.

The poem was only one in a stream of verses, cartoons, reviews, and news stories produced by Chicago papers in the run-up to the exhibit. Several Chicago editors sent reporters to cover the New York show, so Illinois audiences were familiar with the crazy Cubists long before the show arrived. As in most newspapers outside of New York, headlines in Chicago had been scathing: "Bedlam in Art" declared one. "Art Show Open to Freaks; American Exhibition in New York Teems with the Bizarre" claimed another.[8]

Most papers had welcomed the news that the show was heading to Chicago, and stories followed the progress of the trains bringing the art from the East Coast. One paper even reported on the hanging process, claiming humorously, if incorrectly, that much debate went into ensuring the paintings were right side up.[9] In fact, an enormous amount of disinformation piled up. In one particularly egregious article in the *Chicago Record-Herald,* a reporter described Constantin Brancusi's sculpture *Mlle.*

Pogany as a painting, discussed work of Italian Futurists that was not included in the show, and claimed *Woman with Mustard Pot* had been painted not by Pablo Picasso but by his dealer.[10]

Kuhn fumed at the abysmal quality of most Chicago reporting. He was pleased when Arthur Jerome Eddy waded into the fray and hoped the prominent attorney would provide much-needed insight on modern art. Eddy, who divided his practice between New York and Chicago, had supported Aldis in bringing the show to town. He was an enthusiastic collector—only John Quinn bought more art at the Armory—and he welcomed opportunities to give lectures and interviews about modernism. However, instead of furthering the cause, Eddy only confused matters. He spent more time congratulating himself on his purchases than explaining the new art to the public, and what explanations he provided were odd and unhelpful.

In one lecture, to help the audience understand the difference between modern art movements he declared President Wilson a Cubist and Theodore Roosevelt a Futurist,[11] which succeeded in accomplishing nothing except mystifying everyone. Eddy's efforts culminated in an article in the *Daily Tribune* in which he claimed he had "discovered" the nude in Marcel Duchamp's *Nude Descending a Staircase*. As well as a lengthy finding aid ("Her head is located about one inch from the upper border Two white cubes form the torso."), the article included a reproduction of the painting with a thick white line outlining Eddy's "find." Kuhn must have thrown up his hands at this point—Eddy had played into the most simplistic ideas of Cubism and reduced the painting to a puzzle with an obvious solution.[12] To Pach's endless annoyance, people arrived every day carrying clippings of the paper and holding them up to compare to the canvas.

Kuhn and Pach did their best to provide actual information to the public, with little success. Since most Chicago papers had failed to offer any thoughtful criticism, the two men worked with AAPS press agent Frederick James Gregg to print a small volume titled *For and Against: Views on the International Exhibition Held in New York and Chicago*. It included informative articles by Pach, a statement of purpose by Davies, a bewildering essay by Francis Picabia titled "Cubism by a Cubist," and two antagonistic reviews by New York critics. The men took a risk—and demonstrated their confidence—by reprinting these negative reviews. Of course, they knew controversy drew people to the show, but they had been

hoping to raise the level of discourse beyond pointing and snickering. No one in Chicago seemed to pay attention to the volume.

Kuhn and Pach also conducted press interviews with equally unsatisfactory results. The *Examiner* reported on an interview with Kuhn in a disdainful article that painted him as a snob with no respect for his Chicago hosts. The story warned visitors not to laugh when they visited the show or "superior persons"—i.e., Kuhn—"will put it down to vacuity and you will be sneered at from peculiar heights."[13] Kuhn was trying to be reasonable, but the Chicago press was determined to mock him. It was an unfair fight.

Meanwhile, less informed critics weighed in, including the mayor of Chicago, Carter Harrison Jr., who toured the exhibition on opening day. A born actor, Harrison jumped at the opportunity to dramatize the moment; when he emerged, newspapers described him as dizzy from the sight of modern art. When a reporter asked how the show impressed him, "the Mayor gulped, suppressed his feelings and spoke slowly. 'I was impressed,' he answered—'that is all, impressed with no adverbs.'"[14] Harrison told journalists that a blind man with his hands tied behind his back could paint as well as some of the artists and concluded, fatalistically, "Life is too short to try to understand a cubist painting."[15]

Another critic to offer an opinion of the show was W.C. Strauss, a teacher at a Chicago high school. In an interview with the *Record-Herald* on March 29, Strauss declared the exhibit "nasty, obscene, indecent, immoral, lewd, and demoralizing." Chicago schoolchildren should be banned from the exhibit, he insisted, lest their tender minds be contaminated by the display. Strauss considered three nudes in the exhibit particularly shocking: Gauguin's *The Spirit of Evil* (now known as *Words of the Devil*), Georges Seurat's *Models*, and Meltzer's *Loverene*. (Two out of three works on Strauss's list overlapped with Institute president Logan's.) Strauss urged the Institute to close the show or at least bar children from the galleries; the museum, he said, had an opportunity to guide public opinion and should put "the stamp of its disapproval upon whatever in this exhibition is neurotic, half-baked or obscene"—which, in his opinion, was all of it.[16]

Kuhn and Gregg had ignored most press attacks, but they felt that calling the exhibition immoral crossed a line. They decided to interpret Strauss's piece as a personal insult to the honor of Meltzer, and they leapt to her defense, using chivalry as an excuse to confront the paper. Kuhn

thoroughly enjoyed arguing with the editor and threatening lawsuits; he told Elmer MacRae, "It's the finest bit of excitement we have had." Kuhn and Gregg succeeded in cowing the editor and ended the day believing they had won the encounter. They had no idea; in fact, the war had only just begun.

Kuhn didn't take into account the cultural differences between Chicago and New York. Morals hysteria was gripping the city, and virtuous citizens had recently launched an aggressive campaign to stamp out vice. Chicago wasn't alone; communities across the nation pursued public morality and social hygiene crusades throughout this era, fueled by the same reforming spirit that prompted movements such as Prohibition. Vice campaigns, however, were driven by a peculiar terror of the 1910s: white slavery. Americans were convinced that innocent young women were being snatched off the streets and sold into prostitution. Lurid magazine articles, books, and movies warned girls to beware male strangers who might at any moment haul them into a life of sin. Sinister strangers apparently lurked around every corner with chloroform-soaked rags in their pockets and evil thoughts in their hearts.

In fact, white slavery was an imaginary problem inflated into a crisis by well-meaning reformers; despite the combined efforts of hundreds of police and prosecutors, no one uncovered a single shadowy organization forcing girls into brothels. (Sociologists today describe white slavery as a moral panic rooted in anxiety about the number of young women living alone in cities.)[17] Never ones to let facts get in the way of moral outrage, lawmakers across the country sought to combat the growing menace of white slavery. The Illinois State Senate took on the fight in February 1913 when it established a Vice Commission to investigate prostitution.[18] The Senate gave the commission broad authority and wide leeway to accomplish its aims, and, in the timeless way of government commissions, within weeks it had moved beyond the question of white slavery to investigate immorality in all forms—including, of course, art.

This didn't surprise artists of the era, who were used to defending their work from charges of indecency; it came with the territory back then. Censorious museums and arts organizations often removed nudes from exhibits or placed them in separate galleries where only men were admitted—like an "adults-only" section in a bookstore, with all the taboo implied therein. No one wanted their neighbors or colleagues to see them entering the "naughty pictures" section of the museum.

The Art Association of Columbus, Ohio, segregated two paintings by Davies this way in 1911.[19] Artists hated indecency fights, which they found tedious and insulting, but they had to battle them again and again. The September prior to the Armory Show, the Women's Christian Temperance Union of Queens and Nassau in New York protested that several paintings at the Queens agricultural fair were indecent and demanded their removal. ("Not one of the women shown in those pictures has a stitch of clothing on her!" declared one shocked member of the WCTU.) The secretary of the fair sought the opinion of a member of the National Academy of Design, who found the paintings perfectly respectable—a decision that failed to satisfy Mrs. John B. Dayton, WCTU chapter president. She declared there were laws against this sort of thing and that everyone concerned ought to be just ashamed of themselves.[20]

The worst that usually happened in these spats was that paintings were removed from exhibits. However, Chicago raised the stakes only days before the show opened by getting the courts involved. In early March, a police officer spotted a reproduction of the painting *September Morn* hanging in the window of a downtown gallery. The work, by French artist Paul Chabas, depicts a nude woman standing in a pool of water against a background of soaring mountains. It's a standard academic painting, offensive only on the grounds of blandness. Since the French academy greatly prized blandness, Chabas had won a medal in the 1912 Paris Salon for the work.

The Chicago Police Department was clearly unimpressed by such honors. They ordered the work taken down on the grounds the gallery was exhibiting and offering for sale an indecent picture, actions made illegal under a law intended to prohibit the sale of pornography. The gallery owner refused to remove the work, whereupon Mayor Harrison ordered a senior police sergeant to confiscate the painting. The gallery owner took the case to court. In a trial held March 21 and 22, a jury found that *September Morn* was *not* indecent and could be displayed in public. The *Chicago Tribune* pointed out that if the painting had been declared lewd, the Art Institute would have been subject to police raids.

The jury had barely been dismissed from the *September Morn* trial when the Armory Show opened, and naturally the case was on the minds of audiences. Once modern paintings had been declared immoral, there was nothing Kuhn could do to stem the flood of criticism. Complaints poured into newspapers and into the state's designated investigators of immorality, the Illinois Vice Commission.[21] Dirty pictures in a museum

seem a long way from innocent girls in brothels, but the senators refused to shirk their duty. They dispatched an investigator to tour the exhibit.

That agent turned out to be Mrs. Maud J. Coan Josephare, sister of a Vice Commission staff member. Her qualifications for the job included a stint supervising drawing instruction in Philadelphia public schools. Mrs. Josephare declared, "I found pictures at the exhibition which are simply lewd."[22] Josephare's logic is sometimes questionable; she couldn't find anything indecent about *Nude Descending a Staircase* but feared it could influence other artists to paint works that *were* indecent—a criticism that could reasonably be applied to almost any piece of art. Nevertheless, on the basis of Josephare's findings, Lieutenant Governor Barratt O'Hara ordered an immediate examination of the entire exhibition.

So one morning in early April State Senator D.T. Woodward arrived at the Art Institute to investigate the show. Pach provided the senator with a personal tour, and Woodward dutifully studied the works in dispute, peering at paintings by Gauguin, Henri, Seurat, and Meltzer. He particularly asked to see *Nude Descending a Staircase*, but according to Pach, "after one look at its tangle of 'abstract' forms," the senator decided "it would lead no youth nor maiden from the path of virtue."[23] The senator could find nothing objectionable in the exhibit—in fact, he could make no sense of it at all. He departed, convinced that the Armory Show had not spoiled the good morals of the city of Chicago.

At the next commission meeting, Woodward reported on the show, and for the lack of any substantive objections, the commissioners attempted humorous ones. "The only thing immoral about the 'Woman and the Pot of Mustard,'" said one senator of a Picasso painting, "is that a woman with such a face should be allowed to pose for her portrait." Senator Woodward's assessment of the show was matter of fact: "The best thing I can say about the exhibit is that it would have been twice as big if there had been twice as many pictures."[24]

Newspapers around the country had carried stories trumpeting the investigation, but few bothered to report on the results. People around the country were left with the impression the Armory Show had been condemned for indecency. In reality, after a ridiculous amount of buildup, the investigation was quietly dropped. This was a result typical of Vice Commission inquiries. Even its mission of stopping white slavery bogged down when studies revealed women were generally forced into prostitution out of dire poverty, not evil kidnapping schemes. Addressing the plight of poor

women meant tackling sticky issues like the minimum wage, collective bargaining, and overall social conditions, which was much harder and far less sporting than condemning evil procurers and pimps. The white slavery investigation eventually faded away as quietly as the art scandal had.

———

The Vice Commission case annoyed Kuhn and Pach, but it generated enormous press and attracted huge crowds—many of whom came just for the privilege of gawking. Pach observed a steady stream of visitors who didn't look like museum types and often left the show appearing disappointed. One angry man strode up to Pach and said, "I know smutty pictures when I see them; I've sold enough. What's the good of these? Who's going to get any kick out of a thing like that?"

Pach, who had never looked at the exhibit this way, seems to have been flummoxed by the encounter. The man continued, "You've got my quarter and you're welcome. Anyhow I got my money's worth." Pach was surprised the man had found anything to his tastes at the Institute and was startled when he began describing art he had found in another part of the museum: "'Figures—life size, some of them broken, and just white, but, gee! Women with' (anatomical details and gesture of caressing) 'and men with' (more anatomy and enthusiasm)—'I could hardly keep my hands off them.'" These lascivious descriptions had Pach bewildered, until he realized the man had stumbled into the collection of Classical statuary and had been leering over Greek gods and Roman heroes.

The discussion turned out to be useful; Pach used it to his advantage, luring the gawkers even farther in. Over the next weeks, when other men confronted Pach, disappointed in the lack of indecency on display, he would hem and haw and finally admit the museum had in its collection some truly suggestive works. Then with seemingly great reluctance, he would show them the paintings of French academic favorite William-Adolphe Bouguereau. "This is a disgrace," one man announced in apparent satisfaction, taking in the dreamy, soft-focus nudes. "I knew the stuff was here."[25]

———

If some visitors at the Art Institute only cared about dirty pictures, others were a bit higher-minded, embracing the innovations of modernism.

Pach, from his position on the gallery floor, was enthusiastic about the thoughtful reactions he heard from visitors. "You would be *astounded* at the intelligence I find in my rounds of the galleries," Pach wrote Michael Stein. "Even as a small fraction of the comment, it more than makes up for the idiots."[26]

One of the most receptive guests at the show was Harriet Monroe, art critic for the *Chicago Tribune*. Monroe visited the show in New York and had been aghast at the display—she memorably described Henri Matisse as a child throwing a temper tantrum with paint. However, after several repeat visits in Chicago, she caught the spirit of the revolution and decided to join the modernists on the front lines. She wrote:

> *American art, under conservative management, is getting too pallid, nerveless, coldly correct, photographic. Better the wildest extravagances of the cubists than the vapid works of certain artists who ridicule them. Better the most remote and mysterious symbolism than a cameralike fidelity to appearances. We are in an anemic condition which requires strong medicine, and it will do us good to take it without kicks and wry faces.*[27]

Energized and emboldened, Monroe took up the cause of modernism with the zeal of a convert; she spent the rest of her life defending its banner. As well as promoting artists, she became an important supporter of writers. A few months earlier, Monroe had founded the journal *Poetry* to publish contemporary verse; the magazine became as critical in the history of modern poetry as the Armory Show in modern art. Monroe highlighted the work of Ezra Pound, Robert Frost, William Butler Yeats, James Joyce, and dozens more influential writers; T.S. Eliot's first published poem, the iconic "The Love Song of J. Alfred Prufrock," first appeared in *Poetry*.

Another recruit to the modernist cause was Chicago artist Manierre Dawson, who had been fighting alone for years, not realizing he had an army of fellow revolutionaries on his side. The twenty-six-year-old Dawson worked full-time as an engineer and designer for an architectural firm, but on nights and weekends he produced some of the most cutting-edge art in America. Dawson had begun painting soon after he left college. Without any exposure to either European or

American avant-garde art, he produced unique paintings that didn't have subjects; they were instead exercises in color, shape, and line—totally abstract art.

Abstraction expanded the definition of art—before, artistic effort had always included faithful reproduction of the actual, physical world. It was a strange, unwelcome idea to most audiences and artists in 1913. Even radicals such as Matisse and Picasso resisted the idea of paintings without subjects; Picasso's most difficult-to-interpret Cubist works always began with an object, no matter how hard it was to find on the canvas. Nevertheless, two other artists showed abstract works at the show: the American Marsden Hartley and the Russian Wassily Kandinsky. Kandinsky is often credited with inventing modern abstract art in 1910; Hartley met Kandinsky in Munich in 1913, and his interest in abstraction was sparked by exposure to Kandinsky's paintings and essays. Dawson, however, created his abstract canvases at the same time on the opposite side of the Atlantic independently of Kandinsky. He was that rare creature, a completely original thinker.

Dawson only encountered other modern artists in late 1910, *after* producing his first abstract paintings, when he took a leave of absence to tour Europe. He visited the Steins' salon—Gertrude bought one of his paintings—and studied the art of Paul Cézanne, Picasso, and Matisse. Stopping off back in New York, he also met Davies, who was impressed with the young man's unique vision. During preparations for the Armory Show, Davies invited Dawson to exhibit. Dawson, however, felt that none of his works were ready to show and declined to participate. Disappointed, Davies encouraged Pach to look up Dawson in Chicago.[28]

Dawson attended the show the first day it was open to the public and left amazed at what he had seen. "It was with great difficulty that on coming out I could convince myself that I hadn't been through a dream," he wrote in his journal. He hadn't realized how many artists were experimenting along the same lines—"I had thought myself as an anomaly"—and for the first time felt himself part of the art world. This sense of belonging to something greater than himself gave Dawson enormous confidence. The show had the same effect on other young artists, who often had no idea how big and how varied the modern movement could be. Even art collectors like Eddy rejoiced in the discovery that they were part of a larger, even worldwide, revolution. And it was spreading.

Dawson returned as often as he could to the Institute. Pach noticed him in the galleries and struck up a conversation only to realize Dawson was the artist Davies had wanted him to meet. The two began an immediate friendship. Dawson invited Pach to his home, and Pach marveled at the paintings Dawson had completed. Pach fumed that the work of this unusual artist wasn't on display and decided to sneak one of his paintings into the show.

Pach had no authority to add new works to the show, unlike in New York, where the organizers could make changes to the exhibition throughout its run. Pach's decision to flout the rules was as much a way for him to thumb his nose at the stodgy Art Institute as to promote Dawson. Pach selected one of the artist's recent works and called it *Wharf under Mountain*. This misleading title implies the colorful abstract painting *has* a subject. The greenish shapes at the top of the canvas could be a mountain, and the brown triangles and dark blue blocks in the middle could be a ship at a wharf, but that had not been Dawson's intention when he painted it. Either Pach wasn't ready for abstraction either, or he believed—quite correctly—that Chicago audiences wouldn't accept a painting that didn't claim to represent anything.

Pach slipped the canvas into the Institute and, in a quiet moment, hung it in the American section. Dawson hoped an insightful critic or buyer would spot the work. Unfortunately the first person to notice the painting was a senior staff member of the Institute, who ordered Pach to take it down. Dawson's work had been on display for just over a week, but he couldn't have been too disappointed that the stunt failed. He had made a friend in Pach, and his eyes had been opened to the wider world of American modern art. His art would grow more confident in the next few years as his circle of artist friends widened; he started exhibiting in major shows and attracting the interest of collectors. Best of all, he had discovered a community of like-minded explorers on the outer frontiers of art—Dawson was no longer alone.

———

A more sympathetic museum official might have let Dawson's late addition slide, but the Art Institute staff remained cool to the show. Many worried the show would hurt the reputation of the Institute, and one curator even expressed doubts as to the characters of Kuhn and Pach.

"The gentlemen who came on here have done more harm than the exhibition, their personalities being most undesirable," sniffed Bessie Bennet, an assistant in charge of textiles and decorative arts.[29]

The chilly attitude of the staff was preferable, however, to the outright aggression of instructors at the Art Institute School. The conservative, academic faculty didn't waste any opportunity to express their disgust, on one occasion taking their antagonism into the galleries. Kuhn wrote Davies:

> All the instructors are mad through, one even went so far as to take a big class of students into the French room and threw a virtual fit condemning Matisse. We three [Kuhn, Pach, and Gregg] stood in the hall and laughed at him. However, I had this stopped and after this the lecturing will be done outside the exhibition rooms.[30]

Kuhn could only do so much. The instructors condemned modern art at every turn and worked their students into a fever pitch.

Chicago artists supported the instructors and contributed to the heated atmosphere. Members of the Cliff Dwellers, a prominent Chicago arts club, were reportedly "violently opposed to the exhibition." They held a mock Cubist exhibition in which they bragged members completed Cubist caricatures with "infinitely better line and color composition" than works at the Armory Show in less than twenty minutes each. Kuhn could only mutter resentfully that club members would lose business if academic art fell out of favor and were "worried about their bread and butter."[31] About a week before the exhibition closed, Kuhn decided he had had enough; he left Pach in charge and returned to New York to prepare for the Boston leg of the show.

The Art Institute students' wrath exploded on the Armory Show's closing day, April 16. Plans for a demonstration had been brewing for a week or so, and Pach was alarmed that some students planned to hang Matisse, Brancusi, and himself in effigy. (It's alarming to learn one is going to be executed by a mob, even if only symbolically.) The AAPS lodged a complaint with the Art Institute, which demanded students curtail the protest. The result, therefore, was more ridiculous than frightening.

The students held a mock trial of "Henry Hair Mattress"—i.e., Matisse—in which the artist, played by a student, was charged with

"artistic murder, pictorial arson, artistic rapine, total degeneracy of color, criminal misuse of line, general esthetic aberration, and contumacious abuse of title." The jury fainted at the sight of three copies of Matisse paintings, which were then ceremonially burned. The protest concluded with students screaming their hatred of Cubism until a crowd gathered while the police kept an eye on the proceedings.[32]

It was probably for the best that Kuhn had returned to New York—he would never have responded to the demonstration with the good humor of Pach. As long as the Institute kept the students under control, Pach could observe the protest with tolerance. He told the *Record-Herald*, "students who yesterday burlesqued and criticized and satirized would, unless they changed their ideas, spend the remainder of their days 'eating crow.'"[33]

In fact, some student artists *did* change their ideas. The twenty-two-year-old Raymond Jonson couldn't stop thinking about the abstract paintings of Kandinsky that he saw at the show; throughout the next ten years he intensively studied the art and philosophy of the Russian painter. Jonson ended up an artist of brilliantly colored abstract paintings. The reaction of twenty-three-year-old McKnight Kauffer was even more immediate—he toured the Armory Show galleries and converted to Cubism on the spot. Kauffer eventually moved to England and became famous for a series of iconic posters, ads, and book covers he designed in a modernist style.[34]

———

Once the show closed, the Art Institute congratulated itself on giving modernism a fair hearing, a smugly complacent attitude that exasperated Pach, who didn't see much fairness in the Institute's belligerent attitude. Nevertheless, Director French returned to town in late April and reassured his colleagues, "Radicals cannot complain that they have not had a fair chance. We have met them on their own ground, and I see no ill results."[35]

In fact, the results were stupendous, at least in terms of attendance. More than 188,000 visitors poured into the Institute during the course of the exhibition; one weekend alone more than 45,000 people saw the show. The high numbers actually worried Institute staff, who realized they would be hard-pressed to duplicate them. One staff member told

Pach, "We got you fellows here to boost our records, but I didn't think you were going to get them to a point that we can never reach again. I'm figuring out what to do next year so that our statistics don't show too big a decrease."[36]

Unfortunately, the deal the AAPS had made with the Institute meant the association didn't profit from the record attendance. The contract specified the Institute would receive all admission fees and the AAPS all sales commissions. As it turned out, admissions were high and sales dismally low. Most Chicago collectors were as conservative as the Institute's staff and bought nothing, while local promoters of the show such as Aldis and Eddy had seen the exhibit in New York and made their big purchases there. The Institute also agreed in the contract to cover all expenses including transportation and insurance and to split net receipts from the sale of catalogs, reproductions, and prints. However, at the end of the show, the two groups disagreed on exactly what was included in "net receipts" and the Institute pushed a number of expenses back on the AAPS. The AAPS didn't make as much money as they had anticipated, and haggling over receipts was a lousy way to end a contentious relationship.

———

Chicago simply wasn't ready for modernism—and wouldn't be ready for years. Knee-jerk morality and stubborn loyalty to academic art would hinder the acceptance of modernism for decades. When Eddy died unexpectedly in 1920 of acute appendicitis, Aldis encouraged the museum to buy Eddy's entire collection of Post-Impressionist and modern art, but the Institute declined and the collection was broken up. Eleven years later, the Institute recognized its mistake and acquired twenty-three works as the Arthur Jerome Eddy Memorial Collection. Over the years, works of artists who had been mocked in 1913 began to appear on the Institute's walls; even the detested Matisse is now represented by a wealth of paintings, drawings, and sculptures. Dawson also made it back into the Institute—officially, this time, in the Institute's permanent collection.

Meanwhile, the Armory Show was once again packed up. The paintings were removed from the walls, the canvases slipped from their frames, the statues packed in sawdust and nailed into shipping cases. Art Institute staff walking by the galleries probably nodded in satisfaction as the rooms

cleared out. By April 22, the entire exhibition had been shipped out. Pach, ever genial, shook hands all around, but as he boarded a train for New York he must have departed the Windy City with a sigh of relief. It was behind him.

Part III

After the Shooting Stopped

CHAPTER 8

Losing Battles

They have turned the society into a Cubist, a Futurist, a Post-Impressionist organization as radical and narrow in its aims as the National Academy of Design is radical and narrow in its aims.

— Guy Pène du Bois, American artist and critic

March 15, 1913
New York City

In a coincidence only Walt Kuhn might have noticed, the same day the Armory Show held its glorious closing-night party in New York—before packing up for Chicago—the National Academy of Design opened its annual exhibition.

The start of the 1911 Academy show had doomed Kuhn's hopes for his solo exhibition at the Madison Art Gallery. Now, in a reversal of fortune, the Armory Show cast a giant shadow over the opening of the 1913 Academy Salon—no one could help comparing the two events, and after the Armory Show, the Academy just seemed dull. "There are no Cubist paintings at the spring show of the Academy of Design," wrote the *New York Sun*. "This will not surprise anybody, and in fact the main fault to be found with the exhibition is that there are no surprises of any kind."

The *Sun* described the show as displaying "orderly vision" and "careful handling of well worn themes" but "hardly any of the volatile notes, the heady waywardnesses, the bold excursions into unfamiliar domains that cheer and vivify."[1] It was hardly a ringing endorsement. The paper's critic seemed—in a word—bored.

Despite the Academy's feigned antipathy towards everything modern, the Armory Show did force changes on the Academy—although

the institution would never admit it. The jury began to severely limit the number of works admitted so the space wouldn't be crowded. In one gallery the paintings were even hung in a single row (as they would be today) rather than skied all the way to the ceiling. Artists were finally spared the agony of finding their canvases ten feet above the ground in a dark corner of the room.

However, the jury also responded to the radical work at the Armory by becoming even *more* academic—they couldn't compete with progressive art, so, like many conservative politicians, they moved to the right to secure their base. The display was "more conventional, more reserved than ever," said the *New York Press*. Taking advantage of the flurry of press coverage associated with the show opening, the Academy announced yet another building plan. No one paid any attention. Coverage of the Academy show vanished from the papers after a few days.

Incidentally, the Academy didn't get a new building until 1942 when it moved into a mansion on Fifth Avenue donated by the millionaire Archer M. Huntington. It continues to operate there to this day, offering classes, holding exhibitions, and electing prominent artists as Academicians. The Academy remains part of the American art scene, but after 1913 it ceased to wield power. It would never again dominate the lives of artists or determine the taste of the American public.

Kuhn intended to create an alternative to the Academy. He ended up accomplishing far more—he and his fellow artists permanently broke the Academy's nearly ninety-year hold on American art. No more would the exclusive institution tell artists what "art" is or was supposed to be. Kuhn and Arthur B. Davies had adopted the Revolutionary War symbol of the pine tree flag to signify their fight against artistic oppression. In the spirit of their eighteenth-century forebears, the Armory Show artists sent their enemies scurrying and entered a new era of artistic freedom.

However, this victory was one of few for Armory Show organizers in the two years after the show. The period was marked by frustrations, disappointments, and defections. Life had been thrilling on the front lines of the avant-garde during the show—every decision seemed a matter of life or death, or at least critical to the future of art in America.

As the show ended and matters returned to normal, the major fighters Kuhn, Davies, and Walter Pach naturally felt let down; the three men were more than a little disappointed that all their hard work seemed to have limited results. What they didn't realize—what they couldn't

realize—was that they had entered a new normal, one that no one yet understood or appreciated. A few results of the show had been immediate and spectacular—Cubist fashion! Futurist headlines! A nationwide surge in poetry-writing on *Nude Descending a Staircase*!—but these faded away as the show dwindled from memory.

What no one knew at the time was that the long-lasting effects of the show were making their way slowly but steadily through the culture. Changes were bubbling up under the soil in the bedrock. The show transformed the art world over time, like those deep plumes of magma that rise beneath the earth for eons before erupting with the force to split continents.

———

The week after the Chicago show closed, Pach returned to New York, but he spent only a few nights in town before heading to Boston for the third and final venue of the International Exhibition of Modern Art.

The Copley Society in Boston, the nation's oldest art association, had contacted the AAPS in January requesting the exhibition, and plans had been finalized for an exhibit that would run April 28 through May 19. Exhibiting with the society had one obvious downside—Copley Hall was relatively tiny. While the New York Armory comfortably held 1,200 to 1,300 works and Chicago's Art Institute 634, Boston could take only 244. To abridge the show, Davies limited the exhibit to the most radical art, the work of European Post-Impressionists and modernists. American artists were eliminated altogether—another insult to AAPS members already complaining that the organization favored European art.[2] Robert Henri and his circle added this latest slight to a long list of grievances and waited for an opportunity to strike back.

After the sour mood of Chicago, where the staff of the Art Institute didn't bother to disguise their animosity, the newspapers were nasty, and the Vice Commission sent investigators, Pach felt relieved to be in Boston; the Copley Society welcomed him and Kuhn with open arms. "Oh what a difference from Chicago. I feel absolutely at home here compared to that awful town," Kuhn wrote Vera.[3] Pach could feel reasonably confident no one in Boston would try to burn him in effigy.

As usual, Kuhn was convinced that overwhelming success was right around the corner: "On the whole I think Boston will go wild over the show."[4] This time he had good reason for his confidence. The press seemed

as friendly as the Copley staff. The resulting coverage was predictable and, compared to Chicago, mild—the *Boston Herald* contributed some jokes about insanity, a few attacks on Henri Matisse, and another bad poem on the show's whipping boy, *Nude Descending a Staircase*.[5]

However, after a flurry of articles on opening day, a silence blanketed Boston. The press flat out ignored the exhibit. A brief buzz of excitement followed an accident in the galleries when a woman stumbled into Raymond Duchamp-Villon's bust *Baudelaire* and knocked it to the ground, breaking it into several pieces—"Cubist Bust Did Just That" proclaimed one headline.[6] Puns aside, newspapers had nothing to say about the show. After the impassioned and puzzled response in New York and the angry and indignant one in Chicago, the show was ending its tour of America with a whimper. The Boston press seemed to consider the entire exhibit in poor taste and avoided it with the sort of disdain they might have given a display of circus freaks. The hope seemed to have been that if they ignored it, perhaps it would go away.

Boston residents were as unenthusiastic as Boston newspapers. Attendance was nothing to sneeze at—about 13,400 over three weeks—but it declined over time instead of picking up over the course of the show, as it had in New York and Chicago. Sales of the artwork were also slow. The only enthusiastic buyer was Bostonian Walter Arensberg, who had visited the show in New York and returned several times to Copley Hall. He began inviting Pach back to his house in Cambridge for dinner and long discussions about modernism; no doubt Pach told him stories about all of his friends back in Paris—Marcel Duchamp, Pablo Picasso, the Steins—and Arensberg hung on every word. He would eventually acquire one of the most remarkable modernist collections in the United States, but in Boston, Arensberg's purchases were limited since the works he most wanted to buy—the paintings of Duchamp—had already sold.[7]

The flat reception of the show baffled Pach. After weeks at the center of attention, he didn't understand why the public gaze had turned away. He could only conclude Bostonians wanted to distance themselves from the show's unsavory reputation. Pach had been bewildered when a friend who held a prominent position in a Boston museum avoided him for the course of the show. Pach finally tracked him down the last week of the event, and the man sheepishly confessed that he didn't want to be seen anywhere near the exhibition.[8] Pach laughed it off and played the incident for laughs with friends, but underneath the laughter he seems to have

been hurt and perplexed. In New York, the Armory had been the place to be seen by the cream of society. In Boston, it was like a burlesque theater, where the last thing Bostonians wanted was to be recognized by someone they knew.

Pach also suspected Boston's conservative art culture contributed to the show's failure. Boston prided itself on its intellectual tradition; its heroes were ministers and scholars, not artists. The city didn't share Chicago's knee-jerk moralism, but it turned up its nose at New York bohemia. Boston society had a reputation at the time for being well-mannered and restrained—characteristics at odds with exuberantly adventurous modernism. Considering the audience and the radical nature of the art Davies had selected, it's no wonder the show came and went. It didn't even interest the public enough to get them upset.

More important than the mood of Boston, however, was the feeling surrounding the show. The novelty had worn off. All the jokes had been made, all the snarky cartoons drawn, all the bad poems written. The public and the press had quite simply moved on—as they do at the end of any fad. In the words of an American artist not yet born, but whose career was influenced by the work displayed there, the Armory Show's fifteen minutes of fame were up.

However, though flashy front-page news coverage dried up, and trendy hostesses had probably stopped serving Cubist food at their Cubist parties, reverberations from the show had only begun to make their way through American culture. It seemed like nothing happened in Boston, but what really happened was that the show went underground. No one could have realized it at the time—Pach's disappointment was understandable. He had no way of knowing the Armory Show's real impact would take decades to realize.

———

After the Boston show closed, Kuhn and Davies set to work wrapping up the business of the exhibit. For weeks, they slogged through a massive to-do list, terminating leases, cancelling phone service, shipping sculptures, and disposing of 40,000 unsold postcards. They started settling accounts with the Customs Office, a tedious job that took Elmer MacRae not weeks but *years*. Closing the books turned into a nightmare after a conflict sprang up between the AAPS and the Copley Society on contract

terms; negotiations failed to resolve the dispute and the case went to arbitration. The matter wasn't settled for more than a year.

By early summer, Davies and Kuhn decided against organizing a show for 1914. The artists were eager to get back to their life's work. They were also thoroughly fed up with one another. In an ill-spirited letter to Vera over the summer, Kuhn reported Davies was complaining he had "grown tired of too much <u>Pach.</u>"[9] Like actors at the close of a show, they were sick of one another and needed to spend some serious time in the company of anyone but one another. To rest and recuperate, Kuhn and MacRae left town for long vacations, Kuhn on the Maine coast and MacRae in Connecticut. Time apart gave them perspective, and by autumn they were again comrades-in-arms ready to take on the world.

Even when everyone returned to New York City in the fall, Davies hesitated to hold an AAPS meeting. On the surface, this is mystifying. The organization had pulled off the most successful art exhibition in U.S. history. They had generated hundreds of news stories, attracted thousands of visitors, and sold dozens of works of art. Americans from Atlanta to Honolulu had been introduced to modern art. "Cubism" and "Futurism" had become part of everyday conversation.

Yet Davies knew the same thing that had made the Armory Show such a big deal had also fractured it permanently. The show's success offended AAPS members who felt they had been betrayed by the association. An article in the *New York Press* described "a marked division of opinion among members" and identified a split between "the controlling element in the management"—i.e., Davies, Kuhn, and their circle—and "the Henri crowd."[10] Henri's anger over the European focus of the show hadn't faded. Kuhn and Davies knew trouble was brewing. After all he'd been through putting the show together and fending off critics, Kuhn seemed to be itching for another fight. "I am sure that a certain crowd is going to scrap for its very life," Kuhn wrote Vera. "I am looking forward to the scrap with pleasure—it will be lots of fun."[11]

However, the far less confrontational Davies dreaded the impending clash. He hated scenes and avoided conflicts; after all, this was the man who hid an entire second family under a false name rather than face divorce and public censure. It's not surprising Davies dodged a showdown for as long as he could. In fact, it's not surprising he lost interest in the AAPS altogether. Friends had been amazed when Davies transformed from secretive introvert to ruthless dictator of the association; after two years wielding

power, he wanted nothing more than to abdicate. Managing the everyday business of the association had none of the thrill and challenge of leading the crusade to bring modernism to America. It was small potatoes, a step backwards, and not worth the effort of leaving the studio.

Organizing an entirely new exhibit was far more interesting, particularly since it didn't involve Henri. Davies, Kuhn, and Pach spent the fall creating an unofficial follow-up to the Armory Show of progressive American artists. The exhibition ran from December 1913 to May 1914 in cities including Detroit, Cincinnati, and Baltimore. On the first anniversary of the Armory Show, it opened in New York at the Montross Gallery, a former bastion of conservative art that was eager to hop on the modernism bandwagon.

The men promoted the exhibit as displaying recent work from the best American artists of the Armory Show—a slap in the face to American artists *not* invited to participate.[12] Davies, Kuhn, and Pach assembled work from allies including Manierre Dawson, Maurice Prendergast, and MacRae and again deliberately ignored Henri and his circle. The Montross show seemed a continuation of the campaign to make Henri irrelevant. "How curious that a once-eminent figure like Robert Henri could so quickly lose his standing among his peers and authority," John Sloan marveled to his wife.[13]

But Henri wouldn't go quietly into oblivion and had no intention of losing his authority. He would have to be dragged kicking and screaming from his position of influence.

———

On May 18, 1914, almost a year to the day the Armory Show closed in Boston, Davies finally convened a full membership meeting of the Association of American Painters and Sculptors. As much as he would've liked to delay the showdown with Henri's group, he couldn't put it off any longer.

Both sides arrived armed for battle. Strategy sessions had been held at studios around the city as the Henri circle and the Davies circle planned attacks and prepared contingencies. While the meeting was conducted in scrupulous civility according to Robert's Rules of Order, anger bubbled just below the surface. The rules would hold tension at bay for only so long.

First the association held officer elections. The Henri crowd tried to elect Jerome Myers as president and get Henri a seat on the board of

directors, but they failed to land enough votes. Davies resigned from the presidency, but ally Prendergast got the job. Every leadership position and all but one seat on the board were held by the Davies circle. They proved they had the votes to do whatever they wanted—essentially steamrolling Henri's crowd—and decidedly won the first round.

Then MacRae presented a financial report—still preliminary, because the contract dispute with the Copley Society in Boston hadn't been resolved. It showed an income of $87,000 and expenses of $84,000. Thwarted and angry, the Henri circle fumed that the show, for all the attention surrounding it, hadn't generated a greater profit. Apart from the Boston mess, the books seemed incomplete, expenses seemed high, and no accounting had been made of most of the money Davies brought in from his anonymous donors.

The Henri group saw an opening and attacked. They seized on the financial statement as a weapon that would allow them to deal the AAPS a possibly fatal blow. The books provided an ideal excuse, although a thin one. The AAPS seems to have been run honestly, if not always well. The fact that the association ended up in contract disputes with *both* the Art Institute of Chicago and the Copley Society points to a lack of business acumen, but of course these men weren't accountants or attorneys—just artists in over their heads. In any case, the financial statement gave the opposition a ready excuse, and Henri's crowd took advantage of it.

One by one the Henri circle resigned. In grand gestures of protest, eight members walked out of the room that night, each leaving behind a signed letter of resignation written on the spot. Exactly how the session broke down is unclear—accounts of that night are sparse and contradictory, and most memoirs of the Armory Show don't mention it at all. Even Kuhn, the self-professed scrapper, seems to have found the memory so unpleasant he chose not to relive it.

Many bitter insults led to the final battle: Davies' dictatorial decision making; the flood of European art and the attention lavished upon it; the sidelining of Henri; the creation of a jury to select American paintings despite the express banning of juries in the AAPS constitution; even the Montross show in the spring of 1914 from which Davies had shut out Henri and his disciples.

Henri's circle didn't seem to care that the AAPS had just held the most significant art exhibit in American history. They were unable to appreciate the big picture—that advancing progressive art would help

American artists in the long term, even if European art stole some thunder (and sales) in the short term. The AAPS had indeed won with the Armory Show, but in Henri's eyes it had scored a victory for European modernism, not for himself, his colleagues, or his country. None of the achievements of the show lessened Henri's belief American artists were the losers. Henri seemed to believe that American art could turn back the clock to the mid-nineteenth century when Europe seemed far away and American artists could happily ignore it. Henri was futilely trying to slam a barn door after the horses had broken out and were already running free.

————

Local papers reported the breakup and its aftermath, and during the next few weeks, several ran accounts of the AAPS split. The *New York Press* published an article from an unknown source in the Henri camp that attacked the "self-perpetuating Board of Directors" and asked "why, after nearly eighteen months, it was not possible for the treasurer to make a report on the finances of the association."[14] Davies issued a bitter reply:

> *From the moment that the International Exhibition was a success[,]*
> *a minority, which had taken only a passive part in the preparation*
> *of that show, displayed discontent, and, strange to say, those members*
> *seemed most bitter who ought to have been most grateful because of*
> *the success they had in disposing of their own wares on that occasion.*
> *Undoubtedly there is a fear in certain quarters that if there were a*
> *change in the taste of the public our local art producers would suffer.*
> *Hence a natural resentment toward what makes their own work look*
> *old-fashioned and out of date.*[15]

Davies' statement prompted a nasty counterattack from Guy Pène du Bois, an artist and critic who had resigned along with Henri. Du Bois sent a furious letter to the editor of the *Tribune* in which he raged about being excluded from the Montross show and sniped at members "who became post-impressionists overnight, when the time was right." Du Bois seemed to have been most offended by the charge that the Henri circle only cared about making money. He wrote with withering sarcasm, "That cannot be true, for it is a well known fact that painters can live without money. Mr. Davies himself, I am sure, has not the slightest interest in

selling his own pictures."[16] Ill-feeling would linger between the opposing sides for years—in du Bois' memoir, written twenty-six years later, he is *still* angry at Davies and Kuhn.[17]

After the dramatic resignations, the AAPS effectively ceased to exist. There simply weren't enough members with enough enthusiasm to keep it going. It's not clear when the group made the decision to dissolve (no one bothered with minutes or records), but it must have been soon after the May 1914 meeting. The board held occasional sessions during the next two years to resolve lingering financial matters, and the organization officially was finished in 1916 when the last account was settled with the Customs Office. Davies and his peers had wanted to kill the Academy with the AAPS; they got what they wanted, but it came at the cost of their own organization.

Henri had succeeded in exacting his revenge. In his very first letter about starting an artists' association, Kuhn had worried about controlling Henri. He had been right to—keeping Henri at bay had proven impossible. He was intent on bringing Kuhn and Davies down. And he had taken the AAPS down with them.

———

Though Henri had been a significant factor in the AAPS's end, there were other forces at work. For one, Davies and Kuhn wouldn't have let the AAPS die if they had still needed it. Kuhn had wanted to create an association that could grow "as big or bigger than the Academy" because he assumed that only an Academy-like institution could provide the promotion and exhibit opportunities he sought. The Armory Show not only ended the reign of the Academy but also demonstrated all such organizations were *unnecessary*. In the post-Armory art world, artists could hold their own exhibitions without the backing of large associations—Kuhn, Davies, and Pach did just that with their 1914 Montross show. They could get press coverage and find buyers without the help of either the Academy or the AAPS. The Armory Show demonstrated to artists their own power.

The show also created a new market for modern art in America, even if the AAPS itself didn't rake in profits. Patrons such as John Quinn and Arthur Jerome Eddy had been buying progressive art for years, but now figures such as Arensberg joined them and significantly increased the money spent on modern and progressive art. Excited about the new

market, dealers opened new galleries dedicated to modernism, and existing conservative galleries welcomed modern art for the first time.[18]

Pach, with his invaluable connections in Paris, became the European representative for several of these dealers, and most of his time was dedicated to organizing exhibits.[19] Existing modern art galleries were also flooded with visitors. The only person who didn't appreciate the crowds was Alfred Stieglitz, who was annoyed by the number of ill-informed curiosity-seekers at 291. (One of Stieglitz's mind-numbing lectures on modernism was usually enough to keep them from coming back.) Nevertheless, Stieglitz too built on interest generated by the Armory Show with exhibits by Francis Picabia, Constantin Brancusi, and Picasso.[20]

With all the new galleries and shows, artists had unprecedented opportunities to display their work. Between 1913 and 1919, thirty-four New York galleries, organizations, and private clubs sponsored some 250 exhibitions of modern art.[21] It was an amazing transformation from only a few years earlier when progressive artists had to fight for a chance just to show their work.

Exhibition opportunities also expanded outside of New York. The first post–Armory Show exhibit to promote modern art outside the city was sponsored by, of all places, a department store. Gimbel Brothers featured work by Duchamp, Jean Metzinger, Albert Gleizes, and others in a show that toured Milwaukee, Cleveland, Pittsburgh, New York, and Philadelphia in the summer of 1913. Shoppers could study cutting-edge art while buying petticoats, children's shoes, and housewares.

The Gimbels show was a surprising endorsement by a family department store, especially considering only a few months earlier the same art had been subject to a state Vice Commission investigation. After all the brouhaha over indecency, it turned out more Americans found modern art intriguing than indelicate. When the show arrived at the Gimbels in New York in late July, a critic at the *Globe* noted, "Now that the new art movement has found its way to a department store, there ought to be no further doubt of its establishment as part of our American daily life, and its ultimate acceptance must be considered only as a matter of time."[22]

Gimbels hoped to capitalize on the notoriety of the Armory Show, but it was apparently not a profitable exercise, since it wasn't repeated. The market for hats and shirtwaists didn't overlap with that for Cubist canvases. However, arts organizations, galleries, and museums around the

country were eager to bring modern art to their cities, and Pach successfully organized traveling exhibits to many of the institutions that had requested the Armory Show.

———

For all its impact on collectors and dealers, "the essential effect of the big show was, of course, on the work of artists," wrote Pach.[23]

Every artist who participated in the Armory Show—or saw it, or even heard about it—had to respond to the new art in some way. Some resolutely ignored it, which, of course, was a response in itself. Artists such as Henri and Myers stubbornly clung to the same approaches as ever. Older artists such as Maurice Prendergast, who had established their mature styles years earlier, didn't change. For many younger artists, on the other hand, the art at the Armory revolutionized their artistic outlook. European art opened new possibilities unimaginable in the staid American arts academies where they had been taught. Artists went shooting off in all directions like so many fizzing rockets.

Because they had the greatest contact with the new work, Kuhn, Davies, and Pach were among those most affected. Kuhn's paintings became harder-edged and less fuzzily Impressionistic. Pach was inspired by both Cubism and Futurism; in a painting from 1916, *The Cathedral*, St. Patrick's Cathedral and the buildings surrounding it become simple block shapes that soar into a vivid blue sky. Davies took some of the biggest artistic leaps; he still painted female nudes, but instead of strolling through dreamy forests they now danced across black backgrounds, their bodies painted in slices of vivid color. It was as if the art of Picasso and Duchamp had dropped the three men in a new land and they had no choice but to explore its mysterious landscape.

American artists likely expected many more opportunities to find inspiration in European art. Perhaps they even hoped to convince French and German artists that Americans had something to contribute to the modern movement. What they didn't realize—what no one could have possibly realized—was that the coming storm of the Great War would threaten modernism in both France and the United States and have long-lasting implications for the legacy of the Armory Show. In larger terms, Europe was about to enter a period so dark, so bloody, and so traumatic that it would transform the continent entirely.

CHAPTER 9

Conflicts Both Real and Imagined

*You mean to say if an artist put horse manure on a canvas and sent it
to the exhibition, we would have to accept it?*
—GEORGE BELLOWS, AMERICAN PAINTER

May 29, 1913
Paris, France

A buzz was in the air as guests began filing into their seats at the Théâtre
des Champs-Elysées. A sense of palpable anticipation and sounds of
animated conversation rose from the crowd. Premiere night at the ballet
was always thrilling—something new! And this premiere was especially
exhilarating: a new production from the Ballets Russe with music by Rus-
sian composer Igor Stravinsky and choreography by the company's star,
Vaslav Nijinsky. The title of the new work was *Le Sacre du Printemps*—
The Rite of Spring. Everyone looked forward to a delightful evening at
the ballet.

They had no idea what was about to hit them.[1]

The lights dimmed and the crowd settled back in their seats. The
music started out promisingly enough. A melancholy melody with some
unusual chords began the piece, but everyone knew Stravinsky was a
modern composer and no one was expecting Mozart.

Then about three and a half minutes in, the violins started a strange
pulsing beat with harmonies so dissonant people winced. The rhythms were
hard to pin down, and completely unpredictable. And the dancers—what
on earth were they *doing*? Flat-footed jumps and knock-kneed poses—this
was definitely not classical ballet. In fact, it seemed the polar opposite.

The hissing started first. Then the booing. Defenders tried to argue, first in urgent whispers, then with shouts. People jumped to their feet. The yelling grew so loud the musicians couldn't hear one another and the dancers couldn't hear the beat. The conductor tried desperately to keep the orchestra together, and Nijinsky stood on a chair in the wings shouting the beat to the dancers. The manager of the ballet company, Russian impresario Serge Diaghilev, tried flicking the house lights on and off and appealed for calm during the break between movements, but the hysteria only rose. Fistfights broke out; elderly Frenchwomen whacked one another on the head with their umbrellas.

Modern art had caused turmoil before in Europe, but this was the first time it had sparked an actual riot. It was awful and magnificent all at once. For days afterwards, it was all anyone talked about. Of course, *everyone* had been at the ballet—who was going to admit they missed the scandal of the season? If everyone who claimed to be at the premiere of *The Rite of Spring* actually had been in the theater, guests would have been packed in two or three to a chair.

No one bothered with rational objections to the ballet at the time—all they knew was how bizarre it all was. But later criticism focused on the strange, discordant harmonies and irregular, unpredictable beat, elements as essential to modern music as bright colors and strange shapes were to modern art.

The style of dance also came under attack; Nijinsky had invented movements that substituted awkward force for the restrained elegance of classical ballet. Rather than leaping effortlessly through the air as if defying gravity, the dancers seemed bound to the earth.[2] Their convulsive, painful-looking movements led many in the crowd to shout for a doctor; others added calls for a dentist, assuming the line of Young Maidens, who entered with their heads tilted sharply to one side against their hands, were suffering toothaches. In any case, the combination of the two was just too overwhelming, too shocking even for Paris. Chaos erupted at the Théâtre des Champs-Elysées.[3]

Paris had existed for years in a state of permanent artistic revolution; *The Rite of Spring* premiere was the newest and most dramatic example of this exhilarating way of life. Dance, music, art—all were subject to these delicious convulsions. It was an existence only possible at the center of the artistic universe; there seemed to be no reason that it would ever end.

———

With so much excitement in their own city, no one in Paris paid much attention to the news of the Armory Show making waves across the Atlantic. French newspapers refused to waste ink on the reactions of Americans to modern art. *Yankees? Upset over Cubism? How passé. Have the Americans only just now discovered Picasso? Bah!*

While the Armory Show was still going on, Walter Pach wrote his friends the Duchamp brothers about the enormous response to their work and the unexpected fame of *Nude Descending a Staircase*. Both Jacques Villon and Raymond Duchamp-Villon wrote back immediately thanking him.[4] Marcel Duchamp, on the other hand, didn't bother to reply to Pach until early July—one wonders if his brothers had been nagging him for his rudeness. In a typically blasé letter, he said only, "I am very happy; and I thank you for the dedication with which you have defended our painting."[5]

Duchamp could have mustered more enthusiasm considering Pach had sold every one of Duchamp's canvases and the show had made him a sensation—the most famous French artist in America. Duchamp just didn't seem interested. In fact, he had almost given up painting altogether. During the long, quiet hours at the library he took notes on the possibility of a purely intellectual art, art that would exist in the mind rather than on canvas or in clay.

Meanwhile, Pablo Picasso and Georges Braque were gluing scraps of newsprint, wallpaper, and cardboard to their Cubist canvases in a new collage technique. The Puteaux Group argued about how to unseat the Futurists. The Steins hosted their salons, although Leo no longer participated. Leo never got over his dislike of Cubism, and eventually his animus spilled over to the entire art scene. He and Gertrude divided their collection, and Leo moved to Italy in the fall of 1913, where he told a friend he intended to "wait for cubism and futurism and the other inanities that grow from the confused brains of clever young persons, to die valid and natural deaths."[6] The salons continued without him. It seemed that Paris would go on indefinitely in this pleasant vein.

If only.

———

Everyone knew war was coming, but the possibility of conflict had loomed so long that when it actually began in July it took everyone by surprise. The

cause seemed minor: the assassination of Archduke Franz Ferdinand, heir of the throne of Austria-Hungary, by a Serbian nationalist angry about Austro-Hungarian control of Serbian provinces. However, once Austria-Hungary declared war on Serbia, a complex chain of alliances prompted nation after nation to enter the conflict until most of Europe was at war. In August 1914, German troops thundered across Belgium into northern France and were barely stopped by combined French and British forces. The troops dug in, and soon a line of muddy trenches ran from the Alps to the English Channel, bristling with machine guns and mortars.

Every aspect of French life was thrown into chaos. Food and fuel shortages made everyday existence a struggle, and the threat of zeppelin attacks left nerves frayed. The glittering cultural scene that had once seemed an essential element of Parisian life vanished overnight. Cultural institutions such as the Théâtre des Champs-Elysées closed their doors, and no one missed them—all that mattered was getting enough food to eat, enough coal to keep warm, and enough good news from the front to keep spirits from sinking utterly.

The art world wasn't immune from turmoil. Paintings and people found themselves on the wrong side of the lines. Sally and Michael Stein had loaned the heart of their Henri Matisse collection, nineteen paintings, to a gallery in Berlin; the work was seized by the German government and never returned.[7] Henry Kahnweiler, a German citizen who represented Picasso and Braque in his Paris gallery, was on vacation in the Bavarian Alps when the war broke out. He took refuge in neutral Switzerland, and the French government confiscated his entire stock.

Artists responded to the war as their patriotism and consciences dictated. Braque and Fernand Léger enlisted immediately. Villon became an army cartographer and Duchamp-Villon a field doctor. Matisse tried to join up but was turned down because he was too old at age forty-five. Other artists were less enthusiastic. Spain stayed out of the war, allowing the Spanish citizen Picasso to stay out of it as well.[8] According to gossip, Robert Delaunay convinced a doctor to diagnose him with a heart problem so he wouldn't have to fight.[9] Duchamp was also exempted on the basis of a heart murmur, an ailment some biographers have questioned since it never seemed to bother him otherwise.[10] Francis Picabia pulled strings to get a plumb position as a driver for a general.[11]

Although, of course, nothing compared to life in the trenches, life in Paris over the next few years was grim. If you were lucky enough to avoid

the fight, you then had your own citizens to face. Resentment surged against young men not in uniform. Women sometimes handed them white feathers, symbols of cowardice, on the street. For an apparently healthy man like Duchamp, the atmosphere became stifling. Duchamp took a disinterested, almost callous attitude, saying, "I admire the attitude of combating invasion with folded arms."[12] Naturally, this offended many people, especially his sisters-in-law, who were deeply concerned about his brothers.

Into this heated atmosphere in Europe arrived Pach, on a mission to secure art for an exhibit in New York. Pach had begun organizing the show before the war started, and he was determined to carry it through, even though he risked his life sailing to France while German U-boats prowled the Atlantic.[13] Pach spent hours talking to Duchamp about the Armory Show and the sensation caused by *Nude Descending a Staircase*. New York hadn't interested Duchamp two years earlier, but now America sounded delightfully welcoming. In America, there was no war—the country was resolutely neutral, with popular opinion firmly convinced it was in the best interest of the United States to avoid intervention. This hands-off attitude appealed to Duchamp. He resigned his job at the library and in June 1915 booked his passage for New York.

———

Newspapers trumpeted that the "Nude-Descending-a-Staircase-Man" had arrived in the city as Pach met Duchamp at the dockside. Pach introduced the French artist to Walter Arensberg, who with his wife had recently moved from Boston to New York. Arensberg had been fascinated by Duchamp's art at the Armory Show and disappointed he hadn't been able to buy the *Nude*. Now he paid Duchamp's rent in exchange for a promise that Duchamp would hand over his current work in progress, *The Large Glass*, whenever it was finished.[14] This seemed unlikely to be any time soon, since Duchamp would go months without working on the project, but Arensberg was prepared to wait.

Duchamp became a regular at the Arensbergs' salons along with numerous artists from the Stieglitz circle as well as poets William Carlos Williams and Wallace Stevens. It's no surprise that Pach, who continued to be friends with absolutely everyone, was also a regular. The Arensbergs' apartment had replaced Mabel Dodge's as the most fascinating place to hang out in New York, although Duchamp spent more time playing chess

with his host than joining in the wide-ranging philosophical and aesthetic discussions.

Duchamp was not alone in seeing America, free from war and all its implications, as a smart option. During the next few months, other artists drifted from Paris to New York. Cubist Albert Gleizes was discharged after a brief stint in the army; he and his wife then moved to Manhattan.[15] Picabia, whose blithely unmilitary behavior had annoyed the general he was supposed to be chauffeuring—concepts such as "promptness" seemed to elude him—wrangled a diplomatic appointment to Cuba to negotiate the sale of sugar to France. He set sail for the island in May 1915, but when his ship stopped in New York partway through the journey, Picabia abandoned his mission. Had the French government been able to get their hands on him, he would no doubt have been court-martialed.[16]

Gleizes, Duchamp, and Picabia formed the nucleus of a French artistic circle that dazzled Americans. The *New York Tribune* ran a full-page article including photographs of several artists under the headline "French Artists Spur on an American Art." The Frenchmen gave their opinions on the state of American art, with Picabia asserting "the spirit of America seems subtly, yet powerfully, akin to the spirit of artistic creation" and Gleizes stating, "I think that the time is surely approaching when American students will not need to go outside their native land to acquire even technique."[17]

Duchamp made little progress on *The Large Glass* (also known as *The Bride Stripped Bare by Her Bachelors, Even*, a title that provides less help in interpreting it than *Nude Descending a Staircase* does its canvas). In fact, Duchamp spent more time playing chess than he did making art, and what art he did make didn't fit any recognized category. One day in the winter of 1915, Duchamp wandered into a hardware store on Broadway. He noticed a snow shovel and, on impulse, bought it. Back in his apartment he painted the words "In Advance of the Broken Arm" on the shovel's handle and then added his name and the date. *Voila*. Duchamp had created a new work of art.

Duchamp's friends were mystified, but he liked the idea of presenting the shovel as a work of art that wasn't *actually* a work of art. He didn't want audiences to consider the shovel as a visual object by studying its shape, nor did he want people to derive some meaning from the title. Duchamp told his sister, "Don't tear your hair out trying to understand this in the Romantic or Impressionist or Cubist sense—it has nothing to do with all that."[18] What mattered was the perverse, illogical *idea* of a shovel as artwork.

Over the next months, Duchamp picked other random objects—a comb, a coat rack, a plastic typewriter cover—and declared them art as well. He called them "readymades," always using the English phrase, even when writing or speaking in French.[19] One day he even signed the Woolworth Building, making the entire skyscraper a giant readymade. His most famous readymade, however, was unveiled in 1917, at a show of the newly formed Society of Independent Artists (SIA).

The SIA came to life when several artists, including Duchamp and Pach, decided to create a new art association to succeed the AAPS. Walt Kuhn and Arthur B. Davies no longer needed such an organization, but other artists believed New York would benefit from a group to host exhibits open to young artists. In contrast to the AAPS, which limited its membership, the SIA had a radically open structure—any artist who paid the annual fee could exhibit. Its motto proclaimed, "No jury. No prizes. Works hung in alphabetical order." Every effort was made to level the playing field. If the quality of the art was uneven, that was the price for giving everyone a fair shot.

Duchamp served as one of the SIA directors and was elected president of the Hanging Committee. He also submitted one of his own works, but not under his own name. A few days before the opening, a delivery truck pulled up at the exhibit hall and the driver carried in a completed application form signed "R. Mutt" of Philadelphia, the six-dollar annual fee, and a white porcelain urinal. According to the paperwork, the "sculpture" was titled *Fountain*.

As planned, Arensberg, the SIA's managing director, conveniently walked in a few minutes later, and an argument broke out over the scandalous object.

Artist George Bellows shouted at Arensberg, "But we cannot show it! It is indecent!"

Arensberg shouted back, "Only in the eye of the beholder!"

Bellows fumed, "You mean to say if an artist put horse manure on a canvas and sent it to the exhibition, we would have to accept it?"

"I fear we would,"[20] Arensberg replied with a smile.

Nevertheless, a hastily convened group of directors voted *not* to exhibit *Fountain* on grounds of indecency. Duchamp, still not revealing he had submitted the urinal, immediately resigned, charging that the "no jury" principle had been violated. Arensberg also resigned but still showed

up on opening night. He demanded to see the R. Mutt sculpture and, after some searching, found it hidden behind a curtain. He paid for it on the spot and then, to the discomfiture of the SIA organizers, carried the plumbing fixture under his arm for the rest of the show.[21]

Duchamp defended *Fountain* a few months later in an art journal: "Whether Mr. Mutt with his own hands made the fountain or not has no importance. He CHOSE it. He took an ordinary article of life, placed it so that its useful significance disappeared under the new title and point of view—he created a new thought for that object." The emphasis should be on the word "thought"—Duchamp wanted to create new *thoughts*. Some critics and art historians down the years have focused on the appearance of *Fountain*—the curving lines, the gleaming white of the porcelain, etc.—but for Duchamp, appearance was beside the point. It didn't matter what the work *looked like*. What mattered were the contradictory *ideas* generated by it as a formal work of art.

Overall, it's best not to take Duchamp's work too seriously. *Fountain* and the other readymades were to some extent *blagues*—jokes, tricks. The whole setup—the delivery truck, the submission form from the imaginary artist, the timely arrival of Arensberg—was part of an extended prank targeting the well-meaning artists of the SIA. Duchamp was also testing society members. They had proposed a standard—"No juries"—and Duchamp wanted to find out if they meant it.

However, the readymades had a serious purpose as part of Duchamp's quest to invent new, nonvisual forms of art. If a snow shovel and a urinal could be art, then the definition of art must be much broader than traditionally assumed. In fact, Duchamp described his readymades as "a form of denying the possibility of defining art."[22]

The definition of art had moved a long way from 1900. Picasso had said art didn't have to be beautiful and didn't have to follow the rules laid down in the Renaissance. Manierre Dawson and Wassily Kandinsky said art didn't have to have a subject. Now Duchamp said it could be anything you wanted it to be. What made one urinal a piece of plumbing and another urinal a work of art was the intention of the artist. Art was whatever the artist said it was.

This was an astounding assertion. Critics would spend the rest of the century debating whether or not it was true, while artists explored the possibilities.

In April 1917, faced with the possibility of the collapse of France and Great Britain and appalled by unrestricted submarine warfare by Germany, the United States entered World War I. French artists who had found shelter in the United States had to leave the country or face the draft. The U.S. military took a dim view of Duchamp's supposed heart condition; he would have been drafted in 1918 had he not sailed for Buenos Aires, where he spent his time doing little but playing chess. Picabia eventually completed his sugar-buying mission, but spent the last year of the war in Barcelona out of the reach of the French military.[23]

The infusion of American troops, combined with the collapse of the German government and advances in military technology, brought the war to a bitter end in late 1918. The Armistice, effective 11:00 a.m. on November 11, came too late for 1.1 million British, 1.4 million French, 2 million German, and up to 2.25 million Russian soldiers. Among the dead were Italian Futurist Umberto Boccioni and German Expressionist Franz Marc. Braque suffered a serious head wound that resulted in temporary blindness; he required several years to recuperate. Duchamp's brother Duchamp-Villon died in 1918 of complications from typhoid fever contracted at the front.

As soldiers demobilized, life tried its best to return to normalcy—and artists returned to their studios. The war transformed European art drastically: a clear fracture line divided pre- and postwar. After the horror and savagery of the trenches, the old arguments seemed irrelevant. Two distinct strains of art evolved in response to the war. In one, artists abandoned radical movements in favor of neoclassical harmony. In what was known as the "return to order," artists such as Picasso, Braque, and Léger painted traditional themes in traditional styles. Picasso, for example, created a series of mothers with children that resembled Renaissance Madonnas.

Other artists declared that order was impossible: War had made no sense, the world after the war was equally meaningless, and art should reflect this. Art should be nonsensical too. In the movement known as Dada (itself a meaningless word meant to connote meaninglessness), artists and poets threw logic out the window in favor of dark humor, absurd jokes, and cryptic pronouncements. Dadaist "anti-art" events included performances in Zurich in which artists played invisible violins, banged

on huge drums, dressed in costumes made of cardboard, and recited "poetry" composed on the spot by pulling words cut from magazines out of a sack. Dada humor only thinly disguised artists' rage at the suffering of the last four years and a violent desire to tear down the institutions, systems, and culture that had allowed such misery.

Duchamp was never part of any of the Dadaist groups—like Groucho Marx, he was the sort of person who never joined a club that would have him as a member—but he nevertheless created a Dada icon. After his first brief visit home after the war, he bought a postcard of Leonardo da Vinci's *Mona Lisa*. With a pencil, he scribbled a mustache and goatee on the famous face and then added the letters "L.H.O.O.Q." to the bottom. In French, the letters sound like the phrase *"Elle a chaud au cul,"* meaning, "She has a hot ass." The *Mona Lisa* was considered the greatest masterpiece of the Western artistic tradition; mocking it was almost *lèse-majesté*, like sticking out your tongue at the queen. Duchamp had been thinking in terms of readymades with the postcard, but it perfectly captured the attitude of Dada toward established art and culture—humor masking hostility.

Dada was too anarchic to last as a movement, and by the mid-1920s it had been succeeded by Surrealism, which combined the humor of Dada with a passionate interest in exploring the subconscious, an endeavor that gave the movement a purpose beyond sheer rebellion. Artists tried to paint the illogical scenes of their dreams; Salvador Dalí became the leader of the movement with his hyper-detailed yet impossible depictions of melting clocks. A few American artists converted to Dada and Surrealism, but on the whole the dark irreverence of these movements had little appeal on a continent that had escaped the ravages of the war.

Instead, American artists turned inward. They began to seriously examine the implications of European modernism on American art. The Armory Show had been over for nearly a decade, but the battle for its legacy—one that would carry through into the next century—had just begun.

CHAPTER 10

Winning the War

Fate has willed it that America is from now on to be at the center of Western civilization rather than on the periphery.
—WALTER LIPPMANN, AMERICAN WRITER AND INTELLECTUAL

January 1944
New York City

Jackson Pollock was exhausted. Six months earlier, the thirty-two-year-old artist had been handed an incredible opportunity: his first solo show at dealer Peggy Guggenheim's gallery, plus a commission to paint an oversize canvas for the hallway of her apartment. Guggenheim was a mercurial, easily offended kingmaker who could start or end careers on a whim. Artists would give anything for such a chance.

Pollock worked nonstop, finishing ten new paintings in four months. They were all completed in his current style—dark and violent with vaguely discernible figures, some beastlike, some menacingly human. The show opened in early November to favorable reviews—critics praised Pollock's raw energy. One reviewer called him "an authentic discovery" characterized by "basic force and vigor." The same critic wrote that "Mr. Pollock's style, which is a curious mixture of the abstract and the symbolic, is almost wholly individual."[1] It seemed an auspicious start to the next phase of his career.

Once the show closed late in the month, Pollock couldn't rest. In January, Guggenheim expected the delivery of her mural. The twenty-foot-long canvas had been hanging in Pollock's studio for months, and the scale of it terrified the artist. Weeks went by. Every day Pollock entered the studio, and every day he exited, silent and morose. Guggenheim didn't

tolerate delays, excuses, or the fleeting nature of the artistic imagination. The pressure was unrelenting.

The day before the canvas was due, Pollock walked into his studio just as he had done every day since early December. He started painting, at first tentatively, then picking up a rhythm. He covered the canvas with huge, sweeping strokes. All night long, Pollock worked, pouring out his soul in color and finishing the huge painting in one epic session. It looked as if he just might have saved his career.

He also broke into his mature style of work. *Mural* isn't a drip painting, like the later works that made Pollock famous in which he dribbled, slung, and sloshed paint, but it points to these paintings with its overall abstract pattern. *Mural* consists of a series of thick vertical lines that seem to march along the canvas against swirls of yellow, rose, and turquoise. The abstract work evokes figures from Native American rock art—simplified stick men marching forward against a maelstrom of color.

The next morning, Pollock shepherded the canvas to Guggenheim's in the back of a delivery truck. He was giddy with exhaustion and elation—until he unrolled the huge canvas and made a horrifying discovery: *It was too long.* Pollock had miscalculated. Close to panic, Pollock called Guggenheim at her gallery and begged for help. Guggenheim told him to figure it out himself—she was busy working. He hung up but called back minutes later, nearly hysterical. After several more calls, Guggenheim contacted some friends and asked them to go help Pollock. One of people she asked was Marcel Duchamp, who advised Guggenheim on her art purchases.

The fifty-six-year-old Duchamp had recently moved back to New York from Paris, once again fleeing a world war. He hadn't painted in years. His passion—if the emotionally remote Duchamp could be said to have one—was chess. Instead of painting, he spent his time memorizing moves, playing in tournaments, and writing articles on the game. He was good, too, reaching the rank of master and taking tenth place in the French chess championship in 1924. About his only involvement in art was as an organizer of modern and Surrealist exhibitions and as a consultant to Guggenheim.

Duchamp surveyed the situation with his usual detached air and made a seemingly obvious suggestion—so obvious, in fact, the rattled Pollock seems to have been unable to see it: Cut eight inches off one end. Desperate, Pollock agreed to slice up the work.

A few hours later, Duchamp stepped back to view the result of his labors. The newly shorn canvas had been stretched, mounted, and hung in the lobby—an instant masterpiece.

Its maker, however, had disappeared. Everyone knew that Pollock had a drinking problem, including Pollock. He had kept the alcohol under control while he prepared for the show, but the strain of installing *Mural* demolished his resolve. He went up to Guggenheim's apartment and hunted down her stash of liquor, which she had hidden in anticipation of his visit. By the time the painting was on the wall, Pollock was plastered. Guggenheim's roommate Jean Connolly was hosting a party that evening in their apartment. As guests stood chatting, Pollock staggered into the living room, careened over to the mantel, unzipped his trousers, and urinated into the fireplace.[2]

He'd had an incredibly long day.

———

The encounter between Duchamp and Pollock seems slight and accidental, but from another perspective it represented the passing of the torch from the old New York art world to the new New York art world. Presumably anyone could have helped Pollock, but Duchamp got the job. Only Duchamp had the authority to convince Pollock to trim his painting; Guggenheim would have trusted only someone of his stature to come to her rescue in a crisis. The same Duchamp had been part of so much of what had come before and would influence so much of what came after. Now he would help, in a small way, with the triumphant rise of the next generation of artists and the elevation of New York from artistic backwater to capital of the world of art and culture.

Pollock was still an infant in Tingley, Iowa, when Walt Kuhn and Arthur B. Davies held the Armory Show and *Nude Descending a Staircase* made headlines. When Pollock arrived in New York in 1930 as an impressionable teenager, he was entering an art world shaped by the Armory Show. Art instruction had shaken free of academic constraints, and the galleries, museums, dealers, and collectors who crowded the city had a post-Armory enthusiasm for adventurous art. The old battle between academic versus progressive art was over, and a clear victor had been crowned. Art students now argued about what form modern art should take.

Pollock also had a direct, personal connection to the Armory Show through his instructor at the Art Students League, Thomas Hart Benton. Benton had been a young, aspiring artist in New York in 1913, and he would prove to be Pollock's most significant influence—though Benton ultimately influenced him in the *opposite* direction.

The sharply divergent careers of the two men not only illustrate the history of American art from the Armory Show to the middle of the twentieth century but also the challenges faced by artists trying to develop an American art for the twentieth century. To understand how Pollock inherited the legacy of the Armory Show, one must take a step back to Benton.

———

Benton liked to present himself as Ozark backwoodsman from Neosho, Missouri, but this was deceptive. While he had been born in Missouri, as the son of a U.S. Congressman he actually grew up in Washington, D.C. He showed early talent for drawing and moved to Paris to study in 1909. He loved the exotic, intellectual atmosphere and experimented with Cubist-inspired painting. He would have stayed in Paris indefinitely if his mother hadn't arrived unannounced in France and discovered he was living in sin with his girlfriend. The appalled Mrs. Benton packed up her wayward son and returned him to Missouri at once.[3]

After promising to keep away from loose women, Benton convinced his family to let him continue his art career in New York and moved to the city in June 1912. Benton actually missed the Armory Show—he spent the spring of 1913 in Missouri because his mother was ill—but he followed the headlines, learned the details from his friends, and immersed himself in the immediate post-Armory hubbub. Benton found radical art thrilling and experimented with the Synchromist style, a movement invented by a group of American artists. Synchromists painted brightly colored abstract works using rainbows of colors that they compared to chords of music.

Benton's career was interrupted in 1917, like many young men's, by World War I. He enlisted in the Navy and ended up helping paint camouflage designs on ships. He returned to New York after the war and again took up his brushes.

———

Two major schools of artists battled for the soul of American art in the 1920s: the modernists and the realists. To draw the lines simply, it was those who accepted the Armory Show against those who rejected it. Benton held an unusual position in this dispute, since he fought on one side before turning traitor. He not only "fought" for the other side but also hurled vicious propaganda for them.

One circle of artists tried to put an American spin on the innovations of the Armory Show and invent an American form of modernism. Many in this group surrounded the familiar figure of Alfred Stieglitz, but Stieglitz had changed his tune since 1913. Once an ardent Francophile who brought the work of European artists to America, Stieglitz became an Americanist in the 1920s. He still promoted modern and abstract art, but the name he bestowed on his gallery, An American Place, indicated where his loyalties lay.

His rejection of European art was rooted not in aesthetics but rather passion: it dates from his involvement with a young American artist named Georgia O'Keeffe. Stieglitz first saw O'Keeffe's art in 1916, when a friend brought some of her abstract drawings into his gallery. Stieglitz was fascinated by their bold simplicity. His fascination soon spilled onto the thirty-year-old O'Keeffe, who was then teaching art in the Texas Panhandle. Stieglitz convinced O'Keeffe to move to New York in 1918 and spent the next few months photographing her in the nude—much to the displeasure of Stieglitz's wife, who rightly suspected that more than just photography was going on. When his divorce was finalized in 1924, O'Keeffe and Stieglitz got married.

Stieglitz also represented O'Keeffe as her dealer, and he lost interest in European art in favor of what he considered her uniquely American style. Stieglitz declared O'Keeffe's art represented "America without that damned French flavor!" He said, "No one respects France more than I do. But when the world is to be France I strenuously hate the idea."[4] Why loyalty to O'Keeffe required Stieglitz to reject European art is a mystery of the heart and out of the purview of an art historian. In any case, from the early 1920s on, Stieglitz concentrated on promoting the work of O'Keeffe and a handful of other American painters.

Other artists also turned away from European art in an effort to create a uniquely American form of modernism. Walter Pach, for example,

asserted that art should spring out of America's cities, bridges, locomotives, and automobiles—out of "American life itself."[5] By 1920, Pach had quit experimenting with Cubism and returned to a naturalistic style, and he focused on painting scenes of American cities. Walt Kuhn went through a period creating works on the theme of the West; some are highly Impressionistic, while others resemble Paleolithic cave paintings. He titled the series *An Imaginary History of the West*, pointing to its fantastic nature—the paintings don't depict the *real* western United States but the pretend West of adventure novels and Buffalo Bill shows. It was a curious and experimental phase but, nonetheless, unquestionably American.

Many artists in the younger generation—Benton's generation—also tried to craft an American modernism. In the early 1920s, Benton's paintings consisted of blocky Cézanne-esque shapes with strong outlines and bright colors. Even natural scenes such as landscapes and profiles are simplified almost to abstraction. They're nothing to get excited about—and critics, in fact, didn't—but they're competent examples of modern art.

Many artists and critics considered this effort to Americanize modernism a thrilling step forward, one that would allow American art to take its rightful place on the world stage. The United States had proved its military might in World War I. Now the United States could prove its artistic worth as well. One critic declared that while before "we had been sponging on Europe for direction" now we could take the best of Europe and combine it with the best of America to create our own modern culture.[6]

———

A competing circle of American artists took the opposing position. Instead of adapting modernism, they rejected it outright. They considered the Armory Show a disaster for American art, muddying the waters with imported *-isms* that had no place on U.S. soil.

These painters gladly inherited the artistic legacy of Robert Henri. Henri had always promoted American realism, and his battle with Davies was fueled by his anger at the European emphasis of the Armory Show. Henri was growing too old for the fight, but his students took up the quarrel on his behalf.

Edward Hopper, a staunch ally of Henri's, became one of the most vocal supporters of American realism, advising fellow artists to throw off European influence:

If an apprenticeship to a master has been necessary, I think we have served it. Any further relation of such a character can only mean humiliation to us. After all we are not French and never can be and any attempt to be so is to deny our inheritance and to try to impose upon ourselves a character that can be nothing but a veneer upon the surface.[7]

Rejecting French art wasn't easy for Hopper. He made three extended trips to Paris as a young man and by all accounts loved his time there. He was particularly proud of his skill at mastering the language, a challenge many an American college student has failed to meet. His stays in France coincided with some of the most exciting moments in modernism, including the rise of Fauvism and Cubism, but Hopper ignored these cutting-edge movements for the work of the Impressionists. He adopted the bright, light colors of Claude Monet and Auguste Renoir as well as their subjects, but when he returned to New York, no one wanted to buy his sunny paintings of French life.

Hopper's success came only when he abandoned depictions of elegant Frenchwomen at chic cafes for more somber paintings—ones of tired American office girls staring into coffee cups at all-night diners. He found his artistic voice by painting the ordinary American scenes everyone had seen but no one had noticed—lonely lighthouses on hillsides, office workers staying late, the lights of shop windows spilling onto city streets. In 1923, ten years after his first sale at the Armory Show, Hopper had the breakthrough he had been waiting for with a string of highly successful exhibits. His opinions had weight, and other artists followed him in rejecting modernism in favor of American realism.

Benton also threw off French influence, but he did it more violently than Hopper. When Benton's father died in 1924, the artist was moved by the loss of the older generation and inspired to better understand the experiences of men like his father who had fought in the Civil War. Exploring his father's past awakened a desire to learn about the American present, particularly the lives of people who lived far from the centers of power and culture. Benton took multiple cross-country trips in the mid- and late-1920s, crossing the countryside carrying only a sketchbook and a change of clothes. He journeyed from the Deep South to the Southwest, the Gulf Coast to the Midwest, meeting farmers, sharecroppers, stevedores, and truck drivers.

His encounters with real people made Benton look at his art in a new way. Abstract art seemed meaningless on the red dirt roads of Georgia or in the hollows of Tennessee. He came to believe the business of American art should be ordinary Americans. He immediately put his new philosophy into practice. In his *America Today* murals of 1930–1931, he depicted a cross section of Americans, including loggers, tractor drivers, factory workers, and dance hall girls. His style is more stylized than the realism of Henri or Hopper—Benton combines figures in complex, swirling compositions that have an exaggerated, theatrical quality.[8] For all his insistence on depicting the "real" America, his art is actually highly stylized and artificial; it's as though he didn't trust "realness" to be enough on its own and had to add the kick of drama. Benton always seemed to be straining to make his point, not quite trusting the audience to get his message without heavy underlining.

Benton did nothing halfway, and when he changed his style, he reinvented himself. It wasn't enough to adopt realism—he had to become "an enemy of modernism" who despised all things European as "sissified." He grew a bushy mustache, wore plaid shirts instead of suits, and became known as the most foul-mouthed, creative cusser in New York, one who could make union organizers and dock workers blush. He was also virulently homophobic, and his diatribes against modernism usually descended into attacks on the manliness of his opponents—New York artists, he said in a typical slur, were "the gentle feminine type with predilections for the curving wrist and outthrust hip."[9]

———

Benton considered himself engaged in a desperate struggle to save America from the contaminating effects of French culture, and he attacked the Armory Show as the starting point of the contagion. Benton claimed to be in revolt "against the unhappy effects which the Armory Show of 1913 had had on American painting."[10] As usual with Benton, his anger toward modernism in general and the Armory Show in particular seems over the top—his protesting gets to be too much.

While his position was extreme, Benton's attitude was fairly common in the 1930s. Many Americans expressed hostility toward France. As the Great Depression sent the U.S. economy reeling, the country turned inward. Americans had no energy to spare for the rest of the world. Many believed

that abandoning our traditional neutrality by fighting in World War I had somehow gotten us into this mess, and only by relying on American virtues of self-sufficiency and independence could we pull ourselves out of it.

A savvy gallery owner took advantage of the national mood with an exhibition in 1933 of artists who spoke to Americans' desire for singularly "American" art. Dealer Maynard Walker held a show in Kansas City of three artists—Benton, Grant Wood, and John Steuart Curry—and described their work as a new school that he called "Regionalism." In a statement in *Art Digest*, Walker declared, "One of the most significant things in the art world today is the increasing importance of real American art. I mean art which really springs from American soil and seeks to interpret American life."[11]

Benton, Wood, and Curry weren't a school in the traditional sense since they didn't develop their work together or inspire one another's art—Benton didn't even meet the other two men until after the show. However, they were all Midwesterners—Benton from Missouri, Wood from Iowa, and Curry from Kansas—and they all focused on traditionally American themes. Curry painted tornadoes sweeping down on Kansas farms and baptisms held in barnyards, while Wood depicted idyllic rural landscapes and scenes of planting and harvest. Wood is best known for the iconic painting *American Gothic*, his 1930 canvas of a grim-faced man and woman standing before a white clapboard house with a shiny-tipped pitchfork, which has been reprinted and repurposed ad infinitum and satirized as much as any single painting of the twentieth century.

The idea of the Regionalist school caught the attention of the public, and in December 1934 *Time* ran a story about the "movement" that featured a self-portrait of Benton on the cover. The article proclaimed that for years "many a good U.S. artist was content to borrow from France, [and] turn out tricky, intellectual canvases which usually irritated or mystified the public. Today most top-notch U.S. artists get their inspiration from their native land."[12] As well as calling Benton "the most virile of U.S. painters" (he must have been thrilled), the article praised *American Gothic* for taking a stand against "artistic dependence upon Europe."

Regionalism dominated American art in the 1930s. Benton, Wood, and Curry became minor celebrities—strangers recognized Benton in hotel lobbies and asked for his autograph in nightclubs. The movement had echoes in the literature of the period, too. Authors such as Robert Frost, Erskine Caldwell, John Steinbeck, and William Faulkner wrote

fiction and poetry rooted in the everyday experiences of rural life. Both of these styles appealed to Depression-era Americans, who related to their portrayals of ordinary lives and celebrations of hard work and community. In a time of confusion and upheaval, the intelligibility of Regionalist art and literature was a source of comfort; it put things in context and created a feeling of community during a troubled time. Even *Little House on the Prairie* and the other *Little House* books by Laura Ingalls Wilder, published in the 1930s and early 1940s, reflect a desire for American experiences on American soil.

People were also drawn to the everyman approach of the Regionalist painters and the idea of hardworking Midwesterners who treated art like manual labor. Wood played up this idea by painting in denim overalls and converting an old freight car to a studio.[13] Northeasterners had reached an all-time low in national opinion—most people placed the blame for starting the Great Depression squarely on Wall Street. Modernism seemed a product of intellectual New York bohemians who had never worked a day in their lives.

Modernist artists didn't know what had hit them. "We *hated* it," said abstract artist George McNeil of Regionalism. It was "backward and *dumb*, just plain dumb."[14] Pach was deeply disturbed by Regionalism's implied nationalistic politics, which he considered only a step away from the socialist art promoted in Stalinist Russia—the ghastly scenes of resolute revolutionaries and smiling collective farmers that glorified the Soviet Union.[15]

However, with the popular mood in favor of the movement, modernists could do little to defend their art. It seemed the enemies of the Armory Show had won and the groundbreaking art from Europe would slip back across the Atlantic and be forgotten.

———

Pach and Kuhn must have wondered if it had all been for nothing. On the twenty-fifth anniversary of the show, several of the original participants wrote down their memories, and their impressions of the past couldn't help but be shadowed by the present. In a pamphlet he titled *The Story of the Armory Show*, Kuhn asked, "How did we benefit, if at all?" He could only think of one positive result: the influence of the show on fashion, consumer merchandise, and graphic design. That was it. While it's lovely

that the Armory Show allowed Americans to enjoy colorful bathing suits and beach umbrellas—items Kuhn specifically mentioned—such a meager payoff hardly seems worth the trouble.[16] Back in 1913, Kuhn thought they had been changing the world. *Hadn't they destroyed the Academy? Brought Matisse and Picasso to American shores?* But twenty-five years later, it seemed all they had accomplished was to liven up the design of gas pumps at service stations.

The show's enemies also rewrote history and reinterpreted its legacy. Jerome Myers' memoir, published in 1940, echoes with bitterness about the Armory Show:

> *Here the cubist was in his glory, there the abstractionist was on the line. The great French moderns revealed themselves in all their pristine glory; and while the American artists were finally shown, in this swirling medley of art on parade, they had to take it on the chin. People became freak-conscious, the normal art taste was bewildered. Faith lost its balance. Art values shivered; some went down to zero, others leaped skyward. The visitors' attention was raped by sculpture strange and gigantic, by pictures measured in yards.[17]*

Myers was a longtime Henri ally who had been part of the mass resignations that ended the AAPS, and he held resentments that were at this point nearly thirty years old. Anger leaps from the page—the idea that visitors' attention was "raped" is shocking. However, Myers' statements don't make sense in the context of 1913. Modern artists didn't start making their paintings and sculptures oversize until well after the show, and prices for modern art didn't rise until the 1920s. His rhetoric is more a product of the era in which he wrote it than of the events he describes. The present was changing understanding of the past.

———

Pollock was in a unique position to witness Regionalism's meteoric rise. He studied under Benton at the Art Students League, but their relationship was closer than that of student and teacher. Benton served as Pollock's mentor, advisor, and counselor—he was the father Pollock had never had (Pollock's real father disappeared early from his life). Pollock ate dinner at Benton's house at least once a week, stayed with the family on summer vacations, and provided regular babysitting for the Bentons'

baby son.[18] No one else, not even Pollock's brothers, allowed the volatile artist anywhere near their kids—they were terrified of the consequences if he started drinking around a child. The babysitting jobs prove both Benton's trust in the young artist and Pollock's determination to keep his behavior in check around his hero.

Pollock also defended Benton at the Art Students League. Students at the league were disgusted by his attacks on modernism, and in the lunchroom Benton had earned the nickname "that son-of-a-bitch." However, students learned to hold their tongues when Pollock was around.[19] He had a bad habit of replying to insults with his fists.

Pollock tried his best to paint in Benton's style. Early canvases such as Pollock's *Going West* of 1934 reflect Benton's interests more than Pollock's. The painting depicts a covered wagon pulled by a team of horses through a hilly Western landscape. It borrows Benton's swirling compositional style, but the colors are muddy, the figures unclear, and the whole work is a mess. Pollock tried to make this mode of painting his own but failed again and again. He lacked Benton's dramatic touch and, frankly, Benton's technical ability. Pollock's art was most successful when he was direct and confrontational and failed when he tried to get too complicated.

Then Benton walked out of Pollock's life. In 1935, Benton landed a job teaching at the Kansas City Art Institute in Kansas City, Missouri. The offer came in the nick of time—Benton was on the verge of getting fired by the Art Students League. He was also finding it hard to maintain his image as a rough-edged Midwesterner after spending a quarter of a century in New York. Of course, Benton couldn't just move away quietly—that wouldn't have been exciting enough. First he had to cause an uproar by declaring the arts in New York were under the control of homosexuals and Communists.[20] It was Benton's way of rejecting New York rather than admitting New York had rejected him, with the added advantage that he could portray himself as a hero for his willingness to speak truth to power. Most people breathed a sigh of relief once he was gone.

But without Benton, Pollock was bereft. He fell into deep depression, drank constantly, and talked about suicide. Pollock's situation was worsened by the Great Depression. He spent the 1930s in desperate poverty, picking up work with government programs whenever he could, although sometimes they amounted to scraping bird droppings off public monuments for sixty-five cents an hour.[21] He eventually joined the Works

Progress Administration's Federal Art Project, which employed out-of-work artists, but he was always one step from penury.

The state of mental health care in the 1930s also contributed to Pollock's suffering. Friends and family tried to get help for the deeply troubled man, but the doctors didn't do much good. In fact, some of Pollock's therapies seem ridiculously, almost criminally, beside the point. In 1939, Pollock started seeing a Jungian psychotherapist who focused exclusively on Pollock's dreams and deliberately avoided discussion of his drinking, which, incredibly, the therapist considered Pollock's problem alone and not an important subject for their sessions.[22] The therapist believed if Pollock addressed the root issues in the depths of his unconscious mind, his alcoholism would take care of itself. Only the therapist was surprised when this inventive strategy failed to work.

Though the psychotherapist didn't even attempt to alleviate Pollock's alcohol problems, he did in fact help the young man's painting. Pollock brought his canvases to his sessions, and he and his doctor spent hours talking about their meaning. During the next few months, Pollock created works inspired by Jungian notions of "primordial images" rooted in the collective unconscious, the reservoir of symbols psychiatrist Carl Jung believed were shared by all people. Pollock's paintings brimmed with eyes, masks, stars, knives, and serpents.

It was in this fragile and impressionable state that Pollock came upon one of the most significant paintings of the twentieth century—a painting that allowed him to sever his artistic allegiance to Benton and make a decisive break toward modernism: Pablo Picasso's *Guernica*.

————

Picasso never stopped evolving as an artist. By the late 1930s, he had developed a style characterized by swirling black lines and bright colors. He created a cast of figures that he repeated in canvas after canvas, including a bull, a horse, and a woman with her head thrown back in despair. The figures didn't have fixed meanings but became a flexible pictorial language for Picasso.

Guernica was the culmination of this style and an impassioned response to a devastating tragedy. On April 26, 1937, at the height of the Spanish Civil War, German and Italian planes bombed the city of Guernica in Northern Spain at the request of Spanish Nationalist forces. Some

1,600 people died as waves of incendiary bombs fell on the city. While Guernica was known as a haven for the Republican resistance movement, the town had no military significance and most of those killed were civilians. Around the world people were shocked by the unprovoked attack and horrified by the level of destruction. Guernica revealed the new reality that modern technology could deal out death on an industrial scale. Tragically, within a few years the technology of slaughter would kill millions more in World War II.

Picasso began painting within days of the tragedy, and the result of his efforts is a massive canvas, more than eleven feet tall and twenty-five feet long. Picasso's familiar figures appear as victims of a terrifying disaster. The bull looms menacingly. The crying woman holds the body of a dead child in her arms. The horse screams in terror or pain. Under an unblinking eye with a bare lightbulb as its pupil, a soldier lies in pieces like a shattered statue, his sword blade hacked off near the hilt. Although a flower grows beside the broken sword, the painting offers little hope, only raw anguish.

Picasso created many remarkable paintings in his long career. The most innovative were undoubtedly those of his youth, when he lived in squalor in Montmartre and enjoyed dinner with the Steins because it was a square meal in a heated house. But he continued to grow throughout his career, and all those years of striving and experimenting came together in this canvas. Picasso employed all his skill, all his mastery to expose the cost of war in a single, shattering canvas.

———

Pollock saw *Guernica* in 1939 at a Picasso retrospective at the Museum of Modern Art (MoMA). MoMA was one of the bastions of modernism in New York through the dark days of the Regionalist period. In fact, the museum is one of the most important legacies of the Armory Show, founded in late 1929 by show sponsors Lizzie Bliss and Abby Aldrich Rockefeller. Along with their friend Mary Quinn Sullivan, the women realized the need for the museum after the death of John Quinn (no relation of Sullivan) in 1924. Quinn's unsurpassed collection of 2,500 paintings and sculptures was dispersed around the world because no museum would accept or even appreciate the gift.[23] MoMA soon became the most famous and influential modern art museum in the world.

MoMA displayed *Guernica* from November 1939 to January 1940. Pollock filled sketchbooks with images from the canvas and adapted its figures—the bull, the horse, the woman—in his own work. Pollock found inspiration in these images, and they allowed him to move beyond Benton's realism into a more abstract style. Over time, he transformed Picasso's symbols into figures from his own imagination. By 1940, Pollock had rejected Benton's realism as totally as Benton had rejected modernism. One of Pollock's brothers noted in a letter, "After years of trying to work along lines completely unsympathetic to his nature, he has finally dropped the Benton nonsense and is coming out with an honest and creative art."[24]

A painting in this symbolic style caught the attention of Guggenheim. A member of the wealthy, art-collecting Guggenheim family (her uncle Solomon founded the Guggenheim Museum), she owned The Art of This Century Gallery and held annual competitions for young American artists. Pollock submitted a painting to the contest in April 1943. Guggenheim relied on her circle of artist friends to advise her, and on the jury that spring was Piet Mondrian, the Dutch painter famous for his paintings of blocks of color divided by black lines. Mondrian arrived at the studio on jury day and immediately was drawn to Pollock's painting. Guggenheim wandered by.

"Pretty awful, isn't it?" Guggenheim said and walked on.

Twenty minutes later she came back and found Mondrian still looking at the painting. "There is absolutely no discipline at all," she said to the Dutchman. "That young man has serious problems, and painting is one of them."

Mondrian hesitated and finally spoke: "Peggy," he said, "I don't know. I have a feeling that this may be the most exciting painting that I have seen in a long, long time."[25]

Mondrian's endorsement didn't entirely convince Guggenheim. She called on another friend for advice—Duchamp. He agreed to visit Pollock's studio and pass judgment on his work. Pollock worked himself into a fever of anxiety over the inspection—his future rested on Duchamp's opinion. Duchamp arrived on the designated day and observed Pollock's art with polite disinterest, then departed, leaving behind a terrified Pollock. Duchamp reported back to Guggenheim with a shrug of the shoulders and a laconic *"pas mal"*—not bad—that Guggenheim was free to interpret any way she pleased. Fortunately for Pollock, she decided that from the Frenchman, *"pas mal"* was a rave review. Guggenheim agreed

to host Pollock's solo show and commissioned the painting for her lobby, the lobby where the two men would meet again over a canvas that wouldn't fit.

————

Guggenheim's interest in Pollock mirrored a wider cultural move toward modernism by the early 1940s. The art world had turned away from Regionalism since the start of the war. The mood of the country changed with the surprise bombing of Pearl Harbor, and isolationist art seemed as dated as isolationist policies. In fact, the American nationalism that had fueled the movement now, ironically, had unpleasant echoes of German nationalism. One art historian published a scathing indictment of Regionalism that claimed the movement was nourished by "the same ills that, in more virulent form, produced National Socialism in Germany."[26]

Few defenders of the movement remained. Of the three most prominent members of the so-called school, only Benton survived—Wood died in 1942 of pancreatic cancer and Curry in 1946 of a heart attack. Furthermore, Benton alienated many former supporters by embroiling himself in a ridiculous controversy with the Kansas City art establishment over the management of the Nelson-Atkins Museum of Art; he publicly attacked museum staff as "pretty boys" and "ballet dancers." The Kansas City Art Institute decided Benton had crossed a line and refused to renew his contract. Benton continued to work in increasing isolation. Once a minor celebrity, he was now largely forgotten. Benton stayed in touch with Pollock, despite the fact his former student had a habit of calling him collect and drunk, sobbing into the phone that he would never succeed as a painter. To Benton's credit, he tolerated these calls with remarkable patience and always tried to encourage Pollock.

Pollock was a terrible judge of his own progress. Benton's career had descended into obscurity, but Pollock's was about to launch off into the stratosphere.

————

Pollock's art evolved rapidly during and immediately after the war. After *Mural*, his canvases became entirely abstract. Then he made the leap to

the style that made him famous: drip painting. Pollock had moved to rural Long Island with his wife, artist Lee Krasner. He liked to place his canvases flat on the floor of the old barn he used as a studio. At first he applied paint with brushes, sticks, and trowels, but then he started dribbling and splashing paint directly on the surface. Pollock developed enormous control and refinement of his technique. He wasn't just splattering paint wildly—he poured each line exactly where he wanted it.

Pollock didn't invent drip painting—many artists dripped or poured paint, including Francis Picabia.[27] Pollock's innovation was to master the technique, use it exclusively, and employ it to create complex, dynamic paintings. A canvas such as *Lucifer* of 1947 resembles images of neurons in the brain or stars in a galaxy, and like these natural forms it only appears random at first glance; rhythms and patterns gradually emerge out of the tangle of black and green paint.

Pollock's public breakthrough came in 1949 when *LIFE* magazine ran a story that featured a photo of the artist leaning against one his canvases, arms crossed against his chest. He is dressed in paint-splattered denim with a cigarette dangling from the corner of his mouth. He looks tough, confrontational—Stanley Kowalski with a paintbrush. The headline reads, "Jackson Pollock: Is he the greatest living painter in the United States?" The tone throughout the short article is satirical but open to the possibility that Pollock is on to something big:

> *[Some] believe that Jackson Pollock produces nothing more than interesting, if inexplicable decorations. Still others condemn his pictures as degenerate and find them as unpalatable as yesterday's macaroni. Even so, Pollock, at the age of 37, has burst forth as the shining new phenomenon of American art.*[28]

This sullen, smoking painter—artist Willem de Kooning said he "looks like some guy at a service station pumping gas"—was a real American. He had never been to France, never studied at an *atelier* (whatever that was); he painted in a big old barn in cowboy boots and denim, and he produced huge, confident, confrontational paintings. People didn't understand abstract art, but they were willing to accept it was a genuine innovation. They also accepted that it was *American*. No one could accuse Pollock of falling under the spell of France. He would likely slug them if they tried.

———

The magazine article marked Pollock's arrival at the pinnacle of the New York art scene. Just below him in terms of fame and fortune were a handful of colleagues known as Abstract Expressionists. The artists in this loose circle shared an interest in conveying strong emotion in their art. Their canvases are typically huge and totally abstract.

The Abstract Expressionists represented the next stage in the evolution of Western art. Picasso and Georges Braque had made the first steps in freeing painting from representation when they realized they could ignore the rules of art laid down in the Renaissance. At the same time, early abstract artists such as Wassily Kandinsky and Manierre Dawson did away with a subject altogether, and the Expressionists used bright colors and visceral images to represent powerful emotions.

The Abstract Expressionists combined these ways of thinking and came up with a new answer to the question "What is art?" Art is paint on canvas that conveys emotional intensity. The movement doesn't pretend paint or canvas are anything but themselves, and by accepting and understanding these elements, artists could find new ways of using them to express themselves. Pollock's understanding of the properties of paint, for example, allowed him fine control over the poured line or blooming splatter.

Along with Pollock, the Abstract Expressionists de Kooning, Krasner, Franz Kline, Robert Motherwell, Arshile Gorky, Mark Rothko, and Barnett Newman were recognized around the world as the next great thing—the successors to the European modernists Picasso, Henri Matisse, and Salvador Dalí. In 1950, when the movement was represented by Pollock, de Kooning, and Gorky at the Venice Biennale, the world's most important international exhibition, an Italian critic wrote, "Jackson Pollock is the modern painter who sits at the extreme apex of the most advanced and unprejudiced avant-garde of modern art." He continued, "Compared to Pollock, Picasso, poor Pablo Picasso . . . becomes a quiet conformist, a painter of the past."[29]

Considering the effect that the Spaniard's *Guernica* had on a young Pollock—on an entire generation of painters—there could be no greater praise.

———

With Pollock, everything came together. As an artist, he combined the rough-hewn individuality of the Regionalists with the abstract techniques of the modernists. Pollock absorbed the influence of Benton *and* Picasso and came out on the other side with an artistic style that owed nothing to either.

Everything came together in New York as well. In the late 1940s, the U.S. economy was booming; with basic needs taken care of, Americans indulged in luxuries including art. Between 1940 and 1946 the number of private galleries in Manhattan more than tripled. Sales at many galleries also doubled and tripled—*every year.* Europe, however, was still in shock after the war. Rubble covered most cities, and rationing limited the purchase of essential goods. The United States had emerged victorious militarily and economically in the war—now it would dominate culture. Writer and intellectual Walter Lippmann announced the dawn of the "American century" in 1946. "Fate has willed it that America is from now on to be at the center of Western civilization rather than on the periphery," he wrote.[30]

The capital of the art world had shifted across the water: from Paris to New York. No single moment marked the transformation—no alarm sounded, no bells rang, but it's as if an enormous magnet suddenly slid across the Atlantic and settled under Manhattan. In 1913 young artists who wanted to be in the thick of things went to Paris; in 1953, they went to New York. All the anxieties of the Armory Show years, the sense of insecurity and provincialism, the nagging feeling that New York lagged behind the rest of the world, vanished. In their place rose the confidence, even arrogance, of being at the top of the world.

———

A curious thing happened once American art conquered the world: Its "Americanness" no longer mattered. The long-contentious argument about what made art American just ... went away. When Pollock was asked in the early 1950s, "Do you think there can be a purely American art?" he replied, "The idea of an isolated American painting, so popular in this country during the 'thirties, seems absurd to me, just as the idea of creating a purely American mathematics or physics would seem absurd."[31]

The only people who still cared about art's Americanness were cultural critics. In the Cold War, American art represented American culture

and was contrasted with the art produced in Soviet bloc countries. Critics praised the individual freedom and autonomy inherent in Abstract Expressionism—wasn't this what we were fighting for? Abstract art became a weapon in the war against totalitarianism, and programs organized by the State Department and the Smithsonian Institution exhibited modern art around the world to promote American values.

According to some historians, the Central Intelligence Agency even got involved, covertly funding art exhibits in cooperation with MoMA—and proving art and politics make strange bedfellows.[32] Of course, not all GIs agreed that they had stormed the beaches of Normandy and Iwo Jima under withering fire so some kids could throw around paint and call it great art. The CIA kept its funding secret not so much to hide the program from the Russians but rather to conceal it from the American public. One of the State Department's early art programs had backfired when lawmakers got a glimpse of the paintings intended to promote truth, justice, and the American way. President Truman summed up politicians' reaction to American modernism by declaring, "If that's art, then I'm a Hottentot."[33]

However, artists largely ignored both the government programs and their claims of the superiority of American art. Postwar New York was a cosmopolitan city, and its artists came from around the world. Pollock had been born in Wyoming, but de Kooning was Dutch, Gorky Armenian, and Rothko Latvian. This international perspective widened horizons for American artists and freed them to draw inspiration from global sources. They weren't interested in creating an American form of art—such an idea would have seemed limiting. They just wanted to create art.

This attitude would have made sense to the French Academicians or the Impressionists or the Cubists. None of the artists working in Paris in the 1800s or early 1900s thought of themselves as creating French art. They just made art. Ultimately, the effort to define American art was an expression of insecurity. Once New York reached the top spot, it could ignore nationality as blithely as the French had ignored it all along.

———

Pollock only enjoyed his moment in the sun for a few years. Fame became an intolerable burden, and the artist fell into a dark spiral of alcoholism. His behavior eventually grew so intolerable, unpredictable, and violent

that he drove away all of his friends and his long-suffering wife, Lee Krasner. On August 11, 1956, the intoxicated Pollock crashed his Oldsmobile into a tree near his Long Island home, killing himself and a passenger, a young woman named Edith Metzger. A third passenger, Pollock's mistress Ruth Kligman, was thrown free and survived.

Benton was devastated by the news of Pollock's death. For all the vicious attacks he had hurled at modernists throughout the years, he remained loyal to Pollock and never publicly criticized his art. Benton sobbed uncontrollably when he learned the news and refused to attend the funeral, saying he "couldn't take it."[34]

In the hard-hearted economics of art, Pollock's death increased demand for his work. Abstract Expressionism remained the leading art movement through the 1950s, and even when attention shifted to new movements, New York continued to reign in the art world. Europe emerged from the aftermath of the war, but Paris could no longer claim supremacy. The change was real and permanent.

———

During Pollock's brief period of success, he was asked why he didn't go to France to study art. Pollock replied, "It's here. It's not in Paris. It used to be with Benton but now it's with me."[35]

Pollock didn't define "it," but he didn't have to. "It" had been the lure that had drawn Picasso, Braque, Duchamp, and all of the other ambitious artists to Paris in the early 1900s. "It" was the sense of greatness in the air that infused New York in the 1940s and 1950s. "It" had been what the Armory Show organizers wanted to create.

Abstract Expressionism's success was the final success of the Armory Show. The years after the show had been a battle between the realists and modernists, those who accepted the art of the show and those who rejected it. After what had looked like defeat during the Regionalist years, those who accepted the show ultimately pulled off a come-from-behind win.

After all those years, what Pach and Kuhn and Davies had worked for had finally come to fruition. They wanted to rouse New York from artistic stagnation. They wanted to create new opportunities for young artists, new galleries to show their work, and new collectors to buy it. They wanted to destroy old institutions that held back artists and create a new environment where anything was possible.

They pulled it off. It took forty years to take full effect, but they did it. The immediate achievement of the show was remarkable—the amazing array of art, the huge crowds, the headlines, the poems, the fashions. But the ultimate success was grander and longer-lasting and would outlive them all: a city of artistic freedom in a country of unmatched opportunity.

Many people contributed to the transformation. Stieglitz—grouchy, snobbish Stieglitz—brought European modernism to America long before the show and provided support for years to come to modern American artists. The collectors—Quinn, Arthur Jerome Eddy, Walter Arensberg, and all of Davies' rich old ladies—provided essential financial support. Even Henri, anti-European to the last, proved in the years before the show that artists could operate independently of the Academy.

The organizers of the show deserve the greatest credit for their courage and ambition. The little band of underdogs changed the world. Pach, friends with everyone, determinedly cheerful in the face of ignorance. Davies, with his secrets and his shyness, who hid an iron core of resolve. Kuhn, arrogant and overconfident, always ready for a fight, always sure success was right around the corner.

Success took forty years, two generations of artists, two world wars, and a global depression, but when it arrived it was all the sweeter. New York in 1913 was an artistic backwater. In 1953 it was the center of the artistic universe.

In the fight for modern art in America, the Armory Show had won.

EPILOGUE

Dispatch from the Fog of War

Art is a sign of life. There can be no life without change, as there can be no development without change. To be afraid of what is different or unfamiliar, is to be afraid of life. And to be afraid of life is to be afraid of truth.

—1913 ARMORY SHOW CATALOG

February 17, 1963
Utica, New York

Marcel Duchamp took the podium on the stage of at the Munson-Williams-Proctor Art Institute auditorium to thunderous applause. He looked remarkably vigorous at age seventy-five, although his jawline had sagged and his hairline had inched back from his forehead. Crowds of art lovers had arrived in Utica in upstate New York to see Duchamp, a living legend. He was the star attraction at the celebration of the fiftieth anniversary of the Armory Show, a triumphant exhibition of more than 300 works that had appeared at the original show in 1913.[1]

Duchamp delivered a lecture in which he discussed the legacy of the show and described the turmoil it produced. Backed by slides of the art of his contemporaries, he depicted the Armory Show as a battle, one that used "such weapons as derision, contempt, caricature ... in approval and defense of a new form of art expression." It was "a battle which seems, today, hard to imagine."

Indeed, the artists of the Armory Show had achieved the status of icons; their paintings had become masterpieces. Americans now recognized the folly of the original hysterical reaction to the Armory Show, and they looked back with an indulgent smile on the foolishness of their predecessors.

Americans felt an understandable desire to congratulate themselves on the fiftieth anniversary of the show. They marveled at how far they had come—from enemies of modernism to its greatest proponents. The

anniversary seemed a moment for America to pat itself on the back and enjoy the fruits of its labors. After the success of modern art in Abstract Expressionism, it must have seemed that all the questions had been answered, all the problems solved. The Armory Show had done its job. The Academy was dead; Paris had been surpassed. New York could get on with the business of being the center of the artistic universe.

Not so fast, Duchamp said.

———

Duchamp had raised an important, almost fundamental issue in 1917: What is art? How do you define it? *Can* you define it? Can it be a snow shovel? A skyscraper? A urinal? Can it be whatever the artist says it is? That question had never truly been answered. Jackson Pollock challenged conventional art with his huge abstract splatters, but he still defined art as had others before him: it was paint on canvas. Compared with a urinal, Pollock's art is stodgily conservative.

By 1963, artists were ready to accept Duchamp's challenge. American artists began to consider—sometimes seriously, sometimes less so—the possibilities of new, "non-retinal" art. They answered Duchamp by asking questions of their own. Just about any certainty about art was investigated, interrogated, turned on its head; artists pushed boundaries in every direction. New styles, schools, and movements exploded on the scene.

Many artists came to believe their duty was to confront, amaze, and shock audiences. In fact, shock became the primary goal for some. Duchamp himself gets credit for starting artists down this path. In a 1963 interview on the show's anniversary, Duchamp declared, "Unless art shocks, it is nothing," and many artists took his statement as an injunction to find ever-more extreme ways to stun audiences.

In his day, Duchamp found it easy to shock America—he only had to unveil a brand-new, perfectly clean urinal to throw the avant-garde art community into a tizzy—but it became a harder and harder job as audiences grew more cynical and harder to offend. Artists went hunting in search of taboos to violate—and boy, did they find them. No one in Duchamp's audience in the Utica auditorium could have imagined the lengths to which artists would go.

As the years went by, artists, critics, and audiences learned Duchampian art came with its own challenges. They realized that at some point

shock wears off. Boundaries fall down. Newness becomes hard to achieve. Artists living a century after the Armory Show have freedom its creators never imagined, but they also have to work much harder to make art that is inventive, original, or shocking. The pressure to create a wholly new mode of art is one contemporary artists face as a regular part of their profession. Artists in the pre–Armory Show era—working in a form that was *thousands of years old*—would have found this mandate utterly incomprehensible.

——

By 1963 Abstract Expressionism had run its course. New schools rose in its place, some taking its innovations into new directions, others— not surprisingly—rebelling against its entire ethos. In the early 1960s, the hottest new movement, Pop Art, was one that owed more to Dada's humorous pranks than to Pollock's anguished abstractions. The driving idea behind Pop Art was to blur the boundaries between popular culture and fine art and, in doing so, obliterate the traditional division between "high" and "low" culture. Artists such as Andy Warhol, Roy Lichtenstein, and Jasper Johns made art of everything from advertising slogans to comic strips to American flags.

Quintessential Pop artist Warhol inherited Duchamp's fascination with turning ordinary objects into readymade art. He produced Pop icons with his screen prints of Campbell's tomato soup cans and photos of Marilyn Monroe. Warhol also created his own readymades by reproducing Brillo soap pad boxes and Coca-Cola bottles. He even signed cans of actual soup. Warhol adopted Duchamp's detached ironic attitude—Warhol could be so remote he made Duchamp look engaged—but he had a passion for fame and a gift for cultivating his own celebrity. He became the art world's first megastar, wielding his considerable influence across culture, "discovering" musical acts, partying with movie stars, and getting pursued by photographers. And he clearly loved every minute of it.

After Pop, the pace of artistic revolution picked up, and artists defied artistic definitions right and left. They employed every imaginable medium—from steel to neon to video to LED lights—challenging the idea art had to be made from traditional materials. They hired teams or factories to produce art to their specifications, challenging the idea artists had to create with their own hands. They created temporary installations

that were demolished once an exhibit ended, challenging the idea art was permanent. They spray-painted art on buildings and walls, challenging the idea art had to exist in a formal space such as a gallery. They held performances and staged events, challenging the idea art had to be a *thing* at all. The artist Christo, famous for his oversize installations—he once wrapped the Reichstag in fabric and erected more than 7,500 fabric-draped gates in Central Park—barricaded a city street in Paris to cause a traffic jam; the *traffic jam* was his art. We don't know if his unwilling subjects in Paris gridlock were appreciative of his work.

Duchamp's idea of nonvisual art became a reality with the arrival of conceptual art, which breaks the rule of even being a physical thing at all. Conceptual art exists *solely in the mind*. In 1961, when Robert Rauschenberg was asked to contribute a portrait to a gallery, he replied with a telegram that read, "This is a portrait of Iris Clert if I say so." No one argued with him.

Yoko Ono published a book called *Grapefruit* that contains art in the form of instructions for artistic experiences. For example, *Snow Piece* reads:

Think that snow is falling.
Think that snow is falling everywhere
all the time.
When you talk with a person, think
that snow is falling between you and
on the person.
Stop conversing when you think the
person is covered by snow.[2]

Conceptual art can be whimsical, charming, thought-provoking, mind-bending, or outright bizarre, and it often generates responses as hostile as those hurled at art at the Armory Show. Since there is often no actual creation involved—no painting or sculpture, no *thing* that the artist handled—conceptual art often gets the reaction, "Anybody could do that." Many audiences also dislike the intellectual nature of conceptual art. They feel like what they're dealing with isn't art at all but rather a game that the artist is playing at their expense. Of course, this is the exact charge that was hurled at Henri Matisse and other modernists—that they were charlatans and hucksters poking fun at the art-loving public.

Other contemporary artists at the end of the twentieth century and the start of the twenty-first created works that deliberately violated taboos. Duchamp's *Fountain* is usually cited as the beginning of the movement, although a clean urinal is pretty tame compared to the bodily excretions that have been used in shock art. In the Society of Independent Artists exhibition of 1917, George Bellows demanded of Walter Arensberg, "You mean to say if an artist put horse manure on a canvas and sent it to the exhibition, we would have to accept it?"[3] Indeed so, although Chris Ofili preferred elephant dung in his 1996 work *The Holy Virgin Mary*, Andres Serrano went with urine in his 1987 photo *Piss Christ* of a crucifix submerged in urine, and Judy Chicago employed menstrual blood in her 1971 work *Red Flag* depicting a woman removing a tampon. The high ick-factor of these sorts of works, particularly when combined with the use of religious imagery, has made them the inheritors of the type of media and government attention that the Armory Show received.

Serrano was condemned by U.S. Senators Al D'Amato and Jesse Helms because he received support from the taxpayer-funded National Endowment for the Arts. Ofili was attacked by then–New York mayor Rudolph Giuliani, who called *The Holy Virgin Mary* "sick" and "disgusting" and tried to pull city funding from the Brooklyn Museum, which was displaying the painting. However, both cases prove how much art has changed as well as how much the public is willing to tolerate. Duchamp only had to use the word "nude" in his painting's title to attract the attention of the Illinois Vice Commission, while Serrano had to submerge a religious icon in his own piss to get the attention of Congress.

———

The freedom to make art out of anything has no doubt been liberating, but it creates its own dilemmas. For one, the accusation that something's "already been done" becomes a frustratingly common charge. Elephant dung on a canvas isn't new anymore, and once no longer new, it is no longer shocking—worse, it's actually boring and derivative. Soup cans have been done. So have comic strips, snow shovels, and traffic jams, not to mention sharks suspended in formaldehyde (by Damien Hirst) and oversize balloon animals cast in stainless steel (by Jeff Koons). No artist wants to copy old ideas. It can be argued that *by definition,* artists shouldn't do this.

But after fifty-odd years of conceptual and shock art, to be *new*, artists must invent whole new forms of art, or at least new ways of approaching old forms. Earlier generations of artists didn't have this problem. If a painter wanted to paint a landscape or a still life, there was no reason not to—artists were painting landscapes and still lifes before the fall of Rome, and every generation found a way to put a new twist on the old theme.

In pursuit of new boundaries to push, artists have also run up against the limits, not from artistic culture, but from society at large. Duchamp found it easy to shock people, but it has become harder as audiences have grown accustomed to artistic exploits. Today artists have to go much further to get a rise out of viewers, as the Serrano and Ofili cases reveal. In fact, the primary complaint about both *Piss Christ* and *The Holy Virgin Mary* was that government funds were involved. Giuliani probably would still have thought Ofili's work was sick, but it was the fact that taxpayers helped pay for it that really got Giuliani's goat.

If you want to go off and do something appalling on your own time and with your own money, Americans usually shrug and wish you luck. You can even break the law and risk physical harm as long as no one else is involved. No one particularly minded, for example, when American artist Chris Burden had himself shot in the arm by his assistant in a 1971 performance Burden called *Shoot*.[4] The feeling was that if you wanted to get yourself shot—and call it art—that's your problem.

However, the reaction was totally different in 2004 when a student named Joe Deutch played Russian roulette with a loaded gun in a UCLA art classroom. The other students panicked, believing they were about to witness suicide or even murder as art. As it turned out, the gun was a fake and Deutch wasn't in any risk, but no one knew that at the time. Deutch's "performance" was considered grossly insensitive in an era when school shootings are a real and terrifying threat; in a post-9/11 environment, some critics even labeled Deutch's actions "domestic terrorism."

The Los Angeles district attorney, the UCLA campus police, and the UCLA Student Conduct Committee all investigated the incident; all three cleared Deutch since the gun wasn't real and students weren't actually at risk. The decision not to suspend Deutch from UCLA incensed Burden, of all people, who was then teaching art at the university, and he resigned from the school.[5] Burden believed there was a fundamental difference between having himself shot under carefully controlled circumstances and Deutch's apparent threat to shoot others or kill himself.

In seeming to put other students and/or his own life in danger, Burden believed Deutch crossed a line.

Deutch later defended his work with a very Duchampian proposition: "I wanted to ask the question, 'Does our ability to make a statement exist anymore?'"[6] It's a fair question, even if his means of asking was over the top. (It's also dizzyingly self-referential, using art to ask a question about the ability of art to ask a question.) Have all the statements—or at least all the statements that won't land you in prison—been made?

———

The issue comes down to one of originality. How can artists continue to create original work when the standard for originality is so high? How do they avoid doing what's already been done? Is originality even possible anymore?

One of the critics of the Armory Show predicted this challenge. Frank Jewett Mather, a harsh critic of the Armory Show, deplored the emphasis on originality at the 1913 exhibition. Post-Impressionism, he said, "is setting hundreds of young painters to coddling their sacred impulses" and exaggerating the "cult of the individual." The danger, he argued, is that the "artist of the present is urged to cultivate that originality which is only the prerogative of the great."[7] Mather was reflecting a common academic attitude about individuality and creativity. In 1908, academic artist William Ordway Partridge declared "Originality is the bane of art. Art is a matter of evolution; a new note is not struck more than once in a thousand years."[8]

It would be very hard to find someone making this argument today. Partridge and Mather believed coming up with new ideas was the sole purview of "great" thinkers. In their opinion, to invent a new way of making art, an artist needed to be the equal of Michelangelo or Rembrandt—and geniuses of this level are incredibly rare.

Today we're not so skeptical of the abilities of ordinary thinkers. We no longer believe you need to be the next Old Master to produce something unique and amazing. Nevertheless, Mather identified the pressure that the demand for originality places on artists. When the new and novel is so highly valued, novelty becomes an end in itself. Desire for genuine confrontation can turn into the pursuit of shock for shock's sake. Individualism can become the new conformity.

We live in a post–Armory Show art world, and this reality shapes the arts in endless ways. Where the purpose of an arts education was once to develop technique, today technique matters less than concept, if at all. The California Institute of the Arts (CalArts), for example, describes its program as "a forum for the sustained exploration of possibilities in cultural production"—a sentence that would have baffled Walt Kuhn and his peers. Traditional skills such as life drawing—drawing from a human model—aren't even part of the CalArts curriculum.[9]

In the post–Armory Show world, critics have a far harder job than they used to—not that anyone should feel sorry for them (or ever would). The task was once fairly straightforward. Evaluating a work of art began by seeing how well it followed the rules of perspective, color, and form. That out of the way, critics could consider more subjective points of style and subject. Modern and contemporary art is far more difficult to judge because each work must be evaluated *on its own terms*. Critics find it so hard to defend their judgments that they avoid making them. "People have given up staking a position about what is good or bad," said JJ Charlesworth, associate editor of *ArtReview* magazine. "There's a refusal to be judgmental in art criticism."[10]

Contemporary art also makes audiences work harder. Museum- and gallery-goers can't just walk in and expect to "get" what they're seeing—particularly since the popular understanding of art hasn't kept up with revolutions in the art world. Even the most open-minded audiences are often defeated by the obscurity and difficulty of contemporary art. The Museum of Modern Art echoes with the anxious laughter of embarrassed patrons who paid good money to spend their day there.

Artists, and critics, would argue that art is worth effort. They would insist that art *should* require more than a cursory glance. The current mode of art instruction nourishes creativity and promotes artistic freedom. Artists fill an important social role with taboo-pushing conceptual works—they expose our prejudices and expand our narrow-minded patterns of thinking.

Artists also aren't complaining about the demand of originality. The art world grows bigger ever year. It's not as if artists have run out of ideas—yet.

Charles Thomson and Billy Childish never fit into the mainstream of contemporary art. The two men liked to paint. That was enough to make their work odd in the conceptual art scene of the late 1990s where few artists actually lifted a brush to canvas. Thomson and Childish took things a step further by painting *portraits*—old-fashioned paintings of people!—*landscapes,* and even *flowers.* In a wonderfully apt reversal, fellow artists found this baffling —Childish's then-girlfriend Tracey Emin, a conceptual artist, once shouted at Childish in the middle of a fight that he was "Stuck! Stuck! Stuck!" in his art.

Thomson and Childish decided that rather than be ashamed of their archaic tendencies, they should embrace them. In fact, why not start saying out loud all the things they had been thinking about conceptual art? That artists who didn't paint (or draw, or sculpt, or otherwise create objects) weren't artists. That conceptual art was superficial and pretentious. That art had no future as long as it continued down the conceptual path. These were all heresies, but ones that concerned the men for years. So in 1999 the two formed a new artists association that they called the Stuckists, in honor of Emin's knock against Childish. They proclaimed themselves in favor of representational art—art that has a recognizable subject—and opposed to conceptual art.

In a 2000 manifesto, they situated themselves in art history as on the front lines against trends set into motion by Duchamp. Duchamp, they said, had created "anti-art," art that he made as "a protest against the stale, unthinking artistic establishment of his day." They believed they were doing the *exact same thing*—just on the other side of the looking glass.

Today *all* art is anti-art, which means art is nothing since anti-art only exists in opposition to real art. (Just give that sentence a moment to sink in.) The Stuckists claim conceptual art has become so dominant in the culture that it is now "a direct equivalent of the conformist, unoriginal establishment that Duchamp attacked in the first place." The only truly innovative art at this point is traditional.[11]

The Stuckists are a contentious group known for protesting the prestigious Turner Prize for contemporary art, usually awarded to a conceptual artist, outside London's Tate museum; Thomson sometimes shows up in a clown costume. They're outspoken and antagonistic, particularly to British artists; they once displayed a dead shark in a tank

under the title *A Dead Shark Isn't Art* to mock Hirst's famous piece *The Physical Impossibility of Death in the Mind of Someone Living*, which is, in fact, a dead shark in a tank.* Childish later left the group, but Thomson remains a driving force committed to denouncing conceptual art and the entire art establishment, which, he claims, is dedicated to supporting conceptualism. He's confident that conceptualism won't last much longer—"There is nothing as unwanted as novelty when it is no longer new," he has said.[12]

The Stuckists aren't the only artists turning toward representational art. In fact, despite all the focus on conceptualism in the last few decades, representational and realistic art have never entirely gone away. Andrew Wyeth created detailed realist works from the late 1930s until his death in 2009; David Hockney, who first became famous for his Pop Art paintings and Polaroid photo collages, today paints oil and watercolor landscapes and portraits. The world of contemporary representational painting includes realists and neo-academics, modern-day expressionists who create highly emotional and dramatic works and contemporary surrealists and Fantastic Art painters who add bizarre, dreamlike, or fantasy elements to their canvases.

Some critics believe these artists, those who have turned back to styles decades old, are actually the most progressive of their generation. In a study of shock art, *Transgressions: The Offenses of Art*, one art scholar wrote:

> [Artist] Anselm Kiefer, for example, asserts that "to be subversive in the sense of Dadaism would be reactionary, because now it would be the attitude of model students." It has thus been proposed that, when the avant-garde declines into orthodoxy, the academic becomes subversive.[13]

The new representational movement has become so popular that some in the art world are worried about a backlash against conceptual art, which has been nicknamed "con art" by its opponents. This anxiety has fed into other concerns about the contemporary art scene and left members of the art establishment wringing their hands. They fear that the economy has skewed art values; a handful of megastars sell their work for tens of millions of dollars (Hirst and Koons among them), but artists at the start or middle of their careers struggle to survive.

* In 2004, Hirst's piece was sold to hedge fund manager and collector Steven A. Cohen for an estimated $12 million.

Spending the biggest bucks is a new class of buyers, among them mind-bogglingly rich plutocrats from countries such as Russia, China, and Qatar. Dealers and critics fret that these collectors are buying art to advertise their wealth without any concern for its quality. "Never has so much expensive art been made, bought and sold, nor so little discourse applied to its merits," wrote BBC arts editor Will Gompertz in a 2012 article.[14] Even some of the world's most prestigious gallery owners have wrinkled their noses in disgust at the "vulgarity" of new collectors.

Curiously, this is the exact same criticism that was lobbed at American art collectors in the early 1900s; most of those collectors were mind-bogglingly rich industrialists who made their fortunes in the then-emerging economy of the United States. Many of these collectors, men with such names as Morgan and Vanderbilt, considered hanging the work of French academic artists on their walls an excellent way to indicate their wealth to their friends.

So: An entrenched art establishment sells a dominating art style to wealthy collectors who are buying for prestige. Young artists, many working in a radical style disliked by art institutions, struggle to get their work in front of open-minded collectors. It all sounds strangely familiar. Where's Kuhn when you need him?

———

It's impossible to predict where the art world will go in the next century. The Stuckists and other anti-conceptualists believe they have history on their side. They believe that just like the modernists, their art will eventually be recognized as significant, while the dominant art mode—conceptualism—will be forgotten just like academic art. On the other hand, conceptual artists believe that their art will ultimately survive and receive popular acceptance when public understanding catches up with artistic evolution, just like the public came to appreciate Cubism and Fauvism after initially dismissing it as the work of madmen and frauds.

The ordinary art lover is left at a loss as artists fight out their futures. Only two things are certain. First, anyone who tells you what is going to happen has no idea what they're talking about. Second, it's going to be incredibly entertaining to watch it all play out.

It probably would have pleased Duchamp that he remains controversial from the grave. Duchamp liked starting conflicts but preferred to observe them from a comfortable, ironic distance. He's in the ultimate

detached position. Duchamp died on October 2, 1968, one of the last of the Armory Show generation. Edward Hopper preceded him by one year. Pablo Picasso survived until 1973.

Meanwhile, the Armory Show has largely been forgotten except by art historians. Far better known today is the *new* Armory Show, an international art fair founded in 1994. The show was briefly housed in the 69th Regiment Armory but now operates on Piers 92 and 94 along the Hudson River on Manhattan's West Side. The show's name pays homage to the original, recognizing the moment modern art invaded America. It is a huge celebration of New York's reign at the center of the art world.

The spirit of the Armory Show lives on—not just at the new show but also in galleries and museums, schools and studios around the country. It is a spirit not only of rebellion, for rebellion is everywhere in contemporary art, but also of independence. Kuhn picked a Revolutionary War flag as the show's symbol for a reason. Kuhn and the other Armory Show organizers wanted Americans to judge art not based on the criteria set down by the Academy but rather on whether or not individual works had merit, quality, *life*. No doubt he would urge Americans today not to blindly accept the valuations of the art establishment but to have the courage and confidence to evaluate the living qualities of contemporary art.

Not long after Duchamp's speech at the fiftieth anniversary celebration in 1963, the *New York Times* ran an editorial on the legacy of the Armory Show in which it asked:

> *Have we learned much since the Armory Show, or have we done nothing more than cultivate a set of specialized variations on the innovational themes we discovered there? Is modern art truly inventive, or only clever at ringing changes? Have we become so fascinated by our cleverness that we have forgotten that invention is pointless unless it does more than amuse, startle, and fill the salesroom? . . .*
>
> *The major lesson of the Armory Show was that we had failed to distinguish between the quick and the dead. If this lesson still means anything, we will examine the contemporary to see just how quick it truly is, and we will listen carefully to the pulse of some less spectacular art that may have been prematurely announced as ready for burial.*[15]

The *Times* echoed the challenge issued by Kuhn, Arthur B. Davies, and Walter Pach in the catalog of the 1913 Armory Show: "Art is a sign of life. There can be no life without change, as there can be no development

without change. To be afraid of what is different or unfamiliar, is to be afraid of life. And to be afraid of life is to be afraid of truth."[16]

Those looking for a fixed star to guide them through the confusion of the contemporary art scene could do worse than hold on to these words. We still care about art that speaks to something within us, art that achieves some emotional or intellectual or aesthetic resonance, art that is, in Kuhn and Davies's words, "living" and "true." Ultimately, movements don't matter and styles are ephemeral—what matters are the living and true qualities of art. Sometimes we recognize these qualities in an instant when a work of art grabs our attention from across a room. Other times we grow into our understanding of art as its strengths reveal themselves to us with time and study. However we come to appreciate art, we must approach it with minds open to the possibility that life and truth may reside in a style of art we never imagined we would understand or embrace.

Art can be as thrilling and transformative as it was in 1913 as long as we aren't afraid of what is different or unfamiliar. As long as we aren't afraid of life. As long as we aren't afraid of truth.

Postscript

In the years after the Armory Show, *Walt Kuhn* took his event-planning talents to the theater and worked for several years as a writer, designer, director, and promoter for vaudeville acts. His shows were commercially successful and received praise from prominent Broadway producers. However, the theater work distracted Kuhn from his true love, art.

In the spring of 1925, Kuhn fell seriously ill from a duodenal ulcer and nearly died. When he recovered, he reexamined his life and work. He felt none of the paintings he had produced to that point truly reflected his abilities and resolved "to do at least one fine piece of art."[1] He set to work in the studio, and his efforts paid off—in his early fifties, after painting nearly a quarter of a century, he finally discovered his artistic voice. Curiously, his mature style focused on the performers he had worked with in his shows. He painted a series of portraits of circus clowns, acrobats, showgirls, and trapeze artists. Often the performers are pictured backstage, sitting on crates or standing near mirrors, and usually they fix the viewer straight in the eye.

Kuhn continued painting these portraits through the 1940s. However, in late 1948 his behavior became increasingly erratic and eccentric. He developed strange obsessions that turned into delusions, including a burning desire to "expose" the supposed criminal activity of the American Medical Association (AMA). The situation became a crisis when he was arrested carrying a .22 pistol and trying to force his way into the house of the publisher of the *New York Times*, which had ignored his haranguing letters about the AMA. (This instability late in his life puts the often irrational optimism he demonstrated during the Armory Show into a different light.)

On November 28, 1948, Vera Kuhn arranged to have her husband committed at Bellevue Hospital. His behavior began to stabilize, but before he could be released, he died of a perforated ulcer on July 13, 1949, at age seventy-one.

———

Arthur B. Davies returned to his quiet life after the Armory Show, culti-vating his circle of rich old ladies, painting his ethereal nudes, and trying to keep his scandalous private life a secret. While officially still married to Virginia, who lived on her farm in the Hudson River valley, he main-tained his false, second marriage under the name David Owen with his former model Edna. For several years, their daughter Ronnie attended the same school as Brenda Kuhn, and Edna and Vera Kuhn struck up a friendship—although Vera never knew that Edna Owen was the mistress of her husband's good friend.

In 1924 the twelve-year-old Ronnie started asking uncomfortable questions about her family, and Davies decided he was running too great a risk by having Ronnie and Edna in New York. Davies escorted them to Paris, where Ronnie was enrolled in an English school. During the next few years, Davies traveled to Europe every summer to see Edna and Ron-nie, who later moved to Florence, Italy, then returned in late fall to spend the rest of the year in New York.

His 1928 visit would be his last. On October 24, he died of a mas-sive heart attack at Edna's apartment in Florence; he was sixty-five years old. Edna arranged to have his body cremated and then sailed for New York with Ronnie. Somewhere along the way, she had to explain to her sixteen-year-old daughter that her father *wasn't* engineer David Owen but rather well-known artist Arthur Davies; Ronnie never recorded her reaction to this information, but she must have been devastated. Edna and Ronnie took the train up to Virginia's house, knocked on the door, and introduced themselves; the conversation that followed, in which Edna broke the news of both Davies' death and her involvement with the painter, must have been the most painful and uncomfortable of the women's lives.

Virginia would have been furious to learn her husband had been hid-ing a second family for *twenty-five years*, but she didn't want Davies' repu-tation sullied at his death. She, Edna, and her sons concocted an elaborate ruse to hide the circumstances of Davies' death, announcing that he had died hiking in mountains several hundred miles from where he actually had his heart attack. They were only partially successful in concealing the truth. Many colleagues wondered why news of the death was announced two months after the fact and why so few details were available about

what had happened. For years rumors circulated that Davies' famous shyness had driven him to fake his own death and become a recluse.[2]

———

Walter Pach continued to organize exhibits and give talks on modern artists. He became well known as a critic, art historian, and lecturer and taught the first class on modern art ever offered in America. He was also one of the first critics to recognize and promote Mexican art and artists in the United States. He never stopped painting, although he is remembered today more as a critic than as an artist. Pach died on November 27, 1958, at age seventy-five.[3]

———

Robert Henri remained a popular teacher at the Art Students League, where he argued relentlessly for American realist art free from European influence. He was diagnosed with bone cancer in late 1928 and died July 12, 1929, at age sixty-four, leaving behind a devoted circle of friends and former students who remained loyal to his philosophies.[4]

———

Edward Hopper was the most famous of Henri's students, ultimately better known than his teacher. He painted in his mature, realistic style for the rest of his life, producing famous works such as *The Lighthouse at Two Lights* (1929), a brilliantly white lighthouse standing on a high hill, and *Nighthawks* (1942), a group of patrons sitting at an all-night diner, the lights of the restaurant spilling into a dark city street. *Nighthawks* is one of the most influential paintings in American art, inspiring artists, writers, and filmmakers—several movies include scenes styled to evoke the painting. It's also one of the most parodied, with figures from *The Simpsons*, *Star Wars*, and *Seinfeld* ending up at that brightly lit restaurant.

After one of the most successful careers in American art, Hopper died on May 15, 1967, at age eighty-four.[5]

———

Alfred Stieglitz never stopped berating visitors at the various galleries that he operated through the years. He suffered from numerous ailments—or at least believed he was suffering, since everyone agreed Stieglitz was a notorious hypochondriac—but continued to sell and promote the work of his circle of artists into his late seventies. He enthusiastically supported his wife *Georgia O'Keeffe* even after the two began living apart several months out of every year. The increasingly reclusive O'Keeffe preferred the stark beauty of the New Mexico desert to the crowds of New York. Meanwhile, Stieglitz began an affair with a woman more than forty years his junior, a relationship O'Keeffe tolerated with barely concealed contempt.

Stieglitz suffered several heart attacks in the 1940s. In the summer of 1946, he had a massive stroke and fell into a coma. O'Keeffe rushed back from New Mexico to New York and was with Stieglitz when he died on July 13 at age eighty-two. O'Keeffe moved permanently to New Mexico in 1949; she died in Santa Fe in 1986 at the age of ninety-eight, one of the best-known and well-respected artists in America.[6]

———

Curiously, the person who first invited O'Keeffe to New Mexico was *Mabel Dodge*. Dodge abandoned her New York salon after her affair with Communist journalist Jack Reed ended in 1914. Dodge then began a tumultuous relationship with American sculptor and painter Maurice Sterne; they married in 1916.

In 1919, Sterne and Dodge visited Taos, New Mexico, and Dodge became so entranced by the landscape that she never left. Her attraction to the desert was enhanced by her attraction to Tony Luhan, a ruggedly handsome Tiwa Indian from the Taos Pueblo who, she claimed, had visited her in her dreams long before she arrived in Taos. Dodge kicked Sterne out of the house and, as soon as their divorce was finalized, married Luhan, despite the fact he was already married to a woman in the pueblo. Dodge—now Dodge Luhan—developed a complex, rather incoherent mysticism in which she served as a bridge between white civilization and Native American wisdom; her insights would lead, she believed, to a revitalization of Western civilization and a new harmony between the people of America and their native land.

Part of her new mission in life was to bring other souls to Taos for enlightenment, so she invited every writer and artist she knew to visit.

None of Dodge Luhan's friends were particularly interested in being enlightened, but many loved the clear light and stark beauty of northern New Mexico. Over time, Dodge Luhan hosted a glittering array of artists and writers including Marsden Hartley, Ansel Adams, and D.H. Lawrence. The still-thriving artistic communities of Taos and Santa Fe owe much to Dodge Luhan's promotion.

Dodge Luhan died in Taos on August 13, 1962, at age eighty-three.[7]

———

Attorney and art patron *John Quinn* continued to balance his legal career with his passion for collecting. In the months after the Armory Show, his two worlds collided when he resolved to overturn the provision in the U.S. Tariff Law that applied a duty on imported works of art less than twenty years old. Quinn considered the tax a scheme by dealers in Old Master paintings to encourage sales of antique art and discourage the collecting of modern works; he also hated that it cost him so much of his own money. Quinn single-handedly wrote up objections, gathered evidence, and testified before Congress; he deserves full credit for seeing the provision removed from the law.

Quinn died on July 28, 1924, of liver cancer; he was only fifty-four years old. His art collection, which included works by Pablo Picasso, Henri Matisse, Georges Seurat, Constantin Brancusi, and Paul Cézanne, was sold. While many paintings and sculptures ultimately ended up in major U.S. museums, art historians have bemoaned the dispersal of one of the most amazing art collections of the early twentieth century.[8]

———

Gutzon Borglum annoyed, offended, and exasperated artists and patrons for another twenty-eight years after the Armory Show. He remained adamant in his opposition to modernism. His own style, meanwhile, became ever grander and monumental until only mountains were big enough to hold his vision.

His first mountain-carving attempt began in 1915 when the United Daughters of the Confederacy (UDC) asked him to sculpt a bust of Confederate general Robert E. Lee on the 800-foot-high rockface of Stone Mountain in Georgia. This idea wasn't grand enough for Borglum, and he

eventually planned an enormous depiction of Lee, Jefferson Davis, and "Stonewall" Jackson riding around the mountain followed by a legion of artillery troops. Borglum began work in 1923, but progress was delayed by bitter quarrels with UDC officials over every aspect of the project. Borglum befriended members of the Ku Klux Klan during his time in Georgia; it's unclear if he agreed with the KKK's racist views or simply wanted their support for the project—he treated African Americans with the same contempt that he showed everyone who couldn't afford to commission his sculptures. In any case, in March 1925, in a fit of temper Borglum smashed all his models for the project and stormed out of Georgia. The work he had already completed was blasted away, and the current carving of Lee, Davis, and Jackson on Stone Mountain was executed by American sculptor Augustus Lukeman.

Borglum's work on Stone Mountain gave him both the techniques and the drive to attempt an even grander project, and in 1927 he began work on Mount Rushmore in the Black Hills of South Dakota. Supported by a team of several hundred miners, sculptors, and rock climbers, Borglum supervised the carving of four massive heads of U.S. presidents from the granite mountainside. Borglum continued to accept other commissions and also traveled extensively raising money for the project, and eventually his son Lincoln Borglum took over management of most of the day-to-day work on-site. Borglum died on March 6, 1941, a few weeks before his seventy-fourth birthday.[9]

———

Manierre Dawson's involvement with the art world only lasted a short time after Pach discovered his work and tried to sneak it into the Chicago run of the Armory Show. Dawson displayed his unusual abstract works at several shows in 1913 and 1914, but in the fall of 1914 he moved to rural Michigan, purchased an orchard, and became a fruit farmer.

Dawson had little time to devote to art, but he completed sculptures using materials readily available on the farm, including scrap lumber, plywood, and Portland cement. Other than a few exhibits in the early 1920s, he didn't show his art again until the late 1960s, when he was rediscovered as an American original. Dawson died at age eighty-one on August 15, 1969.[10]

Gertrude Stein and *Alice Toklas* lived together in France for the rest of their lives. During World War I, they volunteered with an organization that provided supplies to hospitals near the front; Stein careened across the countryside in a temperamental Ford truck piled high with bandages and Red Cross comfort bags. After the war, they resumed entertaining in Paris, and soon their flat was regularly filled with aspiring American writers who seemed drawn to Stein like pilgrims to a guru. She befriended Ernest Hemingway, F. Scott Fitzgerald, Sherwood Anderson, Ford Madox Ford, and numerous others, and Hemingway later made famous her description of the generation that came of age during the war as the "Lost Generation."

Stein never stopped writing her dense, obscure prose, although in 1933 she wrote her most accessible book, *The Autobiography of Alice B. Toklas.* Written by Stein in Toklas's voice, it tells the story of their salons and encounters with various writers and artists. The book was a bestseller, and it paved the way for a successful lecture tour in America in 1934 and 1935.[11]

Stein and Toklas spent the World War II years in the French countryside near the Swiss border. Their region was not under German occupation but rather controlled by the collaborationist Vichy government; nevertheless, as Jewish lesbians, Stein and Toklas were in danger of deportation to a German concentration camp. They were protected by Bernard Faÿ, a relentlessly anti-Semitic Vichy government official rumored also to have been a Gestapo agent. Faÿ was a close friend of Stein's who had translated her books into French, and he apparently believed that Stein shared his politics. Stein's actual beliefs are unclear and the evidence is contradictory. She seems to have supported the French Resistance while at the same time cooperating with Faÿ to translate the speeches of Vichy government leader Marshal Pétain into English. Some historians believe she went along with Faÿ in a desperate effort to save her own skin, while others consider her pro-Fascist despite her Jewish heritage. Stein's monumental self-regard might have distracted her from what was actually going on in Europe during the war, although this is hardly a justifiable excuse for turning a blind eye to genocide.[12]

Stein survived the war only to die of stomach cancer on July 27, 1946, at age seventy-two. Toklas lived alone in Paris after her death; she died in 1967 at age eighty-nine.

———

Pablo Picasso stayed in Paris through World War II, even though German occupying forces constantly harassed the artist with sudden searches of his apartment and demands to see his papers. On one of these searches, a Gestapo officer noticed a photograph of his anti-Fascist, anti-war masterpiece *Guernica*. "Did you do that?" the officer demanded. "No," Picasso said, "you did."

The years after the war were ones of success and comfort; he spent most of his time in large, luxurious villas in the south of France. He had numerous affairs and married twice; no matter how old the artist became, his lovers continued to be beautiful young women. He continued painting and sculpting until the last years of his life. Picasso died April 8, 1973, at the age of ninety-one.

———

Francis Picabia became one of the major leaders of the Dada movement. Along with producing art and poetry, he also published the Dada journal *391*. (The title paid homage to Stieglitz's gallery 291.) After Dada ended as a movement in the early 1920s, Picabia continued to work in a bewildering array of styles ranging from near-abstract compositions to erotic paintings of beautiful nudes. He lived the last twenty years of his life as a local celebrity in Cannes on the Mediterranean, although World War II dramatically cut into his income and meant he was unable to buy a new car every time he wanted one. Picabia died November 30, 1953 at age seventy-four.

———

Henri Matisse moved away from Paris to the French Mediterranean in 1917. He continued to paint in his colorful style, with his art becoming increasingly bold and simplified throughout the years. The World War II years were difficult—he separated from his wife, his health was poor, and he was in constant anxiety about his daughter Marguerite, who was active in the French Resistance and narrowly escaped death in a Nazi concentration camp. When he grew too weak to paint, he began cutting shapes out of colored paper and relying on assistants to glue the shapes to

canvases. He eventually completed many of these collages, including an entire book called *Jazz* of prints of his cut-paper works. Matisse died of a heart attack at age eight-four on November 3, 1954.

———

Thomas Hart Benton stayed in Kansas City after he was fired by the Kansas City Art Institute and continued painting Regionalist art even after Regionalism grew unpopular. His work was still prized by committees looking for murals for public buildings, and he completed projects for Lincoln University, the Power Authority of the State of New York, and the Harry S. Truman Library. Benton died at age eighty-five on January 19, 1975, while at work on his final mural, *The Sources of Country Music*, commissioned by the Country Music Hall of Fame in Nashville, Tennessee.

———

Marcel Duchamp gave up art for chess in the mid-1920s, and as far as friends and colleagues knew, his only involvement in the art world was consulting with collectors and dealers such as Peggy Guggenheim. However, after Duchamp's death at age eighty-one on October 2, 1968, rumors began to circulate that Duchamp had left one last work of art behind. In 1969 the Philadelphia Museum of Art unveiled the previously unknown project that Duchamp had worked on in almost complete secrecy since 1946.

The work is a tableau called *Étant Donnés: 1. La Chute d'Eau, 2. Le Gaz d'Éclairage* (*Given: 1. The Waterfall, 2. The Illuminating Gas*), a typically Duchampian title. Viewers see an old wooden door framed in bricks in a plaster wall. A pair of peepholes in the door allow one person at a time to look at a strange and shocking scene of a nude woman lying on her back with her legs spread facing the door. Her head is unseen to one side, but she holds a flickering gas lamp in one hand. She is sprawled on a surface of dead grass and twigs, and behind her is a landscape that includes a waterfall that seems to move.

Only a handful of people, including a curator at the Philadelphia museum and Duchamp's wife, knew about the project. Duchamp erected it in his New York studio and left a detailed manual explaining how to

move and reassemble the piece. *Étant Donnés* caused an uproar when it was first shown. Feminists denounced the work as offensive and voyeuristic. Conceptual artists bemoaned that their hero had returned to representational art. No one knew how to classify it—was it Surrealist? Some of kind of proto-Pop?[13]

Even after his death, Duchamp refused to allow his art to be neatly summarized and understood. He confounded audiences and critics beyond the grave and remains the most perplexing twentieth-century artist. It's a legacy that would make him so proud.

Selected Bibliography

Abbott, Karen. *Sin in the Second City: Madams, Ministers, Playboys, and the Battle for America's Soul*. New York: Random House, 2007.

Adam, Georgina, JJ Charlesworth, Danielle Horn, and James Mayor. "The End of the Art World . . . ?" Panel discussion at the ICA Quickfire, London, U.K., January 19, 2013.

Adams, Adeline. "The Secret of Life: Suggested by a Visit to the International Exhibition of Modern Art." *Art and Progress*, April 1913, 925–32.

Adams, Henry. *Thomas Hart Benton: An American Original*. New York: Knopf, 1989.

———. *Tom and Jack: The Intertwined Lives of Thomas Hart Benton and Jackson Pollock*. New York: Bloomsbury Press, 2009.

Adams, Philip Rhys. *Walt Kuhn, Painter: His Life and Work*. Columbus: Ohio State University Press, 1978.

Agee, William C. "Willard Huntington Wright and the Synchromists: Notes on the Forum Exhibition." *Archives of American Art Journal* 24, no. 2 (1984): 10–15.

Altshuler, Bruce, and Phaidon Editors. *Salon to Biennial: Exhibitions That Made Art History*. New York: Phaidon Press, 2008.

Anthony, Julius. *Transgressions: The Offenses of Art*. Chicago: University of Chicago Press, 2003.

"The Armory Puzzle." *American Art News*, March 1, 1913, 3.

Banks, Eric. "Wars They Have Seen." *The Chronicle of Higher Education*, October 23, 2011.

Benfrey, Christopher. "The Alibi of Ambiguity." *New Republic*, June 28, 2012.

Bishop, Janet, Cécile Debray, and Rebecca Rabinow, eds. *The Steins Collect: Matisse, Picasso, and the Parisian Avant-Garde*. Exhibition organized by the San Francisco Museum of Modern Art. San Francisco: San Francisco Museum of Modern Art in association with Yale University Press, 2011.

Blom, Philipp. *The Vertigo Years: Europe 1900–1914*. New York: Basic Books, 2008.

Bochner, Jay. *An American Lens: Scenes from Alfred Stieglitz's New York Secession*. Cambridge, Mass.: The MIT Press, 2005.

Boehm, Mike. "The 'Shot' Heard 'Round UCLA." *Los Angeles Times*, July 9, 2005.

Bois, Guy Pène du. *Artists Say the Silliest Things*. New York: American Artists Group, Inc., Duell, Sloan and Pearce, Inc., 1940.

———. "The Post-Impressionist Quarrel (Letter to the Editor)." *New York Tribune*, June 2, 1914.

Borglum, Gutzon. "The Revolt in Art." *The Lotus Magazine* 9, no. 5 (1819): 215–19.

Borràs, Maria Lluïsa. *Picabia*. New York: Rizzoli International, 1985.

Brown, Milton W. *American Painting from the Armory Show to the Depression*. Princeton, N.J.: Princeton University Press, 1955.

———. *The Story of the Armory Show*. Second ed. New York: Abbeville Press, 1988.

Caffin, Charles H. "International Exhibition Is a Sensation." *New York Journal-American*, February 24, 1913.

Camfield, William A. *Francis Picabia*. New York: The Solomon R. Guggenheim Foundation, 1970.

———. *Francis Picabia: His Art, Life and Times*. Princeton, N.J.: Princeton University Press, 1979.

Childish, Billy, and Charles Thomson. "Anti-Anti-Art: The Spirit of What Needs to Be Done." The Hangman Bureau of Enquiry, www.stuckism.com/StuckistAntiAntiArt .html.

Coates, Robert M. "The Art Galleries: Situation Well in Hand." In *Jackson Pollock: Interviews, Articles, and Reviews*, 50–51. New York: The Museum of Modern Art, New York, 1999.

Cohen-Solal, Annie. *Painting American: The Rise of American Artists, Paris 1867–New York 1948*. Translated by Laurie Hurwitz-Attias. New York: Alfred A. Knopf, 2001.

"Coming Painters and Sculptor's Show." *American Art News*, February 15, 1913.

Cooper, John Milton Jr. *Pivotal Decades: The United States, 1900–1920*. New York: W.W. Norton & Company, 1990.

Corn, Wanda M. *The Great American Thing: Modern Art and National Identity, 1915–1935*. Berkeley: University of California Press, 1999.

Cortissoz, Royal. "The Post-Impressionist and Cubist Vagarities." *New York Tribune*, February 23, 1913.

Cottington, David. *Cubism and Its Histories*. Manchester, U.K.: Manchester University Press, 2004.

———. *Cubism in the Shadow of War: The Avant-Garde and Politics in Paris 1905–1914*. New Haven, Conn.: Yale University Press, 1998.

———. "What the Papers Say: Politics and Ideology in Picasso's Collages of 1912." *Art Journal* 47, no. 4 (1988): 350–59.

Cowles, Virginia. *1913: An End and a Beginning*. New York: Harper & Row, 1967.

Cox, Kenyon. "The 'Modern' Spirit in Art: Some Reflections Inspired by the Recent International Exhibition." *Harper's Weekly*, March 15, 1913.

Cox, Neil. *Cubism, Art & Ideas*. London: Phaidon Press, 2000.

Craven, Thomas. "The Curse of French Culture." *Forum*, 1929, 57–62.

Crunden, Robert M. *American Salons: Encounters with European Modernism, 1885–1917*. Oxford, England: Oxford University Press, 1993.

Dodge Luhan, Mabel. *Intimate Memories: The Autobiography of Mabel Dodge Luhan*. Albuquerque: University of New Mexico Press, 1999.

———. "Speculations, or Post-Impressionism in Prose." *Arts & Decoration* 3, no. 5, 1913.

Duchamp, Marcel. "Armory Show Lecture, 1963." Recorded by Richard N. Miller. Transcription by Taylor M. Stapleton. *tout-fait*: The Marcel Duchamp Studies Online Journal, 2003.

———. "Letter from Marcel Duchamp to Walter Pach." 1913.

———. "The Nude-Descending-a-Staircase-Man Surveys Us." *New York Tribune*, September 12, 1915.

Duchamp-Villon, Raymond. "Letter from Raymond Duchamp-Villon to Walter Pach." 1913.

Eddy, Arthur Jerome. *Cubists and Post-Impressionism*. 2nd ed. Chicago: A.C. McClurg & Co., 1919.

Eksteins, Modris. *Rites of Spring: The Great War and the Birth of the Modern Age*. Boston: Houghton Mifflin Company, 1989.

Evans, R. Tripp. *Grant Wood: A Life*. New York: Alfred A. Knopf, 2010.

"Exhibition of Modern Art." *Bulletin of the Art Institute of Chicago* VI, no. IV (1913).

Fink, Lois Marie, and Joshua C. Taylor. *Academy: The Academic Tradition in American Art, an Exhibition Organized on the Occasion of the One Hundred and Fiftieth Anniversary of the National Academy of Design: 1825–1975*. Washington, D.C.: Smithsonian Institution Press, 1975.

Fleming, G.H. *Rossetti and the Pre-Raphaelite Brotherhood*. London: Rupert Hart-Davis, 1967.

The Forum Exhibition of Modern American Painters. Exhibition by The Forum Committee. New York: Anderson Galleries, 1916.

Fraina, Louis C. "The Social Significance of Futurism." *The New Review: A Monthly Review of International Socialism*, December 1913, 964–70.

French, William M.R. "Letter from William M.R. French to Charles Hutchinson." Department of Archives, the Art Institute of Chicago, 1913.

Gere, Charlotte, and Marina Vaizey. *Great Women Collectors*. London: Philip Wilson, 1999.

Gilbert, Jenny. "The Rite of Spring: Shock of the New." *The Independent*, April 6, 2013.

Glackens, William J. "The American Section: The National Art." *Arts & Decoration* 3, no. 5, 1913.

Gompertz, Will. "I Know a Lot About Art and I Know What I Hate." *The Times*, October 27, 2012.

Goode, Erich, and Nachman Ben-Yehuda. *Moral Panics: The Social Construction of Deviance*. Oxford, U.K.: Wiley-Blackwell, 2009.

Grant, Daniel. "Portrait of the Artist Before and After." *Humanities: The Magazine of the National Endowment for the Humanities*, 2010.

"The Great Armory Show of 1913: The Most Important Art Event of the Century Threw the People of the U.S. Into an Uproar." *LIFE*, January 2, 1950, 58–63.

Harris, Neil. "The Chicago Setting." In *The Old Guard and the Avant-Garde: Modernism in Chicago, 1910–1940*, edited by Sue Ann Prince, 3–22. Chicago: University of Chicago Press, 1990.

Hill, Peter. *Stravinsky: The Rite of Spring*, Cambridge Music Handbooks. Cambridge, U.K.: Cambridge University Press, 2000.

Homer, William Innes. *Robert Henri and His Circle*. Ithaca, N.Y.: Cornell University Press, 1969.

"Jackson Pollock: Is he the greatest living painter in the United States?" *LIFE*, August 8, 1949, 42–45.

Jones, Zoe Marie. "How Futurism Got Left Out at the Armory: A Case Study in the Politics and Exhibition and Its Repercussions." Presentation at the *College Art Association 101st Conference in New York*. New York, 2013.

Joselit, David. *American Art since 1945*. London, U.K.: Thames & Hudson Ltd., 2003.

Kahng, Eik, Charles Palermo, Harry Cooper, Annie Bourneuf, Christine Poggi, Claire Barry, and Bart J.C. Devolder. *Picasso and Braque: The Cubist Experiment 1910–1912*. Exhibition organized by the Santa Barbara Museum of Art and Fort Worth Kimbell Art Museum. New Haven, Conn.: Yale University Press, 2011.

Keay, Carolyn, and Thomas Walters. *Odilon Redon*. New York: Rizzoli, 1977.

Keck, Sheldon. "Some Picture Cleaning Controversies: Past and Present." *Journal of the American Institute for Conservation* 23, no. 2 (1984): 73–87.

King, Ross. *The Judgment of Paris: The Revolutionary Decade That Gave the World Impressionism*. New York: Walker & Company, 2006.

Krenn, Michael L. *Fall-Out Shelters for the Human Spirit: American Art and the Cold War*. Chapel Hill: University of North Carolina Press, 2005.

Kuhn, Walt. "The Story of the Armory Show." Archives of American Art, Smithsonian Institution, 1938.

———. "Walt Kuhn Family Papers and Armory Show Records." Archives of American Art, Smithsonian Institution, 1859–1978, Bulk 1900–1949.

Laurent, Jeanne, Pierre Vaisse, and Jacques Chardeau. "The New Caillebotte Affair." *October* 31, no. Winter, 1984 (1984): 36–90.

Lee, Simon. *David*. London, England: Phaidon Press Limited, 1999.

Leighton, Patricia. "Picasso's Collages and the Threat of War, 1912–13." *The Art Bulletin* 67, no. 4 (1985): 653–72.

Levin, Gail. *Edward Hopper: An Intimate Biography*. 2nd ed. New York: Rizzoli International, 2007.

Levy, Harriet Lane. *Paris Portraits: Stories of Picasso, Matisse, Gertrude Stein, and Their Circle*. Berkeley, Calif.: Heyday, 2011.

Lord, Walter. *The Good Years: From 1900 to the First World War*. New York: Harper, 1960.

Loughery, John. *John Sloan, Painter and Rebel*. New York: Henry Holt and Company, Inc., 1995.

Lyall, Mary Chase Mills. *The Cubies ABC*. Verses by Mary Mills Lyall. Pictures by Earl Harvey Lyall. New York: G.P. Putnam's Sons (Knickerbocker Press), 1913.

MacChesney, Clara T. "A Talk with Matisse, Leader of Post-Impressionists." *New York Times*, March 9, 1913.

MacKenzie, Mairi. *Isms: Understanding Fashion*. New York: Universe Publishing, 2010.

MacRae, Elmer Livingston. "Elmer Livingston MacRae Papers and Treasurer's Records, Association of American Painters and Sculptors, Inc.": Archives of American Art, Smithsonian Institution, 1899–1958 (Bulk 1899–1916).

Marquis, Alice Goldfarb. *Marcel Duchamp: The Bachelor Stripped Bare*. Boston: MFA Publications, a Division of the Museum of Fine Arts, Boston, 2002.

Martin, Richard. *Cubism and Fashion*. Exhibition organized by The Metropolitan Museum of Art. New York: The Metropolitan Museum of Art, 1998–99.

Martinez, Andrew. "A Mixed Reception for Moderism: The 1913 Armory Show at the Art Institute of Chicago." *Art Institute of Chicago Museum Studies* 19, no. 1, One Hundred Years at the Art Institute, A Centennial Celebration (1993): 30–57, 102–5.

Mather, Frank. J. Jr. "Art Old and New." *Nation*, March 6, 1913, 240–43.

McCarthy, Laurette E. *Walter Pach (1883–1958): The Armory Show and the Untold Story of Modern Art in America*. University Park: The Pennsylvania State University Press, 2011.

McCoy, Garnett. "The Post Impressionist Bomb." *Archives of American Art Journal* 20, no. 1 (1980): 12–17.

Mellow, James R. *Charmed Circle: Gertrude Stein & Company*. New York: Avon Books, 1974.

Merrick, L. "The Armory Show." *American Art News*, March 1, 1913, 2.

Miller, Sanda. *Constantin Brancusi*. London: Reaktion Books Ltd., 2010.

Myers, Jerome. *Artist in Manhattan*. New York: American Artists Group, 1940.

Naifeh, Steven, and Gregory White Smith. *Pollock: An American Saga*. New York: HarperPerennial, 1989.

Naumann, Francis M. *"Nude Descending a Staircase."* In *The Recurrent, Haunting Ghost: Essays on the Art, Life and Legacy of Marcel Duchamp*. New York: Readymade Press, 2012.

Nord, Philip. "The New Painting and the Dreyfus Affair." *Historical Reflections / Réflexions Historiques* 24, no. 1 (1998): 115–36.

Oaklander, Christine I. "Clara Davidge's Madison Art Gallery: Sowing the Seed for the Armory Show." *Archives of American Art Journal* 36, no. 3/4 (1996): 20–37.

O'Brien, Patrick. *Picasso: A Biography*. New York: W.W. Norton, 1976.

Ono, Yoko. *Grapefruit: A Book of Instructions and Drawings*. New York: Simon & Schuster, 1964.

Pach, Walter. "Letter from Walter Pach to Michael Stein." 1913.

———. *Queer Thing, Painting: Forty Years in the World of Art*. New York: Harper & Brothers Publishers, 1938.

———. "Walter Pach Papers." Archives of American Art, Smithsonian Institution, 1857–1980.

Perl, Jed. *New Art City: Manhattan at Mid-Century*. New York: Vintage Books, 2005.

Perlman, Bennard B., ed. *American Artists, Authors, and Collectors: The Walter Pach Letters*. Albany: State University of New York Press, 2002.

———. *The Lives, Loves, and Art of Arthur B. Davies*. Albany: State University of New York Press, 1999.

Perloff, Marjorie. *The Futurist Moment: Avant-Garde, Avant-Guerre, and the Language of Rupture*. 2nd ed. Chicago: University of Chicago Press, 2003.

Quinn, John. "Letters." In *John Quinn Papers, 1901–1926*. New York: New York Public Library.

Rabaté, Jean-Michel. *1913: The Cradle of Modernism*. Malden, Mass.: Blackwell Publishing, 2007.

Rainey, Lawrence, Christine Poggi, and Laura Wittman, eds. *Futurism: An Anthology*. New Haven, Conn.: Yale University Press, 2009.

Reid, B.L. *The Man from New York: John Quinn and His Friends*. New York: Oxford University Press, 1968.

Rewald, John. *Cézanne and America: Dealers, Collectors, Artists and Critics 1891–1921*. Princeton, N.J.: Princeton University Press, 1989.

Richardson, John, and Marilyn McCully. *A Life of Picasso: The Cubist Rebel, 1907–1916*. 3 vols. Vol. 2. New York: Alfred A. Knopf, 1996.

Roe, Sue, and Susan Sellers, eds. *The Cambridge Companion to Virginia Woolf*. Cambridge: Cambridge University Press, 2000.

Roosevelt, Theodore. "A Layman's View of an Art Exhibition." In *Documents of the 1913 Armory Show*. Tucson, Ariz.: Hol Art Books, 1913.

Rudnick, Lois Palken. *Mabel Dodge Luhan: New Woman, New Worlds*. Albuquerque: University of New Mexico Press, 1984.

Russell, Thomas Herbert. *The Girl's Fight for a Living: How to Protect Working Women from Dangers Due to Low Wages*. Chicago, Ill.: M.A. Donohue & Company, 1913.

Shaff, Howard, and Audrey Karl Shaff. *Six Wars at a Time: The Life and Times of Gutzon Borglum, Sculptor of Mount Rushmore*. Sioux Falls, S. Dak.: The Center for Western Studies, 1985.

Sheon, Aaron. "1913: Forgotten Cubist Exhibitions in America." *Arts Magazine* 57, March (1983): 93–107.

Sloan, John. *John Sloan's New York Scene: From the Diaries, Notes and Correspondence, 1906–1913*. New York: Harper & Row, Publishers, 1965.

Solomon, Deborah. *Jackson Pollock: A Biography*. New York: Simon and Schuster, 1987.

Spalding, Frances. *Roger Fry: Art and Life*. Berkeley: University of California Press, 1980.

Spencer, Christopher, David Willcock, John Bush, and Julia Cave. "A Wave from the Atlantic." In *PBS American Visions: The History of American Art and Architecture*. PBS Home Video, 1997.

Stavitsky, Gail, Laurette E. McCarthy, and Charles H. Duncan. *The New Spirit: American Art in the Armory Show, 1913*. Exhibition organized by the Montclair Art Museum. Montclair, N.J.: Montclair Art Museum, 2013.

Stieglitz, Arthur. "The First Great 'Clinic to Revitalize Art.'" *New York Journal-American*, January 26, 1913.

Taliaferro, John. *Great White Fathers: The True Story of Gutzon Borglum and His Obsessive Quest to Create the Mt. Rushmore National Monument*. New York: PublicAffairs, 2002.

Tarbell, Roberta K. "The Impact of the Armory Show on American Sculpture." *Archives of American Art Journal* 18, no. 2 (1978): 2–11.

Thornton, Sarah. *Seven Days in the Art World*. New York: W.W. Norton & Company, 2008.

Tomkins, Calvin. *Duchamp: A Biography*. New York: Henry Holt and Company, 1996.

Townsend, James B. "A Bomb from the Blue." *American Art News*, February 22, 1913, 9.

Tuchman, Barbara. *The Guns of August*. New York: Ballantine Books, 1962.

———. *The Proud Tower: A Portrait of the World before the War, 1890–1914*. New York: Ballantine Books, 1962.

von Drehle, David. *Triangle: The Fire That Changed America*. New York: Atlantic Monthly Press, 2003.

Wagner-Martin, Linda. *"Favored Strangers": Gertrude Stein and Her Family*. New Brunswick, N.J.: Rutgers University Press, 1995.

Washton Long, Rose-Carol, ed. *German Expressionism: Documents from the End of the Wilhelmine Empire to the Rise of National Socialism*. New York: G.K. Hall, 1993.

Wetzsteon, Ross. *Republic of Dreams: Greenwich Village: The American Bohemia, 1910–1960*. New York: Simon & Schuster, 2002.

Whelan, Richard. *Alfred Stieglitz, a Biography: Photography, Georgia O'Keeffe, and the Rise of the Avant-Garde in America*. Boston: Little, Brown and Company, 1995.

Williams, William Carlos. *The Autobiography of William Carlos Williams*. New York: Random House, 1948.

Witham, Larry. *Picasso and the Chess Player: Pablo Picasso, Marcel Duchamp, and the Battle for the Soul of Modern Art*. Lebanon, N.H.: University Press of New England, 2013.

Wood, Beatrice. "Marcel." In *Marcel Duchamp: Artist of the Century*, edited by Rudolf E. Kuenzli and Francis M. Naumann. Iowa City, Iowa: Association for the Study of Dada and Surrealism, The University of Iowa, 1989.

Zilczer, Judith. "The Dispersal of the John Quinn Collection." *Archives of American Art Journal* 19, no. 3 (1979): 15–21.

———. "'The World's New Art Center': Modern Art Exhibitions in New York City, 1913–1918." *Archives of American Art Journal* 14, no. 3 (1974): 2–7.

Notes

INTRODUCTION: MARCH 13, NEW YORK CITY

1 "Art and Artists," *New York Globe* and *Commercial Advertiser,* February 17, 1913.
2 Margaret Hubbard Ayer, "Calls Futurist and Cubist Art Brain Vagaries," *New York Journal-American,* March 10, 1913.
3 "Art and Artists."
4 "Nobody Who Has Been Drinking Is Let in to See This Show," *The World,* February 17, 1913.
5 "'There Is Her Neck! I've Found Her Eyes'—Talk at Cubist Show," *Evening Mail,* March 15, 1913.
6 J.A. Fitzgerald, "Flying Wedge of Futurists Armed with Paint and Brush Batters Line of Regulars in Terrific Art War," *New York Herald,* February 23, 1913.
7 Hutchins Hapgood, "Life at the Armory," *Globe* and *Commercial Advertiser,* February 17, 1913.
8 Edith Cary Hammond, "'Sensationalism' in Art," *New York Tribune,* March 11, 1913.
9 Walter Pach, *Queer Thing, Painting: Forty Years in the World of Art* (New York: Harper & Brothers Publishers, 1938), 15.
10 Ibid., 28.

CHAPTER 1: ITCHING FOR A FIGHT

1 Walt Kuhn, "Walt Kuhn Family Papers and Armory Show Records" (Archives of American Art, Smithsonian Institution, 1859–1978, Bulk 1900–1949), Box 3, Folder 46, 30–32.
2 Philip Rhys Adams, *Walt Kuhn, Painter: His Life and Work* (Columbus: Ohio State University Press, 1978), 24.
3 Kuhn, "Walt Kuhn Family Papers and Armory Show Records," Box 3, Folder 45, 12–15.
4 Adams, *Walt Kuhn, Painter: His Life and Work,* 9.
5 Kuhn, "Walt Kuhn Family Papers and Armory Show Records," Box 3, Folder 36, 33–35.
6 "History of the Academy," National Academy Museum and School, www.nationalacademy.org/history/academy/ (November 10, 2012).
7 Lois Marie Fink and Joshua C. Taylor, *Academy: The Academic Tradition in American Art, an Exhibition Organized on the Occasion of the One Hundred and Fiftieth*

Anniversary of the National Academy of Design: 1825–1975 (Washington, D.C.: Smithsonian Institution Press, 1975), 14.

8 "American Art from Different Points of View," *New York Times*, October 11, 1908.

9 "National Academy Elects 3 out of 36: 'Progressive' Painters Criticize the 'Conservatives,'Who Are in Control," *New York Times*, April 14, 1907.

10 Simon Lee, *David* (London: Phaidon Press Limited, 1999), 129–31.

11 Ross King, *The Judgment of Paris: The Revolutionary Decade That Gave the World Impressionism* (New York: Walker & Company, 2006), 171.

12 "Academicians Elected; National Academy and American Artists Ratify Their Merger," *New York Times*, May 10, 1906.

13 Walter Pach, *Queer Thing, Painting: Forty Years in the World of Art* (New York: Harper & Brothers Publishers, 1938), 119.

14 "For Art Building in Park: National Academy of Design Wants Site of the Old Arsenal," *New York Times*, February 16, 1909.

15 "National Academy Elects 3 out of 36: 'Progressive' Painters Criticize the 'Conservatives,'Who Are in Control."

16 William Innes Homer, *Robert Henri and His Circle* (Ithaca, N.Y.: Cornell University Press, 1969), 7–20.

17 Ibid., 128–30.

18 Christopher Spencer et al., "A Wave from the Atlantic," in *PBS American Visions: The History of American Art and Architecture* (PBS Home Video, 1997).

19 Homer, *Robert Henri and His Circle*, 138.

20 Kuhn, "Walt Kuhn Family Papers and Armory Show Records," Box 3, Folder 46, 46–42.

21 Ibid., Box 3, Folder 46, 47–57.

22 Ibid.

23 "Artists in Revolt, Form New Society," *New York Times*, January 3, 1912.

24 Milton W. Brown, *The Story of the Armory Show*, Second ed. (New York: Abbeville Press, 1988), 54.

25 Bennard B. Perlman, *The Lives, Loves, and Art of Arthur B. Davies* (Albany: State University of New York Press, 1999), 33–48.

26 Guy Pène du Bois, *Artists Say the Silliest Things* (New York: American Artists Group, Inc./Duell, Sloan and Pearce, Inc., 1940), 174.

27 Pach, *Queer Thing, Painting: Forty Years in the World of Art*, 177–78.

28 Brown, *The Story of the Armory Show*, 61–62.

CHAPTER 2: GATHERING THE AMMUNITION

1 Smithsonian Institution, "Handbook of Travel, with Hints for the Ocean Voyage, for European Tours and a Practical Guide to London and Paris" (Gjenvick-Gjønvik Archives, 1910).

2 "On Pier, Sees Her Ship Sail; Her Hat, Clothes, and Money Go without Her, but She Gets Another Ship," *New York Times*, June 18, 1911.

3 Kuhn,"Walt Kuhn Family Papers and Armory Show Records"(Archives of American Art, Smithsonian Institution, 1859–1978, Bulk 1900–1949), Box 1, Folder 3, 2–5.

4 ———, "The Story of the Armory Show" (Archives of American Art, Smithsonian Institution, 1938), Box 2, Folder 47, 6.

5 ———, "Walt Kuhn Family Papers and Armory Show Records," Box 1, Folder 3, 2–5.

6 Bennard B. Perlman, *The Lives, Loves, and Art of Arthur B. Davies* (Albany: State University of New York Press, 1999), 203.

7 William Innes Homer, *Robert Henri and His Circle* (Ithaca, N.Y.: Cornell University Press, 1969), 168.

8 Philip Rhys Adams, *Walt Kuhn, Painter: His Life and Work* (Columbus: Ohio State University Press, 1978), 13.

9 Virginia Cowles, *1913: An End and a Beginning* (New York: Harper & Row, 1967), 62–73.

10 Ibid., 58.

11 Barbara Tuchman, *The Proud Tower: A Portrait of the World before the War, 1890–1914* (New York: Ballantine Books, 1962), 303.

12 "German Art Expansion," *New York Times,* July 3, 1905.

13 "Kaiser's Views on Art. Reichstag Resents Imperial Interference with the St. Louis Exhibit," *New York Times,* February 21, 1904.

14 Figura Starr, *German Expressionism: Works from the Collection > Cologne Sonderbund,* Museum of Modern Art (November 15, 2012).

15 Rose-Carol Washton Long, ed. *German Expressionism: Documents from the End of the Wilhelmine Empire to the Rise of National Socialism* (New York: G.K. Hall, 1993), 16.

16 Kuhn, "Walt Kuhn Family Papers and Armory Show Records," Box 1, Folder 3, 16.

17 Ibid.

18 Sheldon Keck, "Some Picture Cleaning Controversies: Past and Present," *Journal of the American Institute for Conservation* 23, no. 2 (1984): 75.

19 G.H. Fleming, *Rossetti and the Pre-Raphaelite Brotherhood* (London: Rupert Hart-Davis, 1967), 45–46.

20 Kuhn, "Walt Kuhn Family Papers and Armory Show Records," Box 1, Folder 3, 16.

21 Bruce Altshuler and Phaidon Editors, *Salon to Biennial: Exhibitions That Made Art History* (New York: Phaidon Press, 2008), 168.

22 Kuhn, "Walt Kuhn Family Papers and Armory Show Records," Box 1, Folder 1, 6.

23 Perlman, *The Lives, Loves, and Art of Arthur B. Davies,* 209.

24 John Rewald, *Cézanne and America: Dealers, Collectors, Artists and Critics 1891–1921* (Princeton, N.J.: Princeton University Press, 1989), 167.

25 Kuhn, "Walt Kuhn Family Papers and Armory Show Records," Box 1, Folder 3, 37.

26 Ibid., Box 1, Folder 3, 40.

CHAPTER 3: RECRUITING ALLIES

1 James R. Mellow, *Charmed Circle: Gertrude Stein & Company* (New York: Avon Books, 1974), 13–24.

2 Linda Wagner-Martin, *"Favored Strangers": Gertrude Stein and Her Family* (New Brunswick, N.J.: Rutgers University Press, 1995), 97.

3 Kuhn, "Walt Kuhn Family Papers and Armory Show Records" (Archives of American Art, Smithsonian Institution, 1859–1978, Bulk 1900–1949), Box 1, Folder 4, 23.

4 Jean-Michel Rabaté, *1913: The Cradle of Modernism* (Malden, Mass.: Blackwell Publishing, 2007), 73.

5 Jeanne Laurent, Pierre Vaisse, and Jacques Chardeau, "The New Caillebotte Affair," *October 31,* no. Winter 1984 (1984): 75–76.

6 Laurette E. McCarthy, *Walter Pach (1883–1958): The Armory Show and the Untold Story of Modern Art in America* (University Park: The Pennsylvania State University Press, 2011), 29.

7 Bennard B. Perlman, *The Lives, Loves, and Art of Arthur B. Davies* (Albany: State University of New York Press, 1999), 182.

8 McCarthy, *Walter Pach (1883–1958): The Armory Show and the Untold Story of Modern Art in America,* 40.

9 Walter Pach, *Queer Thing, Painting: Forty Years in the World of Art* (New York: Harper & Brothers Publishers, 1938), 104.

10 Ibid., 125.

11 Janet Bishop, Cécile Debray, and Rebecca Rabinow, eds., *The Steins Collect: Matisse, Picasso, and the Parisian Avant-Garde* (San Francisco: San Francisco Museum of Modern Art in association with Yale University Press, 2011), 21.

12 Mellow, *Charmed Circle: Gertrude Stein & Company,* 125.

13 Wagner-Martin, *"Favored Strangers": Gertrude Stein and Her Family,* 88–89, 92–96, passim.

14 John Richardson and Marilyn McCully, *A Life of Picasso: The Cubist Rebel, 1907–1916,* 3 vols., vol. 2 (New York: Alfred A. Knopf, 1996), 72.

15 Mellow, *Charmed Circle: Gertrude Stein & Company,* 102–6.

16 Ibid., 20.

17 Bishop, Debray, and Rabinow, eds., *The Steins Collect: Matisse, Picasso, and the Parisian Avant-Garde,* 60.

18 Patrick O'Brien, *Picasso: A Biography* (New York: W.W. Norton, 1976), 133–38.

19 Mellow, *Charmed Circle: Gertrude Stein & Company,* 113.

20 Ibid., 119–20.

21 Ibid., 143.

22 Neil Cox, *Cubism, Art & Ideas* (London: Phaidon Press, 2000), 73–132.

23 Ibid., 111.

24 Eik Kahng et al., *Picasso and Braque: The Cubist Experiment 1910–1912,* ed. Santa Barbara Museum of Art and Fort Worth Kimbell Art Museum (New Haven, Conn.: Yale University Press, 2011), 80–81.

25 Mellow, *Charmed Circle: Gertrude Stein & Company,* 195.

26 Ibid., 19–25.

27 Bishop, Debray, and Rabinow, eds., *The Steins Collect: Matisse, Picasso, and the Parisian Avant-Garde,* 55.

28 McCarthy, *Walter Pach (1883–1958): The Armory Show and the Untold Story of Modern Art in America,* 34.

29 Pach, *Queer Thing, Painting: Forty Years in the World of Art,* 118.

30 Kuhn, "Walt Kuhn Family Papers and Armory Show Records," Box 1, Folder 83, 1.

31 Richardson and McCully, *A Life of Picasso: The Cubist Rebel, 1907–1916,* 211.

32 Pach, *Queer Thing, Painting: Forty Years in the World of Art,* 51, 143.

33 Kuhn, "Walt Kuhn Family Papers and Armory Show Records," Box 1, Folder 3, 59–60.

34 Calvin Tomkins, *Duchamp: A Biography* (New York: Henry Holt and Company, 1996), 81–82.

35 Ibid., 83.

36 Perlman, *The Lives, Loves, and Art of Arthur B. Davies*, 214.

37 Kuhn, "Walt Kuhn Family Papers and Armory Show Records," Box 1, Folder 4, 12.

38 Sanda Miller, *Constantin Brancusi* (London: Reaktion Books Ltd., 2010), 7–44.

39 Pach, *Queer Thing, Painting: Forty Years in the World of Art*, 178.

40 Ibid.

41 McCarthy, *Walter Pach (1883–1958): The Armory Show and the Untold Story of Modern Art in America*, 44.

42 Kuhn, "Walt Kuhn Family Papers and Armory Show Records," Box 1, Folder 1, 18.

43 Frances Spalding, *Roger Fry: Art and Life* (Berkeley: University of California Press, 1980), 131–41.

44 Sue Roe and Susan Sellers, eds., *The Cambridge Companion to Virginia Woolf* (Cambridge: Cambridge University Press, 2000), 168.

45 Spalding, *Roger Fry: Art and Life*, 156–58.

46 Kuhn, "The Story of the Armory Show," 11.

47 ———, "Walt Kuhn Family Papers and Armory Show Records," Box 1, Folder 7, 14.

48 Ibid., Box 1, Folder 4, 31.

49 Ibid., Box 1, Folder 4, 30–34.

50 Ibid., Box 1, Folder 1, 10–14.

51 Ibid., Box 1, Folder 4, 31.

CHAPTER 4: PLANNING THE ATTACK

1 Walt Kuhn, "Walt Kuhn Family Papers and Armory Show Records" (Archives of American Art, Smithsonian Institution, 1859–1978, Bulk 1900–1949), Box 1, Folder 4, 53.

2 Ibid., Box 1, Folder 4, 53–55.

3 David von Drehle, *Triangle: The Fire That Changed America* (New York: Atlantic Monthly Press, 2003), 14, 101.

4 Walter Lord, *The Good Years: From 1900 to the First World War* (New York: Harper, 1960), 321.

5 von Drehle, *Triangle: The Fire That Changed America*, 215.

6 Missouri Bureau of Labor Statistics, "The Thirty-Fifth Annual Report" (Jefferson City: Missouri Bureau of Labor Statistics, November 5, 1913), 628.

7 von Drehle, *Triangle: The Fire That Changed America*, passim.

8 Lord, *The Good Years: From 1900 to the First World War*, 108.

9 John Milton Cooper Jr., *Pivotal Decades: The United States, 1900–1920* (New York: W.W. Norton & Company, 1990), 133.

10 von Drehle, *Triangle: The Fire That Changed America*, 18.

11 Cooper, *Pivotal Decades: The United States, 1900–1920*, 163–89.

12 Ibid., 188.

13 Ross Wetzsteon, *Republic of Dreams: Greenwich Village: The American Bohemia, 1910–1960* (New York: Simon & Schuster, 2002), 15–29.

14 Robert M. Crunden, *American Salons: Encounters with European Modernism, 1885–1917* (Oxford, England: Oxford University Press, 1993), 383–95.

15 Wetzsteon, *Republic of Dreams: Greenwich Village, the American Bohemia, 1910–1960*, 23–24.

16 "Hippodrome's Opening Seen by Thousands; Novel Programme That Includes Circus, War, and Ballet; Passes Off without Hitch," *New York Times*, April 13, 1905.

17 Virginia Cowles, *1913: An End and a Beginning* (New York: Harper & Row, 1967), 235–36.

18 "Social Workers See Real 'Turkey Trots'; Shudder at 'the Shiver,' Gasp at 'the Bunny Hug,' and Then Discuss Reforms," *New York Times*, January 27, 1912.

19 "'Turkey Trot' at Newport. Society Also Dances 'the Grizzly' between Dinner Courses," *New York Times*, November 4, 1911.

20 Kuhn, "Walt Kuhn Family Papers and Armory Show Records," Box 1, Folder 4, 48.

21 Ibid., Box 1, Folder 7, 10–15.

22 Milton W. Brown, *The Story of the Armory Show*, Second ed. (New York: Abbeville Press, 1988), 91.

23 Gail Stavitsky, Laurette E. McCarthy, and Charles H. Duncan, *The New Spirit: American Art in the Armory Show, 1913*, ed. Montclair Art Museum (Montclair, N.J.: Montclair Art Museum, 2013), 19.

24 Kuhn, "Walt Kuhn Family Papers and Armory Show Records," Box 1, Folder 54, 1–7.

25 Ibid., Box 1, Folder 4, 49.

26 B.L. Reid, *The Man from New York: John Quinn and His Friends* (New York: Oxford University Press, 1968), 93–111.

27 Ibid., 142.

28 John Quinn to Walt Kuhn, January 6, 1913, John Quinn, "Letters," in John Quinn Papers, 1901–1926 (New York: New York Public Library, 1913), Reel 21, Box 25, Folder 5–6.

29 John Quinn to Augustus John, December 7, 1912, ibid., Reels A1–A2, Box 22.

30 Christine I. Oaklander, "Clara Davidge's Madison Art Gallery: Sowing the Seed for the Armory Show," *Archives of American Art Journal* 36, no. 3/4 (1996): 20–37.

31 Bennard B. Perlman, *The Lives, Loves, and Art of Arthur B. Davies* (Albany: State University of New York Press, 1999), 216–17.

32 Brown, *The Story of the Armory Show*, 82.

33 Oaklander, "Clara Davidge's Madison Art Gallery: Sowing the Seed for the Armory Show," 30.

34 Crunden, *American Salons: Encounters with European Modernism, 1885–1917*, 394.

35 Reid, *The Man from New York: John Quinn and His Friends*, 157.

36 Brown, *The Story of the Armory Show*, 95.

37 Jay Bochner, *An American Lens: Scenes from Alfred Stieglitz's New York Secession* (Cambridge, Mass.: The MIT Press, 2005), 62–64.

38 Richard Whelan, *Alfred Stieglitz, a Biography: Photography, Georgia O'Keeffe, and the Rise of the Avant-Garde in America* (Boston: Little, Brown and Company, 1995), 265–66, 309.

39 Kuhn, "Walt Kuhn Family Papers and Armory Show Records," Box 1, Folder 9, 4.

40 Guy Pène du Bois, *Artists Say the Silliest Things* (New York: American Artists Group, Inc./Duell, Sloan and Pearce, Inc., 1940), 174.

41 Brown, *The Story of the Armory Show*, 82.

42 Howard Shaff and Audrey Karl Shaff, *Six Wars at a Time: The Life and Times of Gutzon Borglum, Sculptor of Mount Rushmore* (Sioux Falls, South Dakota: The Center for Western Studies, 1985), 88.

43 Ibid., 87.

44 Pène du Bois, *Artists Say the Silliest Things*, 174.

45 Shaff and Shaff, *Six Wars at a Time: The Life and Times of Gutzon Borglum, Sculptor of Mount Rushmore*, 72–73.

46 Roberta K. Tarbell, "The Impact of the Armory Show on American Sculpture," *Archives of American Art Journal* 18, no. 2 (1978): 2–4.

47 Kuhn, "Walt Kuhn Family Papers and Armory Show Records," Box 3, Folder 3, 10–15.

48 Ibid.

49 Ibid., Box 3, Folder 3, 16.

50 Gutzon Borglum, "The Revolt in Art," *The Lotus Magazine* 9, no. 5 (1819): 216.

51 Kuhn, "Walt Kuhn Family Papers and Armory Show Records," Box 1, Folder 4, 47–50.

52 "Coming Painters and Sculptor's Show," *American Art News*, February 15, 1913.

53 Brown, *The Story of the Armory Show*, 106.

54 Jerome Myers, *Artist in Manhattan* (New York: American Artists Group, 1940), 36.

CHAPTER 5: OPENING THE OFFENSIVE

1 Jerome Myers, *Artist in Manhattan* (New York: American Artists Group, 1940), 36.

2 "2,000 at Art Exhibit; Heralded as Epoch-Making Collection in Our History," *New York Tribune*, February 18, 1913.

3 Bennard B. Perlman, *The Lives, Loves, and Art of Arthur B. Davies* (Albany: State University of New York Press, 1999), 230.

4 "2,000 at Art Exhibit; Heralded as Epoch-Making Collection in Our History."

5 Joel E. Spingarn, "Art Madness Recaptured; That, Says Spingarn, Is the International Exhibition," *New York Evening Post*, February 25, 1913.

6 "International Art Show a Sensation; American Painters and Sculptors Open Their First Exhibition at Armory; an Extraordinary Array," *New York Sun*, February 18, 1913.

7 Walt Kuhn, "The Story of the Armory Show" (Archives of American Art, Smithsonian Institution, 1938), 14.

8 Gail Stavitsky, Laurette E. McCarthy, and Charles H. Duncan, *The New Spirit: American Art in the Armory Show, 1913*, ed. Montclair Art Museum (Montclair, N.J.: Montclair Art Museum, 2013), 21.

9 Christine I. Oaklander, "Clara Davidge's Madison Art Gallery: Sowing the Seed for the Armory Show," *Archives of American Art Journal* 36, no. 3/4 (1996), 23, 30–31.

10 Myers, *Artist in Manhattan*, 35.

11 All information regarding the art on display at the show is from the Catalogue Raisonne in Milton W. Brown, *The Story of the Armory Show*, Second ed. (New York: Abbeville Press, 1988), 241–327.

12 Zoe Marie Jones, "How Futurism Got Left Out at the Armory: A Case Study in the Politics and Exhibition and Its Repercussions," in College Art Association 101st Conference in New York (New York, 2013).

13 Arthur Jerome Eddy, *Cubists and Post-Impressionism*, 2 ed. (Chicago: A.C. McClurg & Co., 1919), 6.

14 Roberta K. Tarbell, "The Impact of the Armory Show on American Sculpture," *Archives of American Art Journal* 18, no. 2 (1978), 4–7.

15 Perlman, *The Lives, Loves, and Art of Arthur B. Davies*, 231.

16 "'There Is Her Neck! I've Found Her Eyes'—Talk at Cubist Show," *Evening Mail*, March 15, 1913.

17 Brown, *The Story of the Armory Show*, 109.

18 Arthur Stieglitz, "The First Great 'Clinic to Revitalize Art,'" *New York Journal-American*, January 26, 1913.

19 "International Art Show a Sensation; American Painters and Sculptors Open Their First Exhibition at Armory; an Extraordinary Array."

20 Charles H. Caffin, "International Exhibition Is a Sensation," *New York Journal-American*, February 24, 1913.

21 Nixola Greeley-Smith, "An Alienist Will Charge You $5000 to Tell You If You're Crazy; Go to the Cubist Show and You'll Be Sure of It for a Quarter," *Evening World*, February 22, 1913.

22 Joseph Edgar Chamberlin, "More of the International Exhibition," *The Evening Mail*, February 21, 1913.

23 Hutchins Hapgood, "Life at the Armory," *Globe and Commercial Advertiser*, February 17, 1913, 8.

24 "The 'Ism' Exhibition; Painting and Sculpture at the 69the Regiment Armory," *New York Sun*, February 17, 1913.

25 Greeley-Smith, "An Alienist Will Charge You $5000 to Tell You If You're Crazy; Go to the Cubist Show and You'll Be Sure of It for a Quarter."

26 Royal Cortissoz, "The Post-Impressionist and Cubist Vagaries," *New York Tribune*, February 23, 1913.

27 Kenyon Cox, "The 'Modern' Spirit in Art: Some Reflections Inspired by the Recent International Exhibition," *Harper's Weekly*, March 15 1913, 10.

28 Edith Cary Hammond, "'Sensationalism' in Art," *New York Tribune*, March 11, 1913, 8.

29 Adeline Adams, "The Secret of Life: Suggested by a Visit to the International Exhibition of Modern Art," *Art and Progress*, April 1913, 928.

30 L. Merrick, "The Armory Show," *American Art News*, March 1, 1913, 2. Frank. J. Mather, Jr., "Art Old and New," *Nation*, March 6, 1913. "The International Art Exhibition," *New York Post*, February 18, 1913.

31 "History of Modern Art at the International Exhibition Illustrated by Paintings and Sculpture," *New York Times*, February 23, 1913.

32 David Cottington, *Cubism in the Shadow of War: The Avant-Garde and Politics in Paris 1905–1914* (New Haven, Conn.: Yale University Press, 1998), 9.

33 "History of Modern Art at the International Exhibition Illustrated by Paintings and Sculpture."

34 William B. McCormick, "Art Works of Cubists, Futurists, and Post-Impressionists Interest Public Most," *New York Press*, February 23, 1913.

35 "History of Modern Art at the International Exhibition Illustrated by Paintings and Sculpture."

36 "She Must Have Been Going Fast Indeed," *Evening Journal* (1913). Quoted in Elmer Livingston MacRae, "Elmer Livingston Macrae Papers and Treasurer's Records, Association of American Painter's and Sculptors, Inc." (Archives of American Art, Smithsonian Institution, 1899–1958, Bulk 1899–1916).

37 "Topics of the Times: Innocence as an Art Critic," *New York Times,* March 1, 1913.

38 "The Armory Puzzle," *American Art News,* March 1, 1913, 3.

39 "Elmer Livingston Macrae Papers and Treasurer's Records, Association of American Painter's and Sculptors, Inc," (Archives of American Art, Smithsonian Institution, 1899–1958, Bulk 1899–1916).

40 Ibid.

41 Walt Kuhn, "Walt Kuhn Family Papers and Armory Show Records" (Archives of American Art, Smithsonian Institution, 1859–1978, Bulk 1900–1949), Box 1, Folder 21, 38.

42 "'There Is Her Neck! I've Found Her Eyes'—Talk at Cubist Show."

43 Maria Lluïsa Borràs, *Picabia* (New York: Rizzoli International, 1985), 15, 49–50, 88–95.

44 Alice Goldfarb Marquis, *Marcel Duchamp: The Bachelor Stripped Bare* (Boston: MFA Publications, a Division of the Museum of Fine Arts, Boston, 2002), 88.

45 William A. Camfield, *Francis Picabia: His Art, Life and Times* (Princeton, N.J.: Princeton University Press, 1979), 40–41.

46 "Cubism the One Art, Says Its Champion," *New York Sun,* January 21, 1913, 9.

47 "Picabia, Art Rebel, Here to Teach New Movement," *New York Times,* February 16, 1913.

48 Ibid.

49 "A Post-Cubist's Impressions of New York," *New York Tribune,* March 9, 1913.

50 "Caruso a Cubist at International Exhibit," *New York Sun,* March 2, 1913.

51 Kuhn, "The Story of the Armory Show," 17.

52 Walter Pach, *Queer Thing, Painting: Forty Years in the World of Art* (New York: Harper & Brothers Publishers, 1938), 200.

53 Brown, *The Story of the Armory Show,* 144.

54 Guy Pène du Bois, *Artists Say the Silliest Things* (New York: American Artists Group, Inc./Duell, Sloan and Pearce, Inc., 1940), 166.

55 Charles Vezin, "Congratulates Mr. Borglum," *New York Tribune,* February 11, 1913.

56 Mabel Dodge Luhan, *Intimate Memories: The Autobiography of Mabel Dodge Luhan* (Albuquerque: University of New Mexico Press, 1999), 110.

57 Louis C. Fraina, "The Social Significance of Futurism," *The New Review: A Monthly Review of International Socialism,* December 1913, 964–70.

58 William Carlos Williams, *The Autobiography of William Carlos Williams* (New York: Random House, 1948), 134.

59 Perlman, *The Lives, Loves, and Art of Arthur B. Davies,* 232.

60 Myers, *Artist in Manhattan,* 37.

61 Pène du Bois, *Artists Say the Silliest Things,* 175.

62 John Loughery, *John Sloan, Painter and Rebel* (New York: Henry Holt and Company, Inc., 1995), 190.

63 Myers, *Artist in Manhattan,* 36.

64 Stieglitz, "The First Great 'Clinic to Revitalize Art.'"

65 Perlman, *The Lives, Loves, and Art of Arthur B. Davies*, 222.
66 Myers, *Artist in Manhattan*, 36.

CHAPTER 6: PLANNING THE COUNTERATTACK

1 Walt Kuhn, "Walt Kuhn Family Papers and Armory Show Records" (Archives of American Art, Smithsonian Institution, 1859–1978, Bulk 1900–1949), Box 2, Folder 39, 1.
2 "Art Dinner; Press Committee Celebrates International Exhibition's Success," *Globe and Commercial Advertiser*, March 10, 1913.
3 "50,000 Visit Art Show," *New York Times*, March 9, 1913.
4 Milton W. Brown, *The Story of the Armory Show*, Second ed. (New York: Abbeville Press, 1988), 151–52.
5 "Art 'Beefsteak' Dinner," *American Art News*, March 15, 1913.
6 John Loughery, *John Sloan, Painter and Rebel* (New York: Henry Holt and Company, Inc., 1995), 188–89.
7 "125 Art Works Sold," *New York Sun*, March 6, 1913, 9.
8 Walt Kuhn, "The Story of the Armory Show" (Archives of American Art, Smithsonian Institution, 1938), 18.
9 Guy Pène du Bois, *Artists Say the Silliest Things* (New York: American Artists Group, Inc./Duell, Sloan and Pearce, Inc., 1940), 170.
10 Walter Pach, *Queer Thing, Painting: Forty Years in the World of Art* (New York: Harper & Brothers Publishers, 1938), 161.
11 Brown, *The Story of the Armory Show*, 147.
12 "French Artist at Odds with N.Y. Exhibitors," *New York Tribune*, March 2, 1913.
13 Richard Whelan, *Alfred Stieglitz, a Biography: Photography, Georgia O'Keeffe, and the Rise of the Avant-Garde in America* (Boston: Little, Brown and Company, 1995), 316.
14 Brown, *The Story of the Armory Show*, 148.
15 "Futurist Art," *St. Louis Globe Democrat*, February 22, 1913. "Snapshot of a Real Nightmare," *Tacoma Times*, March 19, 1913.
16 George Fitch, "Cubist Art," *El Paso Herald*, April 21, 1913.
17 "Cubists' Weird Art Disappoints Carr," *University Missourian*, April 1, 1913.
18 Kuhn, "Walt Kuhn Family Papers and Armory Show Records," Box 1, Folders 43–60.
19 Clara T. MacChesney, "A Talk with Matisse, Leader of Post-Impressionists," *New York Times*, March 9, 1913.
20 Mabel Dodge, "Speculations, or Post-Impressionism in Prose," *Arts & Decoration* 1913.
21 Bert Leston Taylor, "A Line-O'-Type or Two," *Chicago Daily Tribune*, February 28, 1913, 6.
22 ———, "A Line-O'-Type or Two," *Chicago Tribune*, February 19, 1913.
23 "A Cubist Romance," *Omaha Bee*, April 10, 1913, 6.
24 "The Armory Puzzle," *American Art News*, March 8 1913, 4.
25 John T. McCutcheon, "How to Become a Post-Impressionist Paint Slinger," 1913. "The 'New Art' Fest! With Explanatory Diagram," 1913.
26 John M. Baer, "As Futurist and Cubist Artists See the National Game," 1913.

27 J.F. Griswold, "Seeing New York with a Cubist. The Rude Descending a Staircase," 1913.

28 Mary Chase Mills Lyall, *The Cubies ABC*, Versed by Mary Mills Lyall; Pictured by Earl Harvey Lyall (New York: G.P. Putnam's Sons (Knickerbocker Press, 1913). From the General Collection, Beineck Rare Book and Manuscript Library, Yale University.

29 Mairi MacKenzie, Isms: *Understanding Fashion* (New York: Universe Publishing, 2010).

30 "Now Comes the 'Cubist' Gown to Conceal the Angularities," *Denver Post*, April 4, 1913.

31 The John Wanamaker Store, "Color Combinations of the Futurists; Cubist Influence in Fashions" (*The Evening World*, 1913).

32 "Futurism Affects Spring Fashions," *Evening Record*, April 4, 1913.

33 "City Social Notes—Club News," *New York Times*, March 9, 1913.

34 "Cubism at the Table," *Grand Rapids Press*, August 12, 1913.

35 "Outcubing the Cubists," *New York Times*, March 13, 1913.

36 "Julian's Anciens Burlesque Cubists," *New York Times*, March 18, 1913.

37 "Outstrip Cubists in Their Own Art," *New York Times*, March 23, 1913.

38 "Cubists Burlesqued in Real Art Spasms," *New York Sun*, March 23, 1913.

39 "Job Hedges Shines as Art Auctioneer," *New York Times*, April 23, 1913.

40 Pach, *Queer Thing, Painting: Forty Years in the World of Art*, 199.

41 Theodore Roosevelt, "A Layman's View of an Art Exhibition," in *Documents of the 1913 Armory Show* (Tucson, Ariz.: Hol Art Books, 1913), 49–54.

42 Joseph Edgar Chamberlin, "More of the International Exhibition," *The Evening Mail*, February 21, 1913.

43 William B. McCormick, "Success of the International Exhibition Disproves Statements That Art Is Dead," *New York Press*, March 2, 1913. "The Armory Exhibition," *American Art News*, 1913.

44 "American Pictures at the International Exhibition Show Influence of Modern Foreign Schools," *New York Times*, March 2, 1913.

45 William J. Glackens, "The American Section: The National Art," *Arts & Decoration* 1913, 161.

46 Gail Stavitsky, Laurette E. McCarthy, and Charles H. Duncan, *The New Spirit: American Art in the Armory Show, 1913*, ed. Montclair Art Museum (Montclair, N.J.: Montclair Art Museum, 2013), 100–9.

47 Ibid., 106.

48 Pach, *Queer Thing, Painting: Forty Years in the World of Art*, 199.

49 "'There Is Her Neck! I've Found Her Eyes'—Talk at Cubist Show," *Evening Mail*, March 15, 1913.

50 "10,300 See Modern Art Show on Its Last Day," *New York Press*, March 16, 1913. "Cubists Migrate; Thousands Mourn," *New York Sun*, March 16, 1913.

51 Jerome Myers, *Artist in Manhattan* (New York: American Artists Group, 1940), 37.

52 Almost every account of the Armory Show mentions the closing-night party, among them Pach, *Queer Thing, Painting: Forty Years in the World of Art*, 203; Kuhn, "The Story of the Armory Show," 19-20; and Brown, *The Story of the Armory Show*, 188–89.

CHAPTER 7: RAIDING ENEMY TERRITORY

1 Andrew Martinez, "A Mixed Reception for Moderism: The 1913 Armory Show at the Art Institute of Chicago," *Art Institute of Chicago Museum Studies* 19, no. 1 (One Hundred Years at the Art Institute, A Centennial Celebration, 1993): 46–47.

2 Walt Kuhn, "Walt Kuhn Family Papers and Armory Show Records" (Archives of American Art, Smithsonian Institution, 1859–1978, Bulk 1900–1949), Box 1, Folder 5, 1–6.

3 Neil Harris, "The Chicago Setting," in *The Old Guard and the Avant-Garde: Modernism in Chicago, 1910–1940,* ed. Sue Ann Prince (Chicago: University of Chicago Press, 1990), 3–22.

4 Martinez, "A Mixed Reception for Moderism: The 1913 Armory Show at the Art Institute of Chicago," 37.

5 William M.R. French, "Letter from William M.R. French to Charles Hutchinson" (Department of Archives, the Art Institute of Chicago,1913). Quoted in Martinez, "A Mixed Reception for Moderism: The 1913 Armory Show at the Art Institute of Chicago."

6 "Exhibition of Modern Art," *Bulletin of the Art Institute of Chicago* VI, no. IV (1913).

7 "Director French Flees Deluge of Cubist Art," *Chicago Record-Herald,* March 21, 1913.

8 Harriet Monroe, "Bedlam in Art; a Show That Clamors," *Chicago Daily Tribune,* February 16, 1913. ———, "Art Show Open to Freaks; American Exhibition in New York Teems with the Bizarre," *Chicago Daily Tribune,* February 17, 1913.

9 "Art Freaks in Chicago," *Rockford Republic,* March 22, 1913.

10 Herman Landon, "Hark! Hark! The Critics Bark! The Cubists Are Coming," *Chicago Sunday Record-Herald,* March 23, 1913.

11 "'I See It,' Says Mayor at Cubists' Art Show," *Chicago Record-Herald,* March 28, 1913.

12 "Here She Is: White Outline Shows 'Nude Descending a Staircase," *Chicago Daily Tribune,* March 24, 1913.

13 "Explain Cubist Array as Move to Teach City," *Chicago Examiner,* March 25, 1913.

14 "Last Art Spasm Is Weird Sight," *Los Angeles Times,* March 24, 1913.

15 "'I See It,' Says Mayor at Cubists' Art Show."

16 "May Bar Youngsters from Cubists' Show," *Chicago Record-Herald,* March 29, 1913.

17 Erich Goode and Nachman Ben-Yehuda, *Moral Panics: The Social Construction of Deviance* (Oxford, U.K.: Wiley-Blackwell, 2009), 6–7.

18 Thomas Herbert Russell, *The Girl's Fight for a Living: How to Protect Working Women from Dangers Due to Low Wages* (Chicago: M.A. Donohue & Company, 1913), 32–33.

19 Bennard B. Perlman, *The Lives, Loves, and Art of Arthur B. Davies* (Albany: State University of New York Press, 1999), 189–92.

20 "His Pictures Too Natural; WCTU of Queens Objects to Parmalee's Unclad Figures," *New York Times,* September 26, 1912.

21 "'Slave' Commission to Probe Cube Art," *Chicago Inter-Ocean,* April 2, 1913.

22 "Cubist Art Called Lewd," *Chicago American*, April 2, 1913.
23 Walter Pach, *Queer Thing, Painting: Forty Years in the World of Art* (New York: Harper & Brothers Publishers, 1938), 195.
24 "Vice Probers Score Cubists," *New York Evening Mail*, April 4, 1913.
25 Pach, *Queer Thing, Painting: Forty Years in the World of Art*, 196–97.
26 ———, "Letter from Walter Pach to Michael Stein," (1913). Quoted in Bennard B. Perlman, ed. *American Artists, Authors, and Collectors: The Walter Pach Letters* (Albany: State University of New York Press, 2002), 383–87.
27 Harriet Monroe, "Cubist Art a Protest against Narrow Conservatism," *Chicago Daily Tribune*, April 6, 1913.
28 Martinez, "A Mixed Reception for Moderism: The 1913 Armory Show at the Art Institute of Chicago," 51–52.
29 Ibid., 52.
30 Milton W. Brown, *The Story of the Armory Show*, Second ed. (New York: Abbeville Press, 1988), 209.
31 Martinez, "A Mixed Reception for Moderism: The 1913 Armory Show at the Art Institute of Chicago," 52.
32 "Cubists Depart; Students Joyful," *Chicago Daily Tribune*, April 17, 1913, and ———, "A Mixed Reception for Moderism: The 1913 Armory Show at the Art Institute of Chicago," 53.
33 ———, "A Mixed Reception for Moderism: The 1913 Armory Show at the Art Institute of Chicago," 53.
34 Harris, "The Chicago Setting," 16.
35 Martinez, "A Mixed Reception for Moderism: The 1913 Armory Show at the Art Institute of Chicago," 54.
36 Pach, *Queer Thing, Painting: Forty Years in the World of Art*, 194.

CHAPTER 8: LOSING BATTLES

1 "Evans Paintings at Spring Academy," *New York Sun*, March 23, 1913.
2 Garnett McCoy, "The Post Impressionist Bomb," *Archives of American Art Journal* 20, no. 1 (1980): 12–17.
3 Walt Kuhn, "Walt Kuhn Family Papers and Armory Show Records" (Archives of American Art, Smithsonian Institution, 1859–1978, Bulk 1900–1949), Box 1, Folder 5, 29.
4 Ibid., Box 1, Folder 5, 46–50.
5 F.W. Coburn, "Boston Sees Cubist Show," *Boston Herald*, April 28, 1913.
6 "Cubist Bust Did Just That," *Boston Herald*, April 30, 1913.
7 Milton W. Brown, *The Story of the Armory Show*, Second ed. (New York: Abbeville Press, 1988), 127–28.
8 Walter Pach, *Queer Thing, Painting: Forty Years in the World of Art* (New York: Harper & Brothers Publishers, 1938), 198.
9 Kuhn, "Walt Kuhn Family Papers and Armory Show Records," Box 3, Folder 47, 38.
10 "Artists Divided About Another Cubist Show," *New York Press*, 1913.
11 Kuhn, "Walt Kuhn Family Papers and Armory Show Records," Box 3, Folder 48, 58–59.

12 "Giving Cube Art a Chance," *New York Sun*, 1914.

13 Annie Cohen-Solal, *Painting American: The Rise of American Artists, Paris 1867– New York 1948*, trans. Laurie Hurwitz-Attias (New York: Alfred A. Knopf, 2001), 234.

14 "Art Society Scandal," *American Art News* 12, no. 34 (1914).

15 "Secession Fails to Worry Artists," *New York Tribune*, May 30, 1913.

16 Guy Pène du Bois, "The Post-Impressionist Quarrel (Letter to the Editor)," *New York Tribune*, June 2, 1914.

17 Guy Pène du Bois, *Artists Say the Silliest Things* (New York: American Artists Group, Inc./Duell, Sloan and Pearce, Inc., 1940), 166–74.

18 Pach, *Queer Thing, Painting: Forty Years in the World of Art*, 201.

19 Laurette E. McCarthy, *Walter Pach (1883–1958): The Armory Show and the Untold Story of Modern Art in America* (University Park: The Pennsylvania State University Press, 2011), 66–71.

20 Richard Whelan, *Alfred Stieglitz, a Biography: Photography, Georgia O'Keeffe, and the Rise of the Avant-Garde in America* (Boston: Little, Brown and Company, 1995), 320–36.

21 Judith Zilczer, "'The World's New Art Center': Modern Art Exhibitions in New York City, 1913–1918," *Archives of American Art Journal* 14, no. 3 (1974): 2.

22 Quoted in Aaron Sheon, "1913: Forgotten Cubist Exhibitions in America," *Arts Magazine* 57, no. March (1983).

23 Pach, *Queer Thing, Painting: Forty Years in the World of Art*, 201.

CHAPTER 9: CONFLICTS BOTH REAL AND IMAGINED

1 Peter Hill, *Stravinsky: The Rite of Spring*, Cambridge Music Handbooks (Cambridge, U.K.: Cambridge University Press, 2000).

2 Jenny Gilbert, "The Rite of Spring: Shock of the New," *The Independent*, April 6, 2013.

3 Judith Mackrell, "Ballet's The Rite of Spring, 100 years later," *The Guardian*, April 3, 2013

4 Raymond Duchamp-Villon, "Letter from Raymond Duchamp-Villon to Walter Pach," (1913). From Walter Pach "Walter Pach Papers" (Archives of American Art, Smithsonian Institution, 1857–1980), Reel 4217, Frames 132–33.

5 Marcel Duchamp, "Letter from Marcel Duchamp to Walter Pach" (1913). Quoted in Bennard B. Perlman, ed. *American Artists, Authors, and Collectors: The Walter Pach Letters* (Albany: State University of New York Press, 2002), 151.

6 Linda Wagner-Martin, *"Favored Strangers": Gertrude Stein and Her Family* (New Brunswick, N.J.: Rutgers University Press, 1995), 113.

7 Janet Bishop, Cécile Debray, and Rebecca Rabinow, eds., *The Steins Collect: Matisse, Picasso, and the Parisian Avant-Garde* (San Francisco: San Francisco Museum of Modern Art in association with Yale University Press, 2011), 160–63.

8 John Richardson and Marilyn McCully, *A Life of Picasso: The Cubist Rebel, 1907– 1916*, 3 vols., vol. 2 (New York: Alfred A. Knopf, 1996), 344.

9 Ibid., 345.

10 Alice Goldfarb Marquis, *Marcel Duchamp: The Bachelor Stripped Bare* (Boston: MFA Publications, a Division of the Museum of Fine Arts, Boston, 2002), 107–8.

11 William A. Camfield, *Francis Picabia* (New York: The Solomon R. Guggenheim Foundation, 1970), 22.

12 Marquis, *Marcel Duchamp: The Bachelor Stripped Bare*, 108.

13 Laurette E. McCarthy, *Walter Pach (1883–1958): The Armory Show and the Untold Story of Modern Art in America* (University Park: The Pennsylvania State University Press, 2011), 70.

14 Marquis, *Marcel Duchamp: The Bachelor Stripped Bare*, 112.

15 Richardson and McCully, *A Life of Picasso: The Cubist Rebel, 1907–1916*, 345.

16 William A. Camfield, *Francis Picabia: His Art, Life and Times* (Princeton, N.J.: Princeton University Press, 1979), 72.

17 "French Artists Spur on an American Art," *New York Tribune*, October 24, 1915.

18 Marquis, *Marcel Duchamp: The Bachelor Stripped Bare*, 120.

19 Larry Witham, *Picasso and the Chess Player: Pablo Picasso, Marcel Duchamp, and the Battle for the Soul of Modern Art* (Lebanon, N.H.: University Press of New England, 2013), 119–22.

20 Beatrice Wood, "Marcel," in *Marcel Duchamp: Artist of the Century*, ed. Rudolf E. Kuenzli and Francis M. Naumann (Iowa City, Iowa: Association for the Study of Dada and Surrealism, The University of Iowa, 1989), 14.

21 Marquis, *Marcel Duchamp: The Bachelor Stripped Bare*, 132.

22 Witham, *Picasso and the Chess Player: Pablo Picasso, Marcel Duchamp, and the Battle for the Soul of Modern Art*, 120.

23 Camfield, *Francis Picabia*, 25–26.

CHAPTER 10: WINNING THE WAR

1 Robert M. Coates, "The Art Galleries: Situation Well in Hand," in *Jackson Pollock: Interviews, Articles, and Reviews* (New York: The Museum of Modern Art, New York, 1999).

2 Steven Naifeh and Gregory White Smith, *Pollock: An American Saga* (New York: HarperPerennial, 1989), 468–69.

3 Henry Adams, *Tom and Jack: The Intertwined Lives of Thomas Hart Benton and Jackson Pollock* (New York: Bloomsbury Press, 2009), 22–75.

4 Richard Whelan, *Alfred Stieglitz, a Biography: Photography, Georgia O'Keeffe, and the Rise of the Avant-Garde in America* (Boston: Little, Brown and Company, 1995), 437.

5 Laurette E. McCarthy, *Walter Pach (1883–1958): The Armory Show and the Untold Story of Modern Art in America* (University Park: The Pennsylvania State University Press, 2011), 150.

6 Wanda M. Corn, *The Great American Thing: Modern Art and National Identity, 1915–1935* (Berkeley: University of California Press, 1999), 8–9.

7 Annie Cohen-Solal, *Painting American: The Rise of American Artists, Paris 1867–New York 1948*, trans. Laurie Hurwitz-Attias (New York: Alfred A. Knopf, 2001), 282.

8 Henry Adams, *Thomas Hart Benton: An American Original* (New York: Knopf, 1989), 134–57.

9 Daniel Grant, "Portrait of the Artist before and After," *Humanities: The Magazine of the National Endowment for the Humanities* 2010.

10 Ibid.

11 Adams, *Thomas Hart Benton: An American Original*, 217–18.

12 "U.S. Scene," *Time* 1934.

13 R. Tripp Evans, *Grant Wood: A Life* (New York: Alfred A. Knopf, 2010), 155, 287–88.

14 Naifeh and Smith, *Pollock: An American Saga*, 226.

15 McCarthy, *Walter Pach (1883–1958): The Armory Show and the Untold Story of Modern Art in America*, 127.

16 Walt Kuhn, "The Story of the Armory Show" (Archives of American Art, Smithsonian Institution, 1938), 24–25.

17 Jerome Myers, *Artist in Manhattan* (New York: American Artists Group, 1940), 36–37.

18 Deborah Solomon, *Jackson Pollock: A Biography* (New York: Simon and Schuster, 1987), 66–77.

19 Naifeh and Smith, *Pollock: An American Saga*, 228.

20 Adams, *Thomas Hart Benton: An American Original*, 240–43.

21 Solomon, *Jackson Pollock: A Biography*, 75.

22 Naifeh and Smith, *Pollock: An American Saga*, 329.

23 Judith Zilczer, "The Dispersal of the John Quinn Collection," *Archives of American Art Journal* 19, no. 3 (1979): 15.

24 Solomon, *Jackson Pollock: A Biography*, 97–98.

25 Ibid., 132.

26 Adams, *Tom and Jack: The Intertwined Lives of Thomas Hart Benton and Jackson Pollock*, 11.

27 Ibid., 8.

28 "Jackson Pollock: Is he the greatest living painter in the United States?" *LIFE*, August 8, 1949.

29 Naifeh and Smith, *Pollock: An American Saga*, 606.

30 Ibid., 574.

31 Ibid., 473.

32 Michael L. Krenn, *Fall-Out Shelters for the Human Spirit: American Art and the Cold War* (Chapel Hill: University of North Carolina Press, 2005), 4–5.

33 Frances Stonor Saunders, "Modern Art Was Cia 'Weapon'," *The Independent*, October 22, 1995.

34 Solomon, *Jackson Pollock: A Biography*, 251.

35 Adams, *Tom and Jack: The Intertwined Lives of Thomas Hart Benton and Jackson Pollock*, 155.

EPILOGUE: DISPATCH FROM THE FOG OF WAR

1 Marcel Duchamp, "Armory Show Lecture, 1963," ed. Recorded by Richard N. Miller (tout-fait: The Marcel Duchamp Studies Online Journal, 2003).

2 Yoko Ono, *Grapefruit: A Book of Instructions and Drawings* (New York: Simon & Schuster, 1964).

3 Beatrice Wood, "Marcel," in *Marcel Duchamp: Artist of the Century*, ed. Rudolf E. Kuenzli and Francis M. Naumann (Iowa City, Iowa: Association for the Study of Dada and Surrealism, The University of Iowa, 1989), 14.

4 David Joselit, *American Art since 1945* (London, U.K.: Thames & Hudson Ltd., 2003), 69.

5 Mike Boehm, "The 'Shot' Heard 'Round UCLA," *Los Angeles Times*, July 9, 2005.

6 Rozalia Jovanovic, "Joe Deutch, Artist Who Presented Russian Roulette at UCLA, Hits Marlborough Chelsea," *GalleristNY*, June 22, 2012.

7 Frank. J. Mather, Jr., "Art Old and New," *Nation*, March 6, 1913, 45.

8 "American Art from Different Points of View," *New York Times*, October 11, 1908.

9 Sarah Thornton, *Seven Days in the Art World* (New York: W.W. Norton & Company, 2008), 48.

10 Georgina Adam et al., "The End of the Art World . . . ?" (paper presented at the ICA Quickfire, London, U.K., January 19, 2013).

11 Billy Childish and Charles Thomson, "Anti-Anti-Art: The Spirit of What Needs to Be Done," The Hangman Bureau of Enquiry, www.stuckism.com/StuckistAntiAntiArt .html (April 18, 2013).

12 Charles Thomson, "The Future of Art, Part 8: Charles Thomson, Founder Stuckist," FAD, www.fadwebsite.com/2010/06/22/the-future-of-art-part-8-charles-thomson-founder-stuckist (April 27, 2013).

13 Julius Anthony, *Transgressions: The Offenses of Art* (Chicago: University of Chicago Press, 2003), 204.

14 Will Gompertz, "I Know a Lot About Art and I Know What I Hate," *The Times*, October 27, 2012.

15 "Armory Show—50 Years Later," *New York Times*, April 6, 1963.

16 Walt Kuhn, "Walt Kuhn Family Papers and Armory Show Records" (Archives of American Art, Smithsonian Institution, 1859–1978, Bulk 1900–1949), Box 2, Folder 7, 7.

POSTSCRIPT

1 Philip Rhys Adams, *Walt Kuhn, Painter: His Life and Work* (Columbus: Ohio State University Press, 1978), 100.

2 Bennard B. Perlman, *The Lives, Loves, and Art of Arthur B. Davies* (Albany: State University of New York Press, 1999), passim.

3 Laurette E. McCarthy, *Walter Pach (1883–1958): The Armory Show and the Untold Story of Modern Art in America* (University Park: The Pennsylvania State University Press, 2011), 167.

4 William Innes Homer, *Robert Henri and His Circle* (Ithaca, N.Y.: Cornell University Press, 1969), 208–9.

5 Gail Levin, *Edward Hopper: An Intimate Biography*, 2nd ed. (New York: Rizzoli International, 2007).

6 Richard Whelan, *Alfred Stieglitz, a Biography: Photography, Georgia O'Keeffe, and the Rise of the Avant-Garde in America* (Boston: Little, Brown and Company, 1995), passim.

7 Lois Palken Rudnick, *Mabel Dodge Luhan: New Woman, New Worlds* (Albuquerque: University of New Mexico Press, 1984), passim.

8 B.L. Reid, *The Man from New York: John Quinn and His Friends* (New York: Oxford University Press, 1968), passim.

9 Howard Shaff and Audrey Karl Shaff, *Six Wars at a Time: The Life and Times of Gutzon Borglum, Sculptor of Mount Rushmore* (Sioux Falls, South Dakota: The Center for Western Studies, 1985), passim.

10 "Manierre Dawson: A Brief Biography," Manierre Dawson Official Site, http://manierredawson.com/biography/ (April 26, 2013).
11 Linda Wagner-Martin, *Favored Strangers: Gertrude Stein and Her Family* (New Brunswick, N.J.: Rutgers University Press, 1995), 197–220.
12 Christopher Benfrey, "The Alibi of Ambiguity," *New Republic*, June 28, 2012.
13 Calvin Tomkins, *Duchamp: A Biography* (New York: Henry Holt and Company, 1996), 451–63.

Acknowledgments

So many people helped make this book possible. Thanks go particularly to my agent, Russell Galen, for helping shape my ideas and sticking with me through months of hard work. Thanks to editor Jon Sternfeld for his enthusiasm, his skill at shaping a narrative, his firmness when I got too art-history-ish, and his willingness to laugh at my jokes. A word of thanks also goes to Meredith Dias for guiding the book from manuscript through production and to all of the other great people at Lyons Press who contributed in so many ways.

Many people have helped guide my research. Thanks especially to Laurette McCarthy, both for allowing me to read her biography of Walter Pach before it was released and for sharing her amazing depth of knowledge about all things Armory Show. Thanks to the College Art Association for welcoming me to their 2013 conference and the scholars at the Armory Show session, including Marilyn Kushner and Kimberly Orcutt of the New-York Historical Society, for their insights. I am deeply in the debt of Armory Show and modern art scholars both past and present, and any errors are mine, not theirs.

It would simply not have been possible to write this book without the incredible digitized collections of the Archives of American Art at the Smithsonian Institution and the Terra Foundation Center for Digital Collections. That I was able to sit at my desk in Fort Worth, Texas, and read the handwritten letters of Walt Kuhn is remarkable.

I'm also grateful for the help of several libraries and librarians; research librarians are simply the most helpful group of people I've ever met. Thanks especially to the Amon Carter Museum of American Art Library, the New York Public Library, the Ryerson & Burnham Libraries of the Art Institute of Chicago, the Harry Ransom Center at the University of Texas at Austin, the Texas Christian University Library, the Helen Farr Sloan Library & Archives at the Delaware Art Museum, and

the Fort Worth Public Library. Museums have also been generous with their help—thanks especially to the Museum of Modern Art and the Montclair Art Museum.

Writing a book is a team effort, and I have a fantastic team. My parents, Tom and Martha Lunday, and my mother-in-law, Zena McAdams, provided both free child care and enormous emotional support, not to mention a willingness to hear endless stories about things that happened in 1913. Nancy Wainscott offered help with the tricky business of being a parent while writing a book. My sister-in-law Kim McAdams-Baker deserves credit as my unpaid publicist and cheerleader. Friends shared their time and occasionally their futons on out-of-town visits. Special thanks go to Laura Moore, Charlotte Huff, Paula Gruber, and the UCC Moms group. Thanks as well to Elliot Richmond for introducing me to bibliography software that saved me a lot of pain and suffering.

I've dedicated this book to my guys—my husband Chris McAdams and my son Nathan. Thanks to Nathan for his patience with a very busy mom who had little time to play Wii Mario Kart as well as for his loving heart. Thanks to Chris for spending an entire day reading old newspaper articles on microfilm in New York and, more importantly, for twenty years of support and encouragement. Thank you for never once saying, "Maybe you should get a real job."

Finally, a word for my daily companions: my dog Abigail, who always listened to Armory Show theories with head-tilting attentiveness, and MaxCat, who never listened at all.

Index